Calvary's Child

The Life of Amanda Carol Hooker

By Tom Hooker

Stoney Mountain Press

Hendersonville North Carolina

For permission to reprint copyrighted material, grateful acknowledgement is made to the following sources:

Cover Photo: ©1993, Glamour Shots, Inc.

p.43: THOMAS JEFFERSON: AN INTIMATE HISTORY" (p.151), by Fawn M. Brodie, ©1974 W.W. Norton & Co.

p 289-290: "If You Could See Me Now", Words/Music by Kim Noblitt, ©1992 Integrity's Praise! Music/BMI & Hold Onto Music (adm by Integrity's Praise! Music) All Rights Reserved. Used by Permission.

PUBLISHED BY:
Stoney Mountain Press
Hendersonville, North Carolina

PRINTED BY:
Morris Publishing
3212 East Highway 30
Kearney, NE 68847

ISBN: 0-9670617-0-9
Library of Congress Catalog Card Number: 99-93721

2 4 6 8 10 9 7 5 3 1

ACKNOWLEDGEMENTS

I extend profound thanks to the following:

God; for the strength He provided through our ordeal.

Carol; for making us the proudest parents in the history of the world.

Elaine, my wife; for her patience, support and encouragement.

Janice Anderson; for her assistance in editing this book.

The many, many medical professionals who helped make Carol's graduation a little easier, and our pain a little less.

CONTENTS

INTRODUCTION

"And now, dear brothers, I want you to know what happens to a Christian when he dies so that when it happens, you will not be full of sorrow, as those are who have no hope"
I Thessalonians 4:13 (TLB)

"You can't be brave if you've only had wonderful things happen to you."
Mary Tyler Moore

At 8:30 AM the halls of Margaret R. Pardee Memorial Hospital's oncology ward bustle with muted activity. Housekeepers in mint and white striped smocks push carts of cleaning supplies from room to room, cleaning as they go. Certified nurse's assistants in colorful print blouses retrieve breakfast trays that were passed out a half-hour before, and prepare for morning baths and linen changes. A phlebotomist in a white gown strides down the hall carrying a tray of vials and needles like a carpenter carrying a toolbox, going to take blood samples from some unlucky soul. Two operating room personnel, clad in green scrubs, roll a gurney carrying a patient to the OR. Registered nurses, also wearing print blouses, administer medications and calmly handle one crisis after another. Doctors, some in business suits, some in white lab coats, and some in green scrubs, make their rounds. I wonder what news they deliver to their patients. Some patients get good news, some, bad. Some get hope; some get despair. The life of a medical professional is a hard one, I decide.

These medical professionals are locked in a grim battle with a demon known as cancer. The patients in the various rooms are the battleground, and the demon tries to suck the life and hope out of each one like a vampire sucking blood from its victim. The nurses, doctors, and others struggle each day to keep the demon at bay. Until I became so intimately involved with this cancer, I didn't realize just how grisly this battle was.

My daughter lies up the hall in room 359, mortally wounded by the demon. Her doctor gives her only days to live. Yet still she fights on. Stacy, her CNA for the day shift, is giving her a bath and changing her linens, so I have been banished to the small alcove at the end of the hall which serves as a waiting room. Thus I have the opportunity to observe the hospital staff at work, while I ponder the past, present and future of my daughter and family.

During the last eight months, while the cancer wreaked its havoc, Carol has amazed her family and friends with her ability to inspire hope and perseverance in others. She loves God, and has demonstrated that love through her activities during this illness. It is this witness that has touched the lives of so many of her friends here in Hendersonville North Carolina as well as her campus home at High Point University. My heart is warmed as Carol receives an outpouring of love and affection in response to what she has already given.

It occurs to me that there may be a way to allow Carol's witness to extend beyond her earthly life. A couple of years ago, I got a crazy notion that I could write a book. My desire was to write fiction, although I wasn't sure I had the imagination for it. I

tell everyone that writing reports for the U.S. Government for over twenty years has given me extensive experience at writing fiction! Of course, writing **ENTERTAINING** fiction is another matter.

My thoughts on this January morning, however, lead me to consider writing a book about Carol's life and her fight with the many illnesses that plagued her over the past eight years. This chronicle of her life will allow her witness to extend beyond the reach of her physical life. So, I will attempt to make a record of Carol's life, her relationship with God, and her fight with the cancer which ultimately took her life, but not her spirit.

This is that book. I first thought that I would write it from Carol's point of view, trying to describe her hopes and fears. Then I realized that is not possible. I could only write about what I **THOUGHT** were her hopes and fears. It would not be fair to Carol for me to try to interpose my thoughts into her head, so I will write an account based on my perception of her life.

Since this is essentially a biography, I thought about trying to present it as an objective, third person account of her life and God's role in it. I realized, however, that I could not be objective. Too much parental pride and love would make complete objectivity impossible. So, I will write a first person account of my observation of Carol's life.

I have asked many of Carol's friends to relate a little of their experiences with her, and some of those are presented here as well.

The purpose of this book is to glorify God by telling about a young person whose

life goal was to glorify God. I pray that this book succeeds in that purpose.

> "For I am convinced that neither death nor life, neither angels nor demons, neither the present nor the future, not any powers, neither height nor depth, nor anything else in all creation, will be able to separate us from the love of God that is in Christ Jesus our Lord."
> Romans 8:38-39 (NIV)

PROLOGUE

"...choose you this day whom ye will serve; whether the gods which your fathers served that were on the other side of the flood, or the gods of the Amorites, in whose land ye dwell: but as for me and my house, we will serve the Lord."

Joshua 24:15 (KJV)

"I have now disposed of all my property to my family. There is one thing more I wish I could give them, and that is the Christian religion. If they had that, and I had not given them one shilling, they would have been rich, and if they had not that, and I had given them all the world, they would be poor."

From the Last Will
and Testament of Patrick Henry

In Jesus' day, the Hebrew people believed that the sins of the father could be visited upon the son, therefore a child could be called upon to pay for a sin committed by a parent. Today, Christians know this is not true. Each person is accountable to God for his or her own sin. It is true, however that the lifestyles and life choices of a parent can influence the growth and development of a child. I have heard many adults remark, "I open my mouth, and I hear my father's voice (or my mother's voice)." Many adults will also admit that their values and habits are learned from their parents, who learned their values and habits from their parents, and so on.

One woman tells the story of how she cooked turkeys. Before she put the turkey in

the oven, she sliced about one-fourth off the end. When asked why, she could only explain that was how her mother cooked it. Upon investigation, she learned that her great grandmother had owned an oven that was too small to hold the turkey, so she had to cut off one end to make it fit. Now, the great granddaughter had a nice, big oven, but she still cut one end off the turkey because that's the way she learned how.

With this in mind, a record of Carol's life must begin with a little history of her parents' families. Where they came from and what they believed became the foundation for where Carol came from and what she believed. Of course, the foundation of Carol's life was a firm and steadfast belief in Jesus Christ as her Savior and Friend. That, as you will see, was the foundation of her ancestors' lives as well.

Barbara Elaine Hooker was born on October 20, 1951 in Union County, Mississippi, the daughter of William Dove Pannell and Lula Blanche Reed Pannell. Union County is part of the rolling hills of the Pontotoc Ridge, located in Northeast Mississippi, about twenty miles from Tupelo. Tupelo was not yet famous as the birthplace of Elvis Presley. In the early 1950's, the area was primarily agricultural. W. D. and Lula, like most of the families in that area were subsistence farmers, working to scratch out a living from the land. Unlike the black loam of the Mississippi River delta to the southwest or the Tombigbee River delta to the southeast, the red clay of the Pontotoc Ridge did not produce very easily. So Elaine was raised in a family accustomed to hard work.

In addition to the household maintenance chores usually assigned to a young person of that era, Elaine and her siblings had the

responsibility of helping her father bring in the crops. Cotton was king in Union County, and W. D. was part of his court. During the summer months, Elaine would spend long hot days chopping weeds from the cotton fields. Come autumn, she spent equally long days picking the cotton.

Elaine was the youngest of seven children. Her four older sisters and two older brothers made up a large, gregarious family infused with love. As the youngest, Elaine had to endure a great deal of ruthless teasing. On the other hand, her older siblings offered loving protection as only older brothers or sisters can. As a result, Elaine grew up as a combative, competitive young girl. She was a tomboy. While other girls played with their dolls, Elaine could be found with toy six-guns on her hips, playing cowboys and Indians. As she grew older, she channelled her competitive spirit into athletics, becoming an all-star basketball player. Unfortunately, this was before the age of women's athletics in college, so she didn't have the opportunity to take her athletic skill beyond high school.

Elaine's family was religious. Lula Blanche made sure her brood was always at church on Sunday, and her family practiced more than a "once-a-week" religion. Lula Blanche always spent a portion of each day studying her Bible and praying. Elaine gave her life to her Savior when she was nine years old.

It is interesting to see how belief systems and culture is incorporated into young children's games. A game in which Elaine participated included one of her sisters, Lula Ruth (the next youngest in the family) and her cousin Leland Hurt, Jr. In

this game, Leland was the preacher, standing on a hillock or tree stump to preach his message. Lula was the choir, singing hymns, and Elaine was the lost sheep who came to know the Lord as her Savior. At the end of the sermon, Elaine was baptized in some nearby mud puddle! Funny thing, Elaine never has cared much for swimming! Leland, by the way, went on to become a minister of music.

Like many of Elaine's generation, she and two of her siblings became the first of her family to get a college education. Doris, the oldest, attended the University of Mississippi, better known as Ole Miss, receiving her degree in elementary education and establishing a tradition of Ole Miss support within the family. Billy Houston came next. His Ole Miss degree was in physical education, and he became the basketball coach at Thaxton High School. Elaine studied secondary education, with an emphasis in mathematics - more about that later.

I was born on December 10, 1951 in Pontotoc County, Mississippi, and named Tommy Brooks Hooker. Like my future wife, my parents were subsistence farmers, at least during my early years.

My great-great-grandfather, William Powell Hooker, moved to Pontotoc County from Alabama in the mid-1830's. He helped to found the Sand Springs Baptist Church. His son, John Allen Hooker, lived north of Buttermilk Springs, Mississippi. Later, Buttermilk Springs was named after its most prominent citizen, Dr. Montgomery Thaxton. John Allen Hooker was a leader in the Thaxton Baptist Church. Once, when I was doing some genealogical research, I asked someone who knew him, what she remembered most about John

Allen. "He loved to read the Bible." she answered.

John Allen's son was named Stanford William Hooker. Stanford married Lillie Mae Owens in 1920. Lillie Mae gave birth to J.C. Hooker in 1922.

In 1929, Stanford bought about sixty acres of land on Turnpike Road 2 miles west of Thaxton. He built a home there and he and Lillie Mae farmed the land with the help of their son. Upon J.C.'s return from World War II, he married Wilma Bernette Coleman in 1946.

With Stanford's help, J.C. built a house right next door to his father. There he and "Net" made their home and started their family. Pamela Annette (Pam) came along in 1949, and I came along in 1951.

My father farmed a few acres of cotton as a cash crop. In addition he kept a few head of cattle. He and my mother milked the cows each day, keeping some for drinking and cooking and selling the rest to the grade B milk plant in Pontotoc. Dad raised corn to feed the cows, and cut hay for winter feed. He also planted some peanuts and sweet potatoes on the back side of the farm, and harvested those for family use. In one corner of the cotton patch, shielded from the other corn to prevent cross pollination, Dad planted a few rows of popcorn. On cold winter nights, we would shuck and shell an ear of popcorn, then pop it on the stove. Delicious!

Behind the house, Mom and my grandmother kept a garden. It contained butter beans, peas, Irish potatoes, green beans, okra, tomatoes, and yellow corn (roast'n ears). Wild blackberries grew along a road which bordered our farm, and when they were ripe, we added them to the family larder.

Muscatine grapes also grew on the back side of the farm, and these were used to make grape jelly. Grandmother always called them "muskiedimes". To round out the farm's yield, a few pecan, plum, and apple trees were spread around.

Oh, yes, and I can't forget the flock of chickens which wandered around the yard. These chickens produced the eggs that we ate for breakfast, or that Mom cooked in various dishes. Periodically, one of the chickens gave its life to become the main course for Sunday dinner.

Like Elaine's family, mine was closely tied to the church. Dad was a deacon and treasurer at the Thaxton Baptist Church, and Mom was active in all church activities.

In August 1959, when I was seven years old, Thaxton Baptist Church held its summer revival. In those days, revivals lasted all week, and sessions were held twice a day, once in the morning at 10:00 and once in the evening. All of the housewives in the community attended the morning session, as well as the men when the weather was too bad to be in the field. Also, the principal at Thaxton Attendance Center (12 grade schools were called attendance centers) would pull a bus up to the front door of the school and any student who wanted to go to the revival could load up and go. The relationship between the schools and churches have changed a little since then!

I decided to go to the revival for two reasons. It would get me in good with Mom to voluntarily go to church, and it would get me out of the classroom for a while. I am not sure why a church service would be more desirable to a seven year old boy than a class at school, unless it was just the change of scenery for an hour or so.

Prologue

The evangelist who led the revival that year was named Brother Billy Baker, and he had a pretty good singing voice. This particular morning, he sang a Tennessee Ernie Ford favorite named, "Wayfaring Stranger". While this is pretty heavy thinking for a seven year old, I remember realizing that in fact we are temporary travelers in this world, and our home is really in Heaven. I was moved to walk down the aisle when the invitation was given to offer my life to Christ.

Evangelist Mike Warnke gives his testimony about being the high priest of a Satanic coven before he was saved by Jesus Christ. Don Babbin and Freddie Gage testify to having been involved in violent gangs in Houston, Texas before their salvation. At age seven, I had done none of these things. I had only committed "little" sins, such as telling little white lies and occasionally disobeying my parents. I might have even stolen a nickel or a pencil from a classmate. Even so, I was destined for Hell just as sure as Warnke, Babbin and Gage were before they were saved. It doesn't matter how "big" or "little" our sins are, the fact that we have sinned separates us from Christ and Heaven.

My parents had raised me in a Christian household, and Thaxton was a Christian community. I had been taught by word and deed, at home and at church and elsewhere, that Jesus was the Son of God, and the way to salvation. Believing this was a natural thing for me. It was part of my family; thus, it was a part of me.

However, believing in your head and believing in your heart are two different things. Before Bro. Baker sang his song, I knew these things in my head. Afterwards, I knew them in my heart. I realize now that I

11

went through several steps to reach this heartfelt belief and subsequent faith.

First, I realized that I had sinned. Because my parents loved me, and still do, their method of raising me involved discipline. I don't mean punishment, although that came into play when I failed to obey their edicts. The discipline I am discussing here is the process of learning self-control by learning and obeying the rules and guidelines my parents established. These rules and guidelines were consistent with the teachings of Jesus Christ and His word. Thus, I learned that the ten commandments were to be obeyed. I was also taught to be courteous and polite and respectful of my fellow man. I learned right from wrong. Up until this point, my reasons for obeying these teachings were to avoid my parent's displeasure and punishment when I disobeyed. Now I realized that failing to obey these teachings were also separating me from Jesus Christ, and that by this disobedience, I was sinning. I further realized that the consequences of this sin was to be lost forever. I realized that I would spend my eternal life in Hell. As Romans 6:23 says, "For the wages of sin is death, but the gift of God is eternal life in Christ Jesus our Lord." (NIV).

My second step was the realization that I didn't want to be separated from Jesus. I experienced remorse because of my actions. I decided that I didn't want to be that way any more. This was repentance.

The next step was the big one. I realized that Jesus had the power to erase the sin and end that separation between me and Him. I had experienced mercy at the hands of my parents. I had done things which were wrong, and which had hurt my parents.

Yet, because they loved me, they had forgiven me and had abrogated the punishment. I became aware that by my sin I had hurt Jesus deeply, and that because He loved me, He could forgive me of those sins. I had sung the song, "Jesus Saves," many times. I had quoted Bible verses which touted the saving power of Jesus many times. Only now did I realize what this really meant.

My next step was to call upon Jesus to save me. I don't remember the exact words I said. I am not even sure I said them aloud. I am sure that it went something like this, "Lord, I have sinned, and I am a sinner. I don't want to be a sinner any more. Please save me," and He did!

I would like to be able to say that after that day I lived a perfect life. I can't. Because I am human, I have failed to live up to Jesus' standards many times. But I am proud to say that since that day I have lived a forgiven life. While my life, like that of most Christians, has been bumpy sometimes, Jesus has been with me every step of the way.

While I was still young, Dad decided he'd had all of the farming life he wanted, and went to work as a carpenter for his cousin, Oakley Hooker. Since my sister and I were at school all day, Mom decided to go to work in Pontotoc to earn some extra money. She worked for a while at a shirt factory there, but that was too hard on her shoulders. Later she went to work at the Ram Golf Corp. plant in Pontotoc making golf bags.

Since Dad wasn't growing crops any more, I found myself free to "hire out" with other farmers in the area. I would chop cotton (actually this involved chopping WEEDS, not cotton) for 50 cents an hour during early

summer. In the fall, I picked cotton for $3.00 a hundred pounds. At other times, I worked on a hay hauling crew. We would load bales of hay on a wagon, haul it to the barn and unload it there. That job paid a whopping penny a bale.

During my senior year at high school, I was faced with several decisions. The Vietnam war was in full swing. When I finished high school, I would face the prospect of joining the military or being drafted. My grandfather Hooker had served in the Army during World War I, and my father had served as a Marine during World War II. I had no reservations about doing my duty in the military if that was what God and Uncle Sam wanted me to do. I did, however, want to fulfill that duty on my own terms. I had done pretty well in school, and I decided that if I needed to serve in the military, I would prefer to do it as an officer. David Manifold, my high school math teacher, encouraged me to apply to the University of Mississippi for admission as a student, and to apply for a Navy Reserve Officer Training Corps scholarship. I was successful in both endeavors.

The NROTC scholarship would pay for all my education costs at Ole Miss. It paid for tuition, room & board, and books, as well as a $50 per month stipend. I would be required to study one Naval Science course each semester, and I would spend six weeks each summer on active duty. After I received my degree from Ole Miss, I would be commissioned as an ensign in the Navy and would serve six years active duty plus two additional years in the reserve.

With those decisions under my belt, I could enjoy my final year at Thaxton High School. A mediocre athlete, I played

14

basketball, but I was too short and too slow to be very good. Thaxton's new basketball coach, Billy Pannell, tried to teach me, but let's face it, the NBA wasn't in my future. His younger sister, Elaine, visited the school occasionally and became good friends with one of my classmates, Dianne Carwyle.

After graduation, I started my college career at Ole Miss. That was a big change from my high school experience. Instead of attending a high school with a total enrollment of about 75 students in all four grades, I was now attending a school with about 7500 students. I had quite an adjustment to make. While I didn't dazzle my professors with my wit and knowledge, I did get by.

One winter night in January 1970, I made the 25 mile trip home to attend a Thaxton H.S. basketball game. While the girls game was being played, I took a seat near the top of the bleachers beside Sammy Wright, and old buddy of mine. About three rows below us, sat Dianne Carwyle and her friend Elaine Pannell.

I had been trying to go out with Dianne. So Sammy and I scooted down to sit beside the two girls. I sat beside Dianne and Sammy sat beside Elaine. Sammy had a girlfriend by the way. Her name was Johnette Henderson, and she was on the basketball court while all this was occurring. The four of us watched the game, Sammy and I flirting our little hearts out while Dianne and Elaine coyly ignored us.

When the girls game ended, Johnette sat about two rows below us and began looking daggers back at Sammy and Elaine. Dianne wisely developed a sudden headache and decided to go home. I wound up sitting beside Elaine while Johnette sat beside

Sammy. After the game we went to Oxford and bowled for a while. The rest is history.

Well, not quite. Elaine and I dated steadily for the next year. After a few months, I asked Elaine to wear my class ring. In 1970 that was a symbol that the relationship was getting serious. Elaine politely refused. That made me wonder if things were really going in the direction I thought they were. Elaine told me later that, at the point I asked, she didn't want to commit to a serious relationship. Later on, she regretted her answer, because she was afraid I wouldn't ask again.

We continued to date, however. My six-week active duty stint with the Navy that summer involved serving on a refueling ship with a 6TH Fleet task force in the North Sea. Because we were at sea most of the time, we didn't have a daily mail delivery. About once a week, a helicopter from the aircraft carrier U.S.S. HORNET, would fly over and drop our mail down to us. The other seamen on the ship (U.S.S. Marias) were jealous of me because I got a big bundle of letters each time the mail was delivered. Elaine wrote every day. I wrote her every day as well.

When 1971 rolled around. I decided to do a little discreet questioning. Without actually asking, I managed to find out that if I were to ask Elaine to marry me, she would say yes. My next job was to find Elaine's ring size. Elaine's sister Sylvia Kelly and Sylvia's husband Paul Hayes were included in my intrigue. They investigated and were able to tell me Elaine's ring size.

I visited the jeweler in Oxford and chose a ring. It wasn't much, since I didn't have a lot of cash. It did have a diamond,

which you could see if you looked hard enough. I also selected a small necklace.

Valentine's day fell on a Sunday in 1971. On Friday night, I visited Elaine and gave her the necklace, telling her that I would be busy on Sunday and wouldn't be able to visit, so here was her Valentine gift. She seemed very appreciative. The next day, I bought a heart shaped box of candy. I pulled the cellophane wrapping loose, being very careful not to tear it. Then I opened the box and removed the center piece of candy. In its place I put a tuft of cotton and placed the ring on top. I then closed the box and resealed the cellophane with glue.

That Sunday, I made a surprise trip to visit Elaine and present her with the candy. I explained that the conflict which had prevented me from coming had been resolved. I watched with anticipation as Elaine opened the candy. She removed the cellophane, lifted the top, and without looking at the candy, blithely offered me the first piece! I reached for a piece of candy near the center of the box. When her eyes followed my hand, she saw the ring and almost dropped the box of candy.

Initially, we planned to marry at the end of our college careers, in about three years. While I thought that was a joint decision, I later learned that Elaine was just going along with my idea. She really wanted an earlier wedding than that. The pastor of my church, Bro. Milton Koon, knew me pretty well, too. When I told him that we were going to wait for three years, he offered a gap-toothed grin and said, "I'll bet you get married before this summer is over."

He was right. When I discovered Elaine didn't want to wait that long, I agreed with her opinion. We moved our wedding date up to June 18.

I was concerned about how we could both go to school and find enough money to live on at the same time. Elaine helped take care of some of that problem. During the 1970 Union County fair, Elaine was the lucky winner of a brand new Chevrolet pickup. She decided to trade the pickup to her father for his 1963 Ford Fairlane and some "boot". "Boot" is cash that is "chipped in" to even the value of a trade. So Elaine helped to finance the first two years of our marriage. Now I tell everyone that I married her for her money.

During my sophomore year, something occurred which caused me to rethink my plans about military service. The Government began the withdrawal of American troops from Vietnam. Along with that withdrawal came the decision to institute a draft lottery, since the need for troops was on the decline. Fortunately, I got a high draft number. Now that I was married, I wasn't looking forward to four years in the Navy, having to spend months at a time at sea. I discussed my dilemma with Captain Hood, the commander of Ole Miss' NROTC unit. Captain Hood agreed to release me from my obligations to the Navy.

Of course that also meant that I had to give up my scholarship. My parents were happy enough to pay the tab for the tuition and books, given that I wouldn't have to go to Vietnam. I was happy enough to let them.

Elaine and I found a small efficiency apartment in the married students' housing at Ole Miss. Essentially, it was one room. The bedroom was in one corner, the living room was in another corner, and the kitchen was in the third corner. The bathroom was in the

fourth corner, but at least it had walls. Our monthly rent, including utilities, was $50.00. Each weekend we drove to Elaine's parents home to visit. We returned with a supply of vegetables from Mamaw Pannell's freezer. Our weekly grocery bill ran about $10.00. We also saved a few pennies by eating a free lunch at the Baptist Student Union each Thursday.

Relieved of my obligations for active military duty in the summer, I attended summer school to accelerate my progress toward a degree. I graduated in August, 1972 with a Bachelor of Business Administration. I then set about earning a living while Elaine finished her last year of college. Oxford didn't have the greatest job market for college graduates. I worked for a while as a sales clerk at a discount store. When it went broke (it wasn't my fault, I promise!), I worked as a stock clerk at a local factory.

In May 1973, Elaine received a Bachelor of Education degree. We then moved to Tupelo, Mississippi. We found a one bedroom apartment at the Chateau Royale apartments, an apartment complex that sounded a lot more exotic that it actually was. At least there were walls between the living room, bedroom, and kitchen. Elaine got a job as a math teacher at South Pontotoc High School in Springville Mississippi which is about twenty miles from Tupelo. I got a job with Lowe's of Tupelo, a building supply house, as their office manager. About a year later, I moved to Hunter-Sadler, a manufacturer of men's suits, as a combination personnel/purchasing manager.

We wisely decided to wait about having children until we had a chance to get comfortable with our roles as husband and

wife. We were able to allow our love to grow unfettered by parental responsibilities. We learned each others likes and dislikes, our hopes and dreams, and our quirks and foibles. Later on when Carol joined our family, we were a strong couple, prepared for parenthood.

Now that we lived in the big city of Tupelo, we were able to enjoy some of the privileges of city life. One of the things we liked to do was bowl. After all, our first date included a trip to the bowling alley. Elaine's brother, Billy; and Pat, his wife, were also bowling fans. We partnered up in a mixed couples league and did very well. Billy and I also found enough male partners to form a men's team.

Saturday afternoons were usually spent with my family. This often consisted of a quiet afternoon in conversation or reading, followed by supper before we returned to our apartment in Tupelo.

Our church membership was at Ellistown Baptist Church, Elaine's home church, and the place where we were married. On Sunday mornings, we would drive out to Ellistown, attend church, and spend Sunday afternoon with Elaine's family. All of her siblings and their spouses would bring their children and come by for Sunday dinner. I remember sitting in a corner in the living room and trying to listen to about a half-dozen conversations going on simultaneously. Since I came from a small family, I was overwhelmed. Every Sunday evening I would go home with a whopping headache. After a while, I adjusted and felt myself a part of the family.

And so our life continued until, in the fall of 1975, we decided to start our own family.

TUPELO

"For You created me in my inmost being.
You knit me together in my mother's womb.
I praise you because I am fearfully and
wonderfully made. Your works are wonderful.I
know that full well"
 Psalm 139:13-14 (NIV)

By the fall of 1975, we decided it was time to increase our family. We'd been married for four years, and were now established in our home and our jobs. We hoped that our timing would be such that Elaine would become pregnant in the fall, and would have her baby during the summer of 1976. Thus she could finish the school year without taking maternity leave. Also, if things went well, she would be able to resume school in the fall. We discussed whether Elaine should stay home and raise our child, or whether she should return to teaching school and keep our baby in a child care facility. Many professionals have expressed concern about the quality of parenting when a child is placed in daily child care. We decided that we could be good parents and still have both of us work. This is not a discussion of "quality time" in parenting. Some parents explain away the issue of spending too little time with a child by arguing that the scarce time spent is "quality time". We had no illusions that we could raise a child without investing a significant amount of time and energy. On the other hand, we did feel we could pursue careers and be parents, too. I will discuss more about how we did that later.

I know we were being optimistic in thinking we could conceive a child according to a narrow time schedule. Believe it or not, however, that is exactly the way things

worked. By November, Elaine was pretty sure she was "in the family way." A trip to the obstetrician confirmed that the due date was July 1! Call it luck if you wish, but I like to think God agreed with our plans and arranged for them to come to pass.

During the early 1970's several new things occurred in the childbirth area. Natural childbirth was becoming popular (again), and hospitals were beginning to let fathers into the delivery rooms. Elaine signed up for a Lamaze class to learn the principles of natural childbirth. As the father, I was supposed to be her coach.

We ran into a problem, however. The Lamaze classes were on the same night that I was scheduled to bowl with the men's team. Elaine left it up to me to decide whether to attend the Lamaze classes with her, or whether to stick with the bowling team. I decided to stick with the bowling team.

Big mistake.

Over the years, Elaine has teased me a lot about not having my priorities straight as a husband. On this occasion, I have to admit that I did not. I should have dropped the bowling league and stuck with my wife. I know I hurt Elaine's feelings, and I regret it. My decision had several consequences. First, Elaine didn't benefit as much from the class as she would have if her coach had been there for her. Second, the hospital had a rule that fathers could not attend the delivery unless they had completed a Lamaze class. As a result I was barred from helping my wife with the delivery of our child. I believe I have matured more as a husband and father since then. I do know that I am more attentive to my wife than I was then.

Elaine's pregnancy was uneventful. That was something for which to be thankful. She

had no complications. Of course she had to deal with the usual discomfort carrying around a swollen belly. With her small frame, that was a big job. She handled it like a trooper, however.

Fortunately, I handled the physical part of the husband task better than I handled the support part. I also did a better job than my brother-in-law Bill had done when his wife Pat was pregnant with Tonya. Bill had such severe sympathy pains that he was almost unable to function. His back hurt so much, that he took one of Pat's girdles, cut the legs out, and used it as a back brace. When the big night came, Pat told her husband it was time to go to the hospital. Bill fell out of bed and couldn't get up off the floor. He had to crawl to a chair to help himself get up! I don't know who was more relieved when Tonya was born, her father or her mother! Of course, this is only a reflection of how much Bill loved Pat, and how much he loved the child she carried. Bill has doted on Tonya, as any good father should. He and Pat are understandably proud of their child.

I did another dumb thing while Elaine was pregnant. I quit my job. When I started at Hunter-Sadler, I was hired as a purchasing manager. Hunter-Sadler makes men's suit coats and sport coats for such retail outlets as Sears and J.C. Penney. My job as purchasing manager was to buy the trim items for the coats and to buy the various maintenance supplies needed to keep the plant in operation. Trim items are buttons, thread, shoulder pads, and other items which go into making the coats. The fabric was purchased by the buyers from Sears or Penney's (or whichever retail outlet we had contracted with).

Early in 1976, the economy went through a downturn, and business at Hunter-Sadler declined. During this time Hunter-Sadler's personnel manager left. In a cost saving move, the plant manager gave the personnel manager duties to me. As a result, my volume of work doubled, but I didn't get any additional assistance. I felt overwhelmed by the enormity of the task facing me, and I felt put upon by having this dumped in my lap. As a result, I became very dissatisfied with my working situation.

Once again, I showed a lack of maturity in handling the problem. Instead of buckling down and mastering the new duties, I pouted and petulantly fumed over my perceived mistreatment. Eventually I talked myself into quitting. I think Hunter-Sadler could have handled the situation better than they did, but I also think I could have handled the situation better than I did.

I submitted my resignation in June, one month before our child was due. To compound my error, I had not secured another job. So I found myself unemployed, and I was about to be an unemployed father.

Elaine's family came through once more. Her older brother, William, was a tool & die supervisor at Krueger Metal Products, a factory that made institutional furniture. If you have ever sat in a folding chair at church, there is a good chance it was a Krueger chair. The factory also made folding tables, like those used at churches and schools. William arranged for me to talk to Jerry Keith, the personnel manager. When I left I had a job in the table production department. This was not a managerial or supervisory level job, but it was a job that would allow me to put food on the table. For once, I did something with a little maturity.

Instead of refusing a job that was inappropriate for a college education (as I have seen some unemployed college graduates do), I took a job that would help see us through this mess in which I had gotten us. I also re-learned a valuable lesson, education has nothing to do with character. The fellows with whom I worked on that factory crew were some of the finest I have ever met. A college education does nothing to help a person unless he has a good personal foundation on which to build.

I was very grateful to William for opening a door of opportunity for me. Time and again, Elaine's family has been there for us when we needed them. I thanked God for the good family that had become my own.

As Elaine's due date approached, we discussed the name we would give our child. We considered naming the child after me, if it were a boy, but we weren't really comfortable with that. We finally decided to give him a name which would have my initials, Thomas Barrett Hooker. We would call him Barry. With a middle name like Barrett, maybe its a good thing we didn't have a boy. I was partial to Carol as a girl's name. It just sounded right. Elaine was okay with Carol. She liked the name Amanda, and I was okay with that. We decided on Amanda Carol, and would call her Carol. Computers were not in use very much at that time, so we didn't realize the battle Carol would have to fight when we decided to use her middle name. Of course, Barbara Elaine has had the same problem. When Carol was sick, we had to prove to the insurance company several times that Amanda C. Hooker and Carol Hooker were the same person.

Elaine finished the school year at South Pontotoc without using any maternity leave,

and we sweltered through the hot Mississippi June. We celebrated our fourth wedding anniversary on the 18th, and began our routine of waiting for the labor pains to start.

Elaine had a doctor's appointment on Thursday, July 1st, the baby's due date. We settled into bed early Wednesday night acknowledging the likelihood that Elaine would go past her due date without starting labor. About 2:30 Elaine woke with pains in her back. She lay on her side for a while, as I rubbed her back. Eventually, the pain subsided and we returned to sleep. The next morning she reported to the doctor's office at her appointed time.

To her surprise, the doctor told her she was in labor. He ordered her to report to the hospital immediately. She broke the rules enough to call me and to go home for the "hospital bag". When she got to the hospital, she was escorted to a labor room, where I joined her. I would be permitted to stay with Elaine until she was taken into the delivery room. We called Doris Hood, Elaine's oldest sister, who came down to the hospital to sit with Elaine as well. We elected not to call our parents until after the baby was born.

Doris, the mother of six children, was a pro at "birthing babies". She was a much better coach than me. The staff at the hospital was good, too. I found myself relegated to the role of spectator, which was good. When Elaine's labor hit high gear, it was harsh. I was overwhelmed. Elaine had all sorts of good intentions about going through the childbirth naturally, but several things conspired against her.

Elaine is a small person, and her pelvic area was almost too small to deliver a baby.

This caused her to experience a lot more difficulty. Eventually, she gave up and asked for some pain relief.

The nurses attached a small cable through the birth canal to the baby's head to monitor the child's heartbeat. I watched the monitor, fascinated. That was **my** child's heartbeat that was being recorded. It ran about 140 beats a minute most of the time. When Elaine had a contraction, the pulse rate went up, only to drop back down when the contraction ended. At one point, the monitor dropped to 0. I thought I was going to faint. Was our baby dead? I fought the urge to panic as I pushed the nurse call button. The baby was fine, the monitor cable had come loose. Once the nurse re-attached it, the monitor display returned to the 140 beats per minute. From then on, my heart rate was right up there with Carol's.

The day wore on and Elaine's contractions became more frequent. About 5:30 or so, Elaine was taken to the delivery room, while I retreated to the waiting area. In the delivery room, Elaine continued to have a hard time. The doctor considered but rejected a Caesarean section. Instead, he did an episiotomy, an incision back toward the buttocks to widen the birth canal, then used forceps to aid the delivery. In later years, Elaine would tease Carol that she had been "a pain in the butt from the day she was born." At 7:13, Elaine delivered a beautiful baby girl. After just a little clean-up, the nurse brought Carol out to show me.

I was thunderstruck. The nurse held this tiny little baby, my baby. Carol's skin was still red from birth, and she had a head full of dark brown hair. What struck me most, however, was the shape of her head. It was pointed, like one of the coneheads from

the old Saturday Night Live TV show. The nurse explained that Carol's soft head had formed that shape to come through the birth canal. It would assume a normal shape before long. Conehead and all, I thought Carol was about the most beautiful baby I had ever seen.

Elaine and Carol stayed in the hospital for four days. During those days, I worked during the day and ran to the hospital at night. I had to wear a paper gown and surgical mask when Carol was in the room. (They were a lot more uptight about exposing newborns to germs in those days.) The nurse brought Carol to the room at feeding time, and I helped feed her. We chose not to breast feed Carol. Carol was just small enough that I could cradle her head in the palm of my right hand and her bottom in the heel of my left hand, with my fingers extending along her back. She fit in my two hands just fine.

We agreed that Elaine and Carol should spend the first week after their hospital discharge with Elaine's mother in Ellistown. the mother of seven, she was an expert in "child-rearing". Also, Elaine was still weak and tender from the birth. She would need her mother's help for the first few days. Our first stop after we left the hospital, however, was our apartment where we collected the clothes and materials we would need for our stay in Ellistown.

Carol was in a yellow child seat with a wire support so that it could be tilted at an angle. Elaine placed the child seat, with Carol in it, on the bed. The two of us looked down on our new responsibility. I'd never felt so overwhelmed in my life. How was I going to be a father to this new little person? How was I going to be wise enough to

teach her, to guide her through her youth to reach adulthood? I couldn't do it. I believed that Elaine felt the same way.

I looked at my wife. "What are we going to do now? How are we going to raise her?" I asked.

Elaine looked at me for a moment, then at Carol. Then she made one of the many wise recommendations she offered over the years. "Let's pray and ask God to help us." She said.

We held hands. "Dear God," I said. "We don't know what to do. We don't know how to raise this child on our own. Please help us. Please guide us and help us make the right decisions so that Carol will grow up to be a fine Christian girl. We know that will happen with your help. Amen."

I suppose as parents, we did many things wrong; but we do know one thing we did right, that was to get God involved early in Carol's life.

Carol grew like a weed through that summer. I was continually amazed upon returning from work to find that, in the eight or so hours that I had been gone, Carol had grown noticeably. Her face would change from morning to night. She would be a little bit different each day. I revelled in her growth and change.

Like all newborn children, Carol did not sleep through the night. She had to be changed and fed even in the wee hours. We set up the extra bedroom as a nursery, with Carol's crib and a rocking chair. Elaine and I swapped out nighttime duties. One night, Elaine would get up in answer to Carol's midnight wails. The next night, I got the job. I remember changing and feeding Carol, then gently rocking as I held her, waiting for her to go back to sleep. Even though I

was often bleary-eyed and tired, I loved the feeling of my daughter in my arms as I rocked her until the sandman came.

Sometimes Carol was stubborn and refused to go to sleep. Instead, she fidgeted and squirmed. Elaine discovered a unique and effective way to settle her down and induce slumber. She placed Carol belly down across her knees. Then she bounced Carol by rhythmically lifting and dropping her heels. At the same time, she thumped Carol on her fanny, following the same rhythm. That was better than a sleeping pill. Carol dropped right off.

In August, Elaine returned to school and I got another job opportunity. I started working at the Farmer's Home Administration (FmHA) in Pontotoc as an Emergency Loan Supervisor. This was a temporary job, but I hoped it would lead to something more permanent. The job called for someone with a background in agriculture. Traditionally, this type of job went to an agricultural graduate from Mississippi State, but my Business Administration degree along with my experience tending and harvesting crops as a teenager convinced David Harrelson, the FmHA County Supervisor in Pontotoc, that I fit the bill.

Now Elaine and I had a new decision to make. With Elaine back in school and me continuing to work, we had to decide what type of child care Carol needed during the day. Many people argue that the mother should not work, that she should stay home and raise her children. For some families, this works well, and that is the way they should conduct their lives. However, I'm not convinced that this lifestyle is for all families.

Elaine and I believed that we could pursue careers and still be good parents to Carol. The key was in finding a good person to take care of Carol during the day. In the evenings and on weekends, we made sure that Carol had our love and care. During the '70's, much ado was made in the parenting books and magazines about "quality time" for one's children. We discovered that all time is quality time. We made sure that we were aware of Carol's needs and we worked to meet those needs. We didn't try to devote an hour or two of "quality time" each day. We made sure that we provided "quality time" around the clock.

We were fortunate to find someone who would take good care of Carol during the day. Eloise was a bowling buddy of ours. With Eloise providing personal care during the day, we felt comfortable with Elaine's return to work when the school year started back in the fall.

We also had to decide how we would take care of Carol while we pursued our hobby. Elaine and I bowled on a mixed doubles team with Bill and Pat Pannell. We didn't want to leave Carol with a babysitter at night, since she stayed with Eloise during the day. We devised a unique solution. We bought a fold-out crib that was about three feet square and set it up behind the lanes where our team bowled that night. While Elaine bowled, I sat beside Carol's crib. When I bowled, Elaine cared for Carol. Carol also realized another unexpected benefit from this method of babysitting. Just about everyone in the bowling center came by at one time or another during the night to play with Carol. She was chin-chucked, hugged, "peep-eyed", and "goochie-gooed" dozens of times each week. Elaine and I believe this early exposure to

many friendly, expressive people helped to make Carol the extrovert that she became.

Carol worked on developing her motor skills early. We put a blanket on the floor of our apartment and placed Carol face down on it. Carol put her palms on the blanket and pushed up, lifting her upper body off the floor. After a few seconds, her arms gave out and her upper body flopped back down. This always caused Carol to bump her nose. When she was older, we often teased Carol that she got her little pug nose from bumping it on the floor so often.

At Carol's first Christmas, we began a tradition that we observed for the rest of her life. We always spent Christmas Eve night at Elaine's parents house. On Christmas morning, Carol awakened to a treasure of Christmas gifts under the tree. One of Carol's first Christmas gifts was a small pink and white gingham doll with a rattle sewed into its head. We named it Roxie, because the rattle sounded like rocks in her head. Roxie was one of Carol's treasured dolls for twenty-one years.

All of Elaine's brothers and sisters brought their spouses and children (and later, grandchildren) to Elaine's parents house for Christmas lunch. After lunch, the group exchanged gifts. The supply of gifts was always liberally salted with pranks and gags. Once Pat Pannell remarked how she liked those boxes of chocolate covered cherries. The next Christmas, she got twenty-one boxes! That was fine with Pat. She put them in her freezer and ate chocolate covered cherries all the next year.

Gary Holley, engaged to William Pannell's daughter Donna at the time, received a box of what appeared to be chocolate covered cherries himself. When he

opened the box, he discovered a box full of dried horse droppings! That was one box that didn't go in the freezer.

Then there was the time Doris Hood's sons started playing golf. The next Christmas, one of the Hood boys received a natural gas powered golf cart and a supply of fuel. The cart was a bathroom commode on wheels, and the fuel was a can of baked beans. This time of fellowship and gift giving was always something we cherished.

Later that afternoon, Elaine, Carol and I packed and travelled the thirty miles or so to my parents house. There Carol found another profusion of Christmas gifts, and we enjoyed a visit with my parents and my sister, Pam Stephens and her family.

Eventually, Carol began to walk, haltingly at first. Once again, Carol demonstrated the determination that became one of her trademarks. She realized that practice would help develop her walking ability. She spent hours walking in the living room of our apartment. She pulled herself to a standing position on the edge of our couch. Then she began walking across the floor. After a few steps, she lost her balance and plopped down. No sooner did her fanny hit the floor than she crawled back to the edge of the couch to pull herself up for another walking effort.

We gave Carol a chocolate Easter bunny on her first Easter. We sat her in her high chair, put the bunny in her hands and backed away. Carol had a blast! Within a few minutes, she had chocolate smeared from head to toe. Some even wound up in her mouth. Sometimes being neat and clean is not the way to go!

Carol's first birthday rolled around and we invited both sets of grandparents and all

the rest of the family to our apartment for a birthday party. Our apartment complex had a pool, and we reserved it for the party. While the "old folks" sat around the pool and watched, the youngsters frolicked in the water, splashing and dunking each other. Even at one year of age, Carol loved water. The party ended with cake and ice cream for everyone.

I had been working for FmHA for almost a year, and had no success at getting appointed permanently. My appointment was only renewed for three months at a time. I finally decided that I couldn't depend on keeping that job. I took and passed a qualifying test which allowed me to compete for several Federal government positions. One of the positions I interviewed for was claims representative for the Social Security Administration.

I really didn't think the interview went very well, but a couple of weeks later, I received a call from Calvin Pugh, the head of the committee which had conducted the interviews. He offered me a job with SSA. There was one catch. I had to agree to be assigned to any Social Security office in the state of Mississippi. I wouldn't know which office I would go to until the end of a thirteen week training course.

I asked for twenty-four hours to think it over. I spent all that night praying for guidance from God on what to do. I knew that the Social Security office in Tupelo would be getting a CR from that training class. I also knew that the SSA offices in Columbus and Corinth would be getting new CR's as well. Both of those offices were only about an hour's drive from Tupelo. Tupelo was home, and I really didn't want to leave. I

knew that Elaine wanted to stay in Tupelo as well.

After a night of prayer, I concluded that God wanted me to take the job. I have to admit, I believed I would be assigned to the Tupelo office or to one of the nearby offices, and that may have influenced my decision. I sincerely believe, however, that it was God's will for me to take that job.

The thirteen week training course was in Lake Hillsdale, Mississippi, about thirty miles southwest of Hattiesburg. It was about 280 miles from Tupelo. The developers of Lake Hillsdale wanted it to be a resort area, but it didn't quite make it. There was a Holiday Inn, which is where we stayed, surrounded by a nine-hole golf course. Below the golf course was a small lake, with a clubhouse resting on its shore. The clubhouse was our classroom.

The material I was to learn was complex. On our first day, we were given a dozen three inch binders filled with operating instructions. That night I called Elaine and wondered aloud about the wisdom of accepting this job. I stuck with it; however, and eventually excelled, achieving the rating of number one in the class.

The most difficult part of the class, of course, was being separated from my family. Once a month, on Friday after class ended, I loaded up my Chevy Monza and headed north. By driving at a steady clip, stopping only to refuel the car, and timing my bathroom breaks to the fuel stops, I reached home at about midnight. I was then able to spend all day Saturday and until about 5:00 PM on Sunday with Elaine and Carol. I then headed south, arriving back at Lake Hillsdale at midnight.

I know that the separation was just as
difficult for Elaine and Carol as it was for
me. Elaine was left to make all the
decisions about care for Carol, and to make
sure that the household continued to operate
as it should. We talked by phone frequently,
but that was nothing like being together as
a family each evening after work to share our
joys and sorrows, our hopes and fears. I
looked forward to the end of the class.

As the end of December approached, the
class members learned of the office to which
each was to be assigned. On the day the
assignments were distributed, we agreed to
have the assignment sheet placed face down on
our desks, so we could all turn them over at
the same time. When we did, many students
groaned. More than a few were as fearful
about where they would be assigned as I was.
I heard one of the classmates in the far
corner mutter, "Where the &*@% is Corinth?"

I was assigned to the Vicksburg
Mississippi office. My gamble that I would
be assigned to Tupelo or an office nearby
hadn't panned out. Vicksburg was about 250
miles from Tupelo. My performance as number
one in the class had worked against me.
Calvin Pugh was the District Manager of the
Vicksburg office, and as a reward for
chairing the selection committee for this
class, he was allowed the first "draft
choice". I was his pick. I learned later
that Hugh Tigrett, the District Manager from
Tupelo, and Calvin almost came to blows over
the fact that Calvin "stole" me from Tupelo.

A couple of the class members simply
refused to go where they were assigned. This
was in spite of the fact that they had
promised up front to go anywhere in
Mississippi. This wasn't a consideration for
me. I had promised Mr. Pugh and the Social

Security Administration that I would go where I was sent. It would be unfair to back out now, after the agency had spent many thousands of dollars on my training. I was going to Vicksburg, there was no doubt.

Once again, in retrospect, I am convinced this was in God's will. At the time I was very unhappy because Elaine and I had to make decisions about how we would relocate to Vicksburg; especially, since her teaching contract wouldn't end until the following May. We both knew that she could resign from the contract, but that would mean giving up her income from the teaching position, and it would put Wilton Chism, the principal at South Pontotoc in a bind. Like me, Elaine had been taught to fulfill obligations.

I talked with Mr. Pugh in Vicksburg. He told me about a YMCA that would rent a room to me by the week or by the month. When I investigated, I discovered it was very cheap. This would allow us to keep the apartment for Elaine and Carol until May. I would go ahead to Vicksburg and stay at the Y. When school ended, Elaine and Carol would join me. My three month separation from my family was stretching to eight months.

THE ROLE OF A PARENT

"Love the Lord your God with all your heart
and with all your soul and with all your
strength. These commandments that I give
you today are to be upon your hearts.
Impress them on your children. Talk about
them when you sit at home and when you walk
upon the road, when you lie down and when
you get up. Tie them as symbols upon your
hands and bind them upon your foreheads.
Write them upon the doorframes of your
houses and upon your gates."
Deuteronomy 6:5-9.

"Love is not giving your child what he
wants, but what he needs."
Adrian Rogers.

Any examination of Carol's life must
include a discussion of the principles by
which she lived. What was she taught, what
was expected of her, and how did she
respond? We have already mentioned that we
attempted to raise Carol according to
Biblical principles. We dedicated her to
the Lord at birth, and we tried to teach
her God's principles as she grew. At first
my plan was to describe these principles at
the points in Carol's life when those
principles came into play. It seems,
however, that would confuse the reader who
wished to examine those principles
together. So,I will try to describe them
in one chapter, and then perhaps I can
allude to them as we travel along Carol's
life.
Until this book, Elaine and I didn't
write a list of "rules" that we applied.
We simply applied the appropriate Biblical
principles as we went along. One of
today's Christian buzzwords is WWJD - What
would Jesus do. I suppose you could say

Elaine and I tried to do that as we raised Carol. What would Jesus do if He were Carol's parent?

I also pondered the decision about where to put this chapter. I considered putting it in the middle. But as a parent, I know it is important to begin raising a child according to Christian principles at the outset. Those who study such things claim (and I believe them) that a child's personality and a great deal of behavior is established in the first few years of a child's life. In order to teach a child to live by God's Word, that child must become familiar with God's Word before he or she begins school. So, I will present this chapter at the beginning of Carol's life, and explain that we tried to apply these throughout her life.

So, here is a discussion, reduced to writing for the first time, of how we raised Carol. I pray that it will help those of you who are parents as you raise your child.

Introduce the child to Jesus

My interpretation of the verse that opens this chapter is that the parents should suffuse the household with the love of Jesus, and the word of Jesus. Doing what Jesus would do should be a natural activity. The parents should talk about Jesus' love for the child and for the parents. Bedtime stories should include stories about characters from the Bible. Elaine and I also told stories about Cinderella and Sleeping Beauty and such. I don't think every word has to be from the Bible, but the atmosphere of the household should be one of comfort with the presence God.

In a recent Sunday morning message, Bro. Steve Scoggins, the pastor of First Baptist Church in Hendersonville NC, told about his

discovery of how chicken and dumplings are made. He told of visiting his grandmother for a holiday meal and how he watched her as she prepared her chicken and dumplings.

> She put a pot of water on the hot stove and added the chicken, salt and seasonings. As the pot simmered, the mouth-watering smell of chicken soup wafted through the room. Then my grandmother added the dumplings. She grabbed handfuls of dough from a mound on the sideboard and dropped the handfuls of dough into the pot. Yuck!, I thought. Who would want to eat that? Later, when the dumplings were served, I said 'No, thank you.'
>
> Many years later, I did muster the courage to try the dumplings. Actually, they were pretty good! I discovered that while the dough cooked in the simmering pot, it absorbed the flavors of the chicken and seasonings.

That's what happens in a family. As the seasonings of values the parents hold important simmer in the pot of daily living, those "little dumplings" (kids) who live in the household absorb those flavors. Unfortunately, some dumplings absorb the flavors of greed, or selfishness, or jealousy, because those are the flavors in the household. Wouldn't it be wonderful if those dumplings could absorb the flavors of love and compassion and forgiveness that is present in a Christian household where the parents love the Lord?

I think I should mention here that we read to Carol a lot. I grew up with books, and I knew how important the development of vocabulary and reading skills would be to Carol in her future. Daniel J. Boorstin, Pulitzer Prize winning historian and former Librarian of Congress said, "The most significant factor influencing a child's achievement in first and second grade is whether the child has been read to at home before beginning school and whether he has seen his parents reading." So we read to Carol at every opportunity. We had children's books all over the place. We read those little "Golden Books" of stories for children. We read books of stories from the Bible, we read newspaper articles (Daddy read the article aloud, while Carol listened. There is a scene from the movie "Three Men and a Baby, where one of the guys reads from Sports Illustrated magazine. I don't see anything wrong with that. Carol still was entertained with hearing Daddy or Mommy's voice, while Daddy or Mommy caught up with the news). I sincerely believe that Carol's later success in academics was at least partially a result of our efforts to read to her when she was a baby.

I have heard adults say that they don't want to influence their children about what religion, if any, they will adopt when they grow older. I believe those parents don't love their children as much as they claim they do. Any parent who is not as concerned with the spiritual well-being of their child as they are with their physical and emotional well-being is shirking their responsibility as a parent. What parent would say, "I don't want to influence my child. I will let them decide which elementary school they want to go to, or even if they want to go to school.

If they decide not to go to school, well, that's their choice.?"

No parent would say that. They care very much about their child's education, and they care very much about their child's success in life. So, they try to make sure that their child goes to a good school and studies hard.

What parent would say, "I will leave it up to my child to decide right from wrong. If they want to become a murderer or a thief, who am I to stand in their way?"

No parent would say that. Those parents want their children to become productive, respected contributors to society. They will try to make sure that the child learns the value of being a part of society and contributing to it.

What parent would say, "I don't care if my child goes to Hell, or not. I will leave it up to him to decide where he wants to go after he dies?"

No parent would say that. But those who fail to introduce the child to Jesus are saying that very thing by their actions. As parents, it is our responsibility to provide guidance on how to grow up. We teach our children how to be good students, and how to be good citizens. We must also teach them how to be good Christians. We cannot save our children, Jesus does that. But we can pave the way for our children's salvation by helping to prepare their hearts for the touch of the Holy Spirit.

Love Unconditionally

Thomas Jefferson has gone down in history as one of our greatest presidents. However, I'll bet he wasn't much of a father. There is a record of a letter he wrote his daughter, Martha, admonishing her to do well

in her studies so that he could love her. It was written on 11/28/1783, and one paragraph goes like this: "I have placed my happiness on seeing you good and accomplished, and no distress which this world can bring on me could equal that of your disappointing my hopes. If you love me, then strive to be good under every situation." To make his love contingent upon his daughter's behavior, or even to make her believe that, was a heartless act on his part.

Jesus loves me unconditionally. It doesn't matter what I do, I am still in the grip of His love. That gives me the encouragement to try to serve Him according to His will - according to His desire for my life. Because Jesus loves me and Elaine unconditionally, we were able to love Carol the same way. It didn't matter what she did, she still had our love. She could have committed murder, and we would still love her. We wouldn't love her actions, but we would love her.

In order for a child to have the self-respect and self-confidence that is necessary for him or her to develop into adulthood, that child must know that he or she is accepted. There is nothing that he or she can do which would cause that love to stop. That is the kind of love that Jesus has for every one of his creation. There is a cartoon for which I have always had a fondness. It depicts a hillbilly standing with a piece of straw in his mouth. He is wearing bib overalls, a straw hat and nothing else -- no shirt, no shoes, nothing. The caption says, "God made me, and God don't make no trash!" I like that. Because God made us, we are worthy of love and respect. Anyone who fails to give us that love and respect is outside of God's will.

Jesus loves Charles Manson. I know He doesn't like what Manson did, but He loves him. Jesus also loved Ted Bundy, Hitler and Stalin. This may be crazy, but I find that comforting. Because I am loved in that way, I find myself wanting to do what pleases my Heavenly Father, who loves me so. I study His word to find what is important to Him. I try to follow His example, so that I might be worthy of that love. I know that I will never be worthy of that love, but I can try. We tried to offer that same kind of love to Carol.

The second part of this principle is that the child must **know** that he or she is loved unconditionally. If Elaine and I loved Carol unconditionally, but we never told her or demonstrated that to her, she would still experience the uncertainty of not knowing that we loved her. So, we told her at every opportunity. Each night ended with a kiss and a hug and a whispered, "I love you." We always tried to do things that allowed Carol to see and experience our love.

I believe that, because we loved Carol unconditionally and told her so, she had the self-confidence and self-respect to accept herself as worthy of being loved. As a result, she felt secure enough to try to experience life as God intended. She knew that if she tried something and failed, that was okay, her parents and God still loved her. She had the confidence to try and fail and learn from her failure, so she could succeed next time. She had the confidence to love and respect others, because she was loved and respected. That helped to make Carol the kind of person that God wanted her to be.

Children Learn What They Live

If a child lives with criticism,
 he learns to condemn.
If a child lives with hostility,
 he learns to fight.
If a child lives with ridicule,
 he learns to be shy.
If a child lives with shame,
 he learns to feel guilty.
If a child lives with tolerance,
 he learns to be patient.
If a child lives with encouragement,
 he learns confidence.
If a child lives with praise,
 he learns to appreciate.
If a child lives with fairness,
 he learns justice.
If a child lives with security,
 he learns to have faith.
If a child lives with approval,
 he learns to like himself.
If a child lives with acceptance and
 friendship, he learns to find love
 in the world.

Author Unknown

Be a parent, not a friend
Carol had many friends, but she had only two parents. Elaine and I were ultimately Carol's friends as well, but our first responsibility was to be her parents. We had to be willing to say no. We had to be willing to apply discipline. There were times when Carol was very angry at us, because we wouldn't let her do something that she wanted to do. That was okay, we were willing to be the bad guys if that was what it took to teach and protect our daughter.

Carol and I had a routine that we went
through when we disagreed over something that
Carol wanted. Eventually this routine became
affectionate banter, but at first Carol was
serious when she said it. When I refused her
some desire, she said, "You're so mean!"

I smiled and said, "That's my job."
Actually, my job was to instill Christian
values and to teach the "What Would Jesus Do"
principle. Carol knew I was only joking when
I responded that way.

I believe many parents have difficulty
applying this principle. Children are very
smart. When a parent denies them their
desires, they will often become very upset
and will do or say things calculated to hurt
their parents. They don't want to hurt their
parents, they only want their own way.

Have you ever heard a child say to a
parent (or has your child ever said to you),
"I hate you!" I guarantee you that the child
doesn't hate the parent, he or she is only
using that threat as a cold-blooded attempt
to get the parent to cave in. What's bad is
that sometimes the parent does just that.

Some parents are not willing to put up
with the hassle of fighting with a child.
The child learns that if he or she throws a
tantrum, the parent will relent rather than
create a scene or listen to the tantrum.
Then the child knows that all he or she has
to do is to is throw a fit and he will get
his way.

When I was a child, I remember one time
(of many, I am sure) when I wanted to play
sandlot football with a bunch of older boys.
My mother, fearing that I would get injured,
said no. I really wanted to play ball, so
for the next several minutes I walked around
the house and yard wailing at the top of my
voice. When Mom got tired of listening to

me, she came and punished me. I learned that throwing a tantrum would do two things: 1) fail to get me my way, and 2) get me punished. So I decided to shut up.

When Carol was a child, we went shopping at a K-MART store in Jackson Mississippi. Carol saw something that she wanted, but Elaine and I thought it best not to get it for her. Carol proceeded to make a scene (have you ever seen a child in a grocery store or department store do the same thing?). When we got tired of Carol's behavior, we packed her up and went home. When we got home, we punished her. We did not get her what she wanted. Carol learned the same lesson I had learned when I was young. True, Elaine and I had to give up our shopping trip that day, but that was a necessary sacrifice to be the kind of parents we needed to be. Later, Carol learned to behave on shopping trips, because she knew she wouldn't win by acting out.

Set an Example
Part of being a parent is the responsibility of setting boundaries or rules by which the child must live. I believe the parent has an excellent guide book on what boundaries to set. That guidebook is The Holy Bible. In that Book, we see the standards that God set for us. We see the principles of love and respect and compassion. As parents we can teach those same things to our children.

It doesn't matter what we tell our children, if we don't act according to those same principles, our children will not learn those lessons. Instead they will learn another lesson, how to be duplicitous - how to say one thing and do another. We often call a person who acts like that two-faced.

Our children learn a great deal from us parents. We are role models. The child learns that what Daddy or Mommy does must be okay. Therefore she can do what Daddy or Mommy does. The child will learn what is important to Daddy and Mommy. That understanding will come from what the parent does, not what he or she says. If the parent says don't lie or cheat, but the parent cheats on his or her tax return (in effect, lying to the IRS) , the child will learn that is okay to lie or cheat.

If the parent tells the child not to steal, but the parent brings home supplies from the job without permission, the child learns that it is okay to steal.

What we say is less important than what we do.

You don't have to win all the battles

Our goal with Carol was to allow her to grow in confidence and responsibility as she grew in age and maturity. We wanted her upon graduation from high school to be equipped to move away to college and live on her own - to make her own decisions and accept the outcome of those decisions. Of course, we would always be available to give advice when she needed it or wanted it, but it would only be advice. We believe Carol reached that level of maturity. There were several things as parents that we had to do to help make that happen.

First, we had to show Carol that we were human. Everybody makes mistakes. Carol needed to know that it was okay to make a mistake as an adult. There were times as we raised Carol that we made the wrong decision. When we did that, we decided to confess those mistakes, apologize, and try to make them right.

There were times when I criticized Carol for some action I thought she had taken. If I discovered later I had criticized her improperly, I went to Carol and apologized to her. I then resolved to try to avoid making that mistake again. The end result was, that we both learned to give and take in the parent/child relationship.

Second, as I mentioned above, we allowed Carol to grow into responsibility. When Carol was small, she was only allowed to roam portions of the house, with one of us keeping a watchful eye on her, of course. We were very careful about allowing Carol outside activity while we lived in Tupelo, because she was so small, and because there was a pool just outside our apartment door. When we moved to Vicksburg, however, we had a generous backyard, so we allowed her to roam there. We did get a scare one time, when she came to tell Elaine about the "big stick" in the backyard. It turned out to be a poisonous snake! Carol handled it well, she got Mom (who got Dad, who killed the snake). She showed that she could handle the responsibility of having freedom of the yard.

As time progressed, Carol learned to handle new responsibilities. At times, of course, we discovered that she wasn't ready for something, so we scaled back that responsibility until she was a little older. Carol demonstrated remarkable maturity, so that by the time she was in high school, we found ourselves merely approving most of the decisions Carol made. We discovered that she was prudent in her choices. We were very proud of her for that.

I think some parents err in two ways in this area. Some, perhaps because they are so involved in their own lives, exercise insufficient oversight and give a child too

much freedom. These children often make poor decisions because the parent isn't there to slow down their assumption of early responsibility. Sometimes these children spin out of control. When the parent tries to exert some control later, it is very difficult to do so. By then, the child may be in trouble.

On the other hand, some parents are afraid of allowing the child to assume responsibility. These parents don't allow the child to make decisions on their own. As the child grows, he or she will either rebel, creating conflict between the parent and child, or will reach adulthood without the ability to make mature decisions or assume the responsibility necessary to function independently. Perhaps the parent is afraid to allow the child to fail occasionally. As mentioned earlier, parents and children make mistakes. The child must learn to make mistakes and recover from them. Another possibility is that the parent is afraid to let the child mature, because then the parent fears that he or she will lose the child. One of the goals of the parent (it should be a goal, anyway) is to have the child leave home and function on his or her own. That's not losing the child. That's successful parenting. I am still the child of my parents, and I always will be; because I live separately from them doesn't change that.

Lastly, as Carol grew older, we allowed her to negotiate her privileges. When Carol asked permission to do something or to go somewhere, Elaine or I would assess Carol's ability to handle the situation. We would also assess the risks that Carol might be encounter by participating in the activity she wanted to do. Let's say Carol wanted to go to a party. If we feared that the party

might be inadequately supervised, or that alcohol might be made available to the young people at the party, we would say no. Part of our answer would be to explain why we were denying Carol's request. Hopefully, that would help Carol to see that we were not being arbitrary, and that we really did have concerns about her safety and well being.

Carol might then negotiate terms that would allow us to say yes. For example, she might promise us that responsible adults would be there to supervise the party. She might also promise to call us (this was before Carol could drive) if someone brought alcohol or drugs on the premises. If we were satisfied that these conditions would apply, we might then say yes. This allowed Carol to assess the dangers or concerns of her actions and to make prudent decisions for herself.

This actually happened. Carol did go to a party under these conditions once. Someone did bring alcohol, and Carol did call us to come and get her. By doing this, Carol allowed us to gain confidence in her maturity.

Of course, there were also times when we could not say yes. We still exercised the prerogative to be Carol's parents before we were her friends.

Dare to Discipline

No child is perfect. There were times when Carol did something that we had expressly forbidden. We then had to punish her. We punished her because we loved her, not because we were angry at her disobedience. She learned that discipline was an act of love, and was meant as a method of teaching her what was acceptable. When Carol was small, we paddled her. When she got older, and had earned some privileges, we

restricted those privileges - "grounding". As an adult, Carol often joked that she spent her entire junior high years "grounded". We'll talk about her junior high years later in this book.

The issue of corporal punishment, i.e. paddling, is very controversial today. Elaine and I were paddled when we were children, and we were and are comfortable with the fact that our loving parents used this form of discipline justly and compassionately. There are several issues that parents should consider when making a decision about whether to apply corporal punishment.

A. This should be a joint decision. Actually all parenting decisions should be made jointly by the parents. If the parents cannot agree that corporal punishment is appropriate, it should not be used.

B. Paddle to teach. All forms of discipline should be applied to teach the child what is appropriate behavior. The goal here is to make sure that the child understands that he or she has stepped outside the bounds set by the parents. It is also important to explain to the child why he or she is being paddled. When the child is a baby, for example, the parent should firmly say, "no" to let the child know that he or she is doing something forbidden. If the child persists, the parent could then add a determined whack on the fanny to the verbal command.

C. Never paddle when angry. Don't be misled, a child knows what is going on in a parents head. If a parent punishes while he or she is angry, the child may believe that he or she is being punished because the parent is angry, not because of the child's transgression. If the parent is angry, he or

she should tell the child that the child will be punished and why, but at a later time. I believe discipline should be administered quickly, but not before the parent has had a chance to cool down, if cooling down is necessary. This cool down period might be a good time to discuss what the child did wrong and why discipline applies.

D. Never paddle anywhere except on the backside. Hitting, slapping, punching or striking anywhere but on the backside is not paddling. That, in my opinion, is abuse. We resolved that we would only paddle Carol on her backside with a broad object, such as a hand or a wide belt. If the parent can't restrict the paddling to these limits, it should not be used.

E. **Do not paddle** if a history of abuse exists in the background of either parent. It is too easy to perpetuate the cycle of abuse. If either parent was abused, or had a sibling or parent who was abused, corporal punishment should not be considered. The risk is too great that the parent could lose control and fall into the old pattern of abuse that he or she experienced before.

For what it's worth, this is a brief discussion of how we tried to raise Carol. All of our actions were taken with the goal of following God's guidance and love in our household.

We who are parents are like the servants in the parable of the Talents. "Again, it will be like a man going on a journey , who called his servants and entrusted his property to them. To one he gave five talents of money, to another two talents, and to another one talent, each according to his ability. Then he went on his journey." (Matthew 25:14-15).

The talents we have been given are the souls of our children. We have been entrusted with them by our Master. How will we manage this awesome responsibility? Will we forget about them and focus our attention on our career and accumulating wealth or power - or something else? Or will we pour ourselves into them, teaching them the love of God, and such virtues as respect, perseverance, and honesty? I hope we will be like the servants who received five talents and two talents, respectively.

"The man who had received five talents went at once and put his money to work and gained five more. So also, the one with two talents gained two more." (Matthew 25:16-17). I can assure you there will be many blessings on this earth as you watch your children grow and prosper spiritually in God's eyes.

But there is another reward, as well. "After a long time the master of those servants returned and settled accounts with them. The man who had received the five talents brought the other five. 'Master,' he said, 'you entrusted me with five talents. See, I have gained five more.' His master replied, 'Well done, good and faithful servant! You have been faithful in a few things; I will put you in charge of many things. **Come and share your master's happiness!**'" (Matthew 25:19-21)

Hallelujah! Can you imagine being invited by the Master himself to share in His joy? There can be no greater reward!

VICKSBURG

Vicksburg is one of the better known Mississippi cities because of its Civil War heritage. Positioned on a bluff overlooking a horseshoe bend in the Mississippi River, Vicksburg frustrated the Union's effort to sever Arkansas, Louisiana and Texas from the rest of the Confederacy until 1863. Eventually, General U.S. Grant mounted a siege of the city, forcing its surrender on July 4, 1863. For many years after that, Vicksburg refused to celebrate Independence day, because it fell on July 4th.

I arrived in Vicksburg shortly before Christmas, 1977. Elaine and I decided that she and Carol would stay behind in Tupelo, so she could finish her school year at South Pontotoc. Elaine has a strong sense of responsibility, and she wanted to complete her contract at the school. In addition, we would be able to keep her income flowing through the summer of 1988, whereas if Elaine resigned her contract and moved to Vicksburg in the middle of the school year, she might have difficulty finding a teaching position right away.

In order to save money, I chose to stay in the YMCA until June, when Elaine and Carol would be able to join me. A person could rent a room there by the week or month. It was a popular place for transients to stay for a few days. It seemed to me to be a bizarre blend of a prison cell and a college dormitory. The small rectangular room had a cot, a closet and a bureau. Each floor had a communal shower and restroom. I could watch TV by going to a sitting room on the fourth floor (I was on the third floor). The residents of the Y decided what channel to watch by taking a vote. The rules also

specified that no hot plates could be used in the rooms. In spite of this, I sneaked a cooking device up to the room in another effort to save a few dollars. When I plugged it in, however, all the lights went dim. I decided I would prefer to spend a little extra for a McDonald's burger, and avoid burning the place down. I sneaked the hot plate back home on the next trip.

Elaine and Carol were stuck with an absent husband and father for a few more months. Fortunately, Elaine's family was nearby and was able to help when necessary. During the spring, Carol had several episodes of bronchitis. Dr. Stockton, our pediatrician, was located in Amory, about 30 miles away. Elaine had to take Carol there several times for tests and shots.

Eventually, Carol spiked a high temperature and broke out in lesions all over her body. She had chicken pox. Elaine took the two of them to receive some TLC (tender loving care) from Mamaw Pannell for a few days. When her temperature subsided and the spots went away, so did the bronchitis problem. I was proud of Elaine for taking such good care of Carol while she was ill, and I was guilty that I was not there helping.

As summer approached, I looked for a place for our family to live. One of our goals in Tupelo had been to find or build a house, so we could move out of our apartment and accumulate some net worth. We had purchased a lot north of Tupelo and were saving some money toward eliminating that debt and making a down payment on a house. Instead, we found ourselves selling the lot and putting money aside to find a place in Vicksburg.

I discovered that a home buyer had to be careful in the Vicksburg area. The Mississippi River was prone to flooding, as was the many area tributaries that fed into "Ole Man River". The realtor showed me a beautiful house with three bedrooms and two baths for fourteen thousand bucks. I almost had to tie my right hand behind my back to keep it from signing the contract before I could investigate this unbelievable price. I learned that it sat near a small creek which flooded with every heavy dew. Unless I was prepared to relax in my living room in one of those floating chairs you see in some swimming pools, I had to forgo that house.

As it was, God led me to a reasonable house on a spot south of town. It had shingle siding, three bedrooms and a bath and a half. Elaine demonstrated her trust in me by allowing me to contract for the house without seeing it herself. I found out later that Papaw Pannell was prepared to loan us the money to buy a house if we couldn't swing it on our own. God was taking care of us in more ways than one!

June arrived, and moving day came. I rented a U-Haul truck and we loaded it with the contents of our Tupelo apartment, all our worldly possessions. I led the caravan on its trip southward. Elaine and Carol followed in our 1975 Chevrolet Monza, and Mamaw and Papaw Pannell brought up the rear. They planned to stay a few days and help us get settled.

We'd hardly parked in front of our new home before Elaine had paint buckets out to paint the house. It was a sickly shade of pea soup green. One of the traditions that Elaine adopted was to repaint every new house that became ours. Although this house needed painting badly, I decided that Elaine used

the painting ritual to establish ownership of
her new home. Over the next few days, Mamaw
and Papaw Pannell and Elaine and I unloaded
our furniture and arranged it in the house.
Carol, in the meantime, supervised our
operation.

Eventually, Mamaw and Papaw Pannell had
to head home. As they drove away, Elaine
buried her head in my shoulder and cried. I
learned for the first time (I was to learn
this lesson twice more) how difficult moving
was on Elaine. She is a person who dislikes
change. That's just the way God made her.
So, having to say goodbye to old friends and
moving into a strange new place was very
traumatic for her. I suppose if anything
tested the strength of our marriage, the
moves we have made were it.

Conversely, that first move to Vicksburg
strengthened our marriage, as well. For the
first time, we were many miles away from our
parents. We learned to lean on each other
for emotional support, rather than on our
parents. As a result, God made our marriage
stronger. I grew to trust Elaine in her
decisions and actions, and she grew to trust
me. Although we had been married six years
by this time, this is the point where our
marriage really became the strong marriage
that God had planned for us.

Once Elaine got our house painted and
cleaned up inside and out, it was very nice.
It was just the right size for a family of
three. A very nice couple lived across the
street. Bob Hope worked at the Westinghouse
factory in town. He even had the ski-nose
profile of his better known namesake. He
also fished in the Mississippi River to earn
some income on the side. Once he showed us
a fifteen pound mud catfish that he caught.
It was about three feet long, as long as

Carol was tall. Marie Hope was a kindly neighbor who frequently babysat Carol for us, so we could have some time to ourselves.

As we adjusted to our new home, we investigated some of the entertaining sites in the area. On a Saturday or Sunday afternoon, we drove down to Grand Gulf, a state park on the banks of the Mississippi, just west of Port Gibson. On other days we drove up to Greenwood to the LeFlore Plantation. That was a living history demonstration of an antebellum cotton plantation. We found that very interesting.

One of our favorite afternoon jaunts was to the National Battlefield Park in Vicksburg. The park covered the same area occupied by the Union and Rebel lines during the siege of the city. Many cannon were arrayed over the park, marking the sites of the artillery. Carol walked from one to the other and peeked into the barrels, hoping to find something interesting. A road looped around the park in a lopsided figure eight. One side of the loop was eight miles long, while the shorter side was three. Grandmaw and Grandpaw Hooker gave Carol a red Radio Flyer wagon, and the three of us often walked the shorter loop pulling the wagon behind us. When Carol got tired, she'd crawl in the wagon and Elaine and I alternated pulling her along. Later, we bought bikes to ride around the park. We added a child seat on the back of my bike, so Carol could ride with me. Spending time together at the battlefield or on other trips around the area was one of the ways our family bonded. As Carol grew older, we gave her the opportunity to choose the family's activity from time to time. If she chose to go to the battlefield, we went. If she chose to play leap-frog, well, we played leap-frog. This allowed her to grow

comfortable as a part of the family, and to gain confidence in her ability to make choices that were acceptable to her and to us.

We hoped Elaine would be able to use the summer months to find a teaching job, so she could pick up in the fall without a break in her income or in her teaching routine. We were pinching pennies at this point. If we had to go without her income for a while, our budget would suffer.

Once again, God took care of us. Early in the summer Elaine received a call from Father Alex Dickson, the headmaster of All Saints Episcopal School. All Saints was a private boarding school in town. They had a math position open, and were interested in hiring Elaine. After talking with Father Dickson, she took the job. This was the first time I had heard of a high school teacher being recruited by a school.

The students who attended All Saints came from all across the Southeast, with a couple from foreign countries thrown in for good measure. The tuition for the school was comparable to a private college, so the families of the students were well-to-do financially. I enjoyed watching all the limousines and luxury cars pull into the campus when the students arrived. I feared that the rich parents might be inclined to muscle the administration into giving good grades to the students without their having earned them. I knew Elaine would have trouble with that; however, Father Dickson ran a tight ship. The students were expected to do the work and earn their grades.

The primary drawback to the private school environment was the Saturday classes. Elaine had to teach classes during the week,

plus a half-day on Saturday. So Carol and I had to fend for ourselves on Saturday morning. After a while, we learned to handle that inconvenience okay.

As it turned out, the sense of community at All Saints was very strong. The teachers, staff and their families were all close. We participated in the many social activities that occurred, and we developed friendships with many of the folks there. There was one person who became very fond of Carol. Charlene Eichelberger Thomas was the physical education director. Miss Ike, as she was known, was slender and athletic with graying hair and a weatherbeaten face. Everyone loved her.

During the summers, Miss Ike used the All Saints facilities to operate a day camp for the school age kids of Vicksburg. Carol was much too small to be a part of the camp, but Miss Ike made Carol the camp's unofficial mascot. Miss Ike had photographs of herself and Carol "planning" day camp activities and published the pictures in the paper. Carol had a blast helping Miss Ike.

There was another blessing awaiting us, as well. Shortly after we moved into the house, we began our search for a church home. We decided to visit several churches in the area. One of our first visits was to Vicksburg's First Baptist Church, Calvin Pugh's home church. I figured it wouldn't hurt to visit my boss's church, it might make a good impression. In reality, impressing the boss wasn't my goal. I just wanted to find the church that God had chosen for us to attend. The church was a very nice church, and the pastor delivered a good sermon, but the church was just a little bit too big for a country boy like me. Elaine felt the same way. I vowed that I would never join a First

Baptist Church; they were all just too "big city" for me.

After the service Elaine, Carol and I stayed around to speak to Mr. Pugh and to the pastor. As we headed to our car, the church staff member who had custodial duties that day came through locking up the building. When he greeted us, Carol took him by the hand and marched him out to the car with us. He was delighted with Carol's friendly smile and outgoing demeanor. Carol had developed into a blond-headed darling. Her hair was in a soft page-boy style, and her sparkling blue eyes lit up when she smiled. She loved to smile, too. When Carol was with us, we were guaranteed to receive a warm greeting wherever we went.

Of all the churches we visited, one stood out. That's the one God had led us to, no doubt about it. Woodlawn Baptist Church was located on the northeast side of town, and was a small church that had experienced an explosion in the Holy Spirit and growth. It still had a small church feel, but had grown enough to require the construction of a new sanctuary and educational facility. We have been blessed to have been led to a Spirit-filled growing church in every place we lived.

Along with God's work in strengthening our marriage, He also used Woodlawn to inspire us to grow in our relationship with Him. We learned about growing through prayer and Bible Study, and we learned about serving God with our resources.

Until we joined Woodlawn, the extent of our contributions to God's work was to give $5.00 or maybe $10.00 a week. While at Woodlawn, we were convicted to follow God's guidance in our lives and to begin tithing. It is interesting that God chose to convict

us of this need at the very time our finances were so tight. Despite this, we committed to give God at least 10% of our gross income each month.

Not long after we made that commitment, God gave us a test. By the way, I don't believe God tests us to discover how we will respond. Since He is omniscient, He already knows what we will do. He gives us tests to allow **us** to discover what we will do. When we successfully meet a test, we are encouraged in our service to Him. When we fail the test, we learn where we need to grow in our relationship to Him.

In Mississippi, we have to pay the property tax on our car when we buy the tag. In 1978, this was always done in October. When tag-buying time came around, I ran the budget figures and discovered that I would be about $72.50 short. Elaine and I had to decide whether we would continue to tithe, as we had promised God, or whether we would divert some of that money to pay for the car tag. After much prayer, we decided to leave it up to God to provide for our need. We would continue to tithe.

Shortly after that, my supervisor came to me and told me that she needed me to work overtime on Saturday. I was to work six hours. This was the first overtime I had been asked to work on my new job. I was also surprised, because I understood that the rare overtime sessions were usually all day (eight hours) or half days (four hours). I shouldn't have been surprised. When I got my overtime pay just before the end of the month, I discovered that my six hours of overtime had netted me $75.00 after deductions for tax, etc. I realized that God had answered our prayer. Then I marvelled at how close God had come in His math. I had

needed $72.50 and I had gotten $75.00. I had to swallow another lump in my throat when I remembered I had spent $2.50 for lunch that Saturday!

By this test, God assured us that if we would follow His plan for our lives, He would provide for us. We did not believe that God was promising that no hardship, even financial hardship, would come our way. He was only promising that He would provide for us during whatever hardship we faced. In this way, God used our lives in Vicksburg to draw us closer to Him.

When Elaine began her school year in August, we had another decision to make. Once again, we had to decide how we would provide for Carol during the day when both of us were at work. We considered asking Mrs. Hope to keep Carol, but that wasn't what we thought we should do.

There was a combination day care/kindergarten/private elementary school known as the First Methodist Protestant Christian School. For two year olds such as Carol, it offered a quality day care environment. In addition, Carol and her classmates would be exposed to some reading and comprehension drills designed to get them started reading. Elaine and I were not interested in getting Carol on the "fast track" for education. So we were not interested in putting Carol under any kind of academic pressure at her age. We knew that the schooling process would begin soon enough. However, Carol was ready to begin developing some reading skills. We had been reading to her regularly, and she had a decent vocabulary for a two year old. We decided to start her at FMPC and see how things went. The overriding factor in our decision to send her to FMPC, however, was

the quality and concern of the caregivers there. We were convinced that she would be treated well.

Carol's experience with FMPC went very well. She learned to interact with other kids her age. Her social skills developed very well. As time would tell, social interaction was one of her greatest skills. She also learned to read, and more importantly, to comprehend what she read. Over all we were happy with our choice, and so was Carol. While at FMPC, Carol met her first love. A young man named Dewey was in her class. She and Dewey developed a strong friendship. Carol solemnly told us that she and Dewey were going to marry when they grew up.

In the spring of 1979 one of the children at FMPC developed spinal meningitis. Meningitis is an inflammation of the meninges, a membrane which surrounds the brain and spinal cord. Symptoms of this disease are severe headache, fever, rigid neck, and bouts of unconsciousness. This is a contagious disease, and representatives of the school and the health department feared that the children might have been exposed. They arranged for the families to meet at the school on a Saturday morning to receive some medicine for the children to take.

Elaine was at All Saints, so I went to the school for the medicine. My parents were down from Thaxton, and they went with me. I was given several capsules and instructed to give them to Carol at specific intervals. For a grown-up like me, swallowing a capsule was no big deal, but almost three year old Carol had never had to swallow a capsule. Most of the medicine she had taken had been in liquid form. I was already nervous about the fact that my baby might have been exposed

to spinal meningitis, and I wasn't thinking too clearly. I just shoved the capsule in Carol's mouth and gave her a little water to wash it down. Carol decided chewing was the best thing to do with this stuff in her mouth. When she broke through the capsule and the medicine reached her taste buds, she realized that wasn't such a good idea after all. So she spit it out.

Carol's poor old daddy was panic stricken. Not only had Carol not taken a dose of her medicine, she had destroyed one of the doses. At that point, my Mom decided to help a little. She suggested that we open a capsule and mix the contents with some applesauce. That's exactly what we did, all the while I marvelled at how much smarter moms were than dads. At last Carol was on track with getting the medicine to help her fight off the possible effects of spinal meningitis. Later that day we went to Mercy Hospital in Vicksburg and got another dose of medicine to replace the one that was destroyed.

To my knowledge, none of the other children at FMPC got meningitis. Once again, we thanked God for watching over us.

As Carol's second year at FMPC approached its end, we encountered a controversy. The school board decided to dismiss Carol's teacher. In our opinion, and the opinion of many of the parents, the dismissal was political in nature and had nothing to do with the quality of her teaching. We held a meeting with the board, but they were unbending. The dismissal stood.

When Carol finished the year. We re-assessed her kindergarten plans. She would be four years old when school resumed next fall, old enough to enroll in Woodlawn

Baptist Church's kindergarten. We decided to move her there. Certainly we had confidence in the staff, since they were essentially a part of our church family. As we expected, Carol flourished at Woodlawn, just as she had at FMPC. Two years later, Carol "graduated" from kindergarten. She even had a cap and gown! She really thought she was something special when she marched up to receive her diploma.

While we lived at Vicksburg, we had another addition to our family. A co-worker of mine brought a litter of puppies from Baton Rouge, and asked if we wanted one. Carol picked a small black puppy with a white blaze on its chest. It was a cute one. we decided to name it Cajun, since it was born in Louisiana.

Cajun's first few days in our household was a nightmare. First we put him in a box in the kitchen, but he was so frightened that he whimpered all night long. We understood. The pup was spending his first night in a strange place and was scared. I finally lay down on the couch in our living room with the box on the floor beside me. When Cajun whimpered, I put my hand in the box beside him. As long as my hand was resting on his back or in the box, Cajun was happy. Eventually, Cajun got settled in as part of the family, and my nightly "puppy-sitting" came to an end.

Elaine and I were farm people, keeping a dog in the house just wasn't done. When Cajun got settled into his new surroundings, we put him in the back yard. We installed a chain link fence around our large back yard to protect him. He made it just fine. Carol spent hours on end playing with Cajun. Their favorite game was tug-of-war using an old towel. Cajun showed no interest whatsoever

in the towel when it lay on the ground, but when Carol picked it up, Cajun leaped to grab the other end, and the tug was on. Cajun won every time. In addition to his persistence, Carol got tickled at his antics and would lose her balance. Cajun then dropped the towel until Carol retrieved it again.

I don't know what made Cajun afraid of storms, but he was terrified of them. When a thunderstorm rolled in, Cajun retreated to the carport. Every time the thunder rumbled from the sky, Cajun ran out into the storm and barked furiously. After a few seconds of this outburst, he ran back into the carport and hid under the car until more thunder arrived.

During our stay in Tupelo, with a swimming pool in front of our apartment, Carol had developed a love affair with water. She loved to swim. At Vicksburg, we didn't have ready access to a swimming pool, and Carol sorely missed her opportunities to swim. We adopted a practice of going on vacation during the summer, usually June, shortly after Elaine finished her duties at school. One year, we planned a vacation to Disney World in Orlando. We were excited about the trip. We rode many of the rides available at the park, and Carol met a number of the Disney characters, including Mickey Mouse, Goofy, Tigger, and Winnie the Pooh. We stayed at a nice hotel just outside the gates of the park. In the evenings after bustling about the park all day, we relaxed in the hotel's swimming pool. Carol loved to swim. When we returned to Vicksburg, our friends asked Carol what she did on vacation.

"I went swimming!" she said enthusiastically. She never mentioned Disney World. We could have gone across town to

Vicksburg's swimming pool everyday and Carol would have been just as happy!

On another occasion, Jim and Elaine Horn invited us to their lakeside house for an afternoon of fishing, capped by a cookout for supper. When we arrived, Jim brought out a supply of fishing poles and bait, and we went to work. The lake had a good supply of white perch - a small, scaled fish that we called bream in North Mississippi. The four adults managed to catch enough to cook for supper. Carol even caught a small one. Carol decided, however, that the one she caught was to be her pet. I had my doubt about how long the fish would survive, but we put it in a small bucket to make Carol happy. Jim and I went about cleaning the fish while the two Elaines prepared the other fixin's. Aaah, this was the epitome of a lazy summer afternoon. After supper, the three of us said our goodbyes and loaded into our car. I checked the bucket which held Carol's "pet" fish. The poor thing had long since gone to "fish heaven". When I took it out of the bucket it was so stiff I could drive a nail with it! I tried to convince Carol to allow us to put it back in the lake, since I didn't have the heart to tell her it was dead. Carol would not hear of it. So far, she hadn't touched the fish, so she didn't know it was dead. I put it in the back seat of the car. As we drove along the road around the perimeter of the lake, I continued to lobby Carol to give the poor fish its freedom. At last, Carol agreed. I stopped the car, grabbed the fish and dashed to the shore of the lake. After dropping the fish in the water, I ran back to the car and took off before Carol could see the deceased floating along the surface of the water.

1982 approached. I had been working in the Vicksburg Social Security office for four years. I felt the call to request a promotion. While Elaine was not crazy about the idea, she was willing to support me if that's what I decided to do. When I applied, I was offered the position of operations supervisor in the Hattiesburg Social Security office. I was to report in January 1982.

Since Elaine's teaching contract ran until May and she wanted to complete her obligation just as she had at South Pontotoc, I went on to Hattiesburg ahead of her and Carol. Hattiesburg didn't have a YMCA, thank God! Instead I rented a small, furnished efficiency apartment for the five months I would be alone. Charlie Williams, the District Manager of the Hattiesburg Social Security office, took mercy on me and loaned me a black and white TV.

We repeated our routine of four years before. On Friday nights, I loaded my car and headed for Vicksburg to spend the weekend. On Sunday night, I returned to Hattiesburg to perform my job during the week. I scoured the Hattiesburg area during my off hours looking for the perfect house for our family. In the meantime, Elaine worked with the Vicksburg realtor, showing our house to prospective buyers.

Once again, God worked things out perfectly. We found a buyer for our house very quickly. At first I thought it was too quick. If we closed immediately, Elaine and Carol would have no place to live for two months. The buyers, however, were very understanding. We agreed to close the sale, and the buyers would rent the house back to us for two months. That allowed us to get the equity from our house sale to use on the purchase of our house in Hattiesburg.

Actually, the house we found was not in Hattiesburg. It was in Petal, a small suburb just "across the tracks" from Hattiesburg. Petal had that small town feel that we liked so much. Yet we were only a few minutes from the amenities that Hattiesburg offered. Our new home was a small ranch style, three bedroom home. It had two baths, and a large back yard which would suit Cajun nicely. It was located on a small side road away from traffic. Petal's school system was excellent. We were convinced Carol, who would start first grade in the fall would do very well here.

So, In June 1982, Elaine, Carol and I said our final good-byes to Vicksburg and headed even further into south Mississippi. Hattiesburg, here we come!

PETAL

"For God so loved the world, that He gave His only begotten son, that whosoever believeth on Him should not perish, but have eternal life." John 3:16 (KJV)

Hattiesburg is a city of about 35,000, located in South Mississippi's Pine Belt. It was born when railroads were built to haul the logs which were cut from the vast pine forests in the area. Positioned about sixty-five miles from the Gulf Coast, and about one hundred miles from New Orleans LA, the city gets quite a bit of traffic destined for both of those areas.

Petal is a small town of about 7500 people. Separated from Hattiesburg by the Bowie River and the railroad tracks, it has a personality of its own. It is almost rural in nature. Everybody knows everybody else. Friendship prevails. Air conditioning is a necessity. Mosquitoes may sometimes be mistaken for small birds. We loved it.

On moving day, we loaded the rented U-Haul truck and started our convoy along I-20 from Vicksburg to Jackson. At Jackson we turned south on Highway 49. As on our last move, I led the way, with Elaine and Carol following in our Chevrolet Monza. Mamaw and Papaw Pannell were with us, along with Elaine's brother William and Nona, his wife. The drive took almost three hours.

Once there, the menfolk did most of the unloading, while the women unpacked the boxes and supervised the positioning of the furniture. While in Vicksburg, we had purchased a queen sleeper sofa. I had always liked that sofa, until I had to load it into the U-Haul and then unload it again. That sucker was heavy! Eventually we got

everything unloaded and in position. We were home.

Elaine's first task was to look for a teaching position on the Hattiesburg area. She applied in the Hattiesburg Municipal system, the Forrest County system, the Oak Grove school in neighboring Lamar County, and in the Petal Municipal system. Once again, God took care of us. Petal had an opening. Willie Stokes, the principal at Petal High School, offered Elaine a contract for the 1982-1983 school year. Petal High School was located right next door to Petal Elementary School, where Carol would start her school career.

Our next goal was to find a church home. We visited several churches in the Hattiesburg and Petal area. One Sunday we visited Carterville Baptist Church, about ten minutes from our home. Carterville had a Sunday School attendance of about 450, which made it the same size as Woodlawn. It's membership was made up of mostly blue-collar workers. We felt comfortable there.

The next day a car pulled into our driveway. A slender, silver-haired man got out and walked up to the door. He was Leland Hogan, Carterville's pastor. His approach was relaxed and warm. He welcomed us to Petal and told us about the town and what it had to offer. Carol was smitten by this affable gentleman, and the deal was done. We would attend Carterville. God again led us to a growing, Spirit-filled church. During our years at Carterville, we grew in our walk with the Lord. At Woodlawn, God taught us how to build our relationship with Him through Bible study, prayer and tithing. At Carterville, He took us on the next step by teaching us how to serve Him through participation in His work. He led me to

teach a Sunday School class for a while, and to accept His call as a deacon. God led Elaine to sing in the choir. She has an excellent voice. God used her singing talent to build valuable friendships with several ladies in the church. Elaine also serves Him through her support of the church family and through prayer. After Carol came to know Christ as her Savior, she also learned to develop her relationship to Him. Her work as a leader in Christian service came when she was a little older.

We fenced in the backyard, making a nice place for Cajun to stay. Cajun's house had been a fifty-five gallon drum with a door cut in the lid. I decided that it was time for Cajun to have something a little more substantial. I bought some 1" X 4" framing lumber, and some 3/4" plywood. My plan was to make Cajun's new home myself. My father was a carpenter, during his career he was very handy with a hammer and saw. He even did some cabinet construction. I, however, did not inherit his skill. When I assembled Cajun's new dog house, Elaine the math teacher couldn't even describe it. It was a geometric figure where no two sides and no two angles are equal. Cajun wouldn't go near it! I put some straw inside and waited patiently. Eventually, Cajun swallowed his pride and moved in. The house kept him warm and dry, but an architectural masterpiece, it was not.

Cajun and Carol adjusted to the new home very well. In addition to the towel tug-of-war, Carol added a new game, fetch the tennis ball. Carol tossed a tennis ball across the backyard and Cajun galloped off to retrieve it. They repeated this process until Cajun's tongue was hanging out. He loved it, though.

When he got too tired, he would just fetch the tennis ball and hide it.

On one of our visits to Elaine's parents, we learned that Elaine's sister Doris Hood and Claude her husband were tending a new batch of puppies delivered by their dog. Carol decided that Cajun needed a companion. Who were we to refuse? Carol picked the runt of the litter. Naturally, the young female dog was named "Little Bit". When Little Bit grew older, however, she became a little butterball. She was a mixed breed puppy, but the predominant line was a black and tan hound. Her black coat, along with her tan eyebrows and tan muzzle made her very cute. Since Cajun was a male, we took both of them to the vet at the first opportunity. A little surgical work ensured that we wouldn't have to find homes for puppies in the future.

We discovered that we had some friendly neighbors. One family who lived directly across the street had a young boy about Carol's age. Chris Morrow and Carol became close friends. Diagonally across the intersection from us lived Christina Hart and her family. Christina's father was the local Army recruiter. Christina and Carol grew very close also. The Huffmasters lived between the Morrows and the Harts. They didn't have anyone Carol's age, but Carol (and we) enjoyed visiting them and being visited by them.

Carterville Church offered a variety of friends for us and for Carol as well. We developed a close sense of kinship with our church family. Whitney Jordan, Kelly Levi, Tony Tims and many others offered hours of companionship for Carol. While their parents offered support for Elaine and me as we settled into our new home. Of all her church

friends, Whitney Jordan was Carol's closest buddy. They visited each other and spent lots of time together. After Carol died, Whitney wrote Elaine and me a comforting letter which recounted some of her time with Carol:

> I have been trying to find the words to express myself about Carol. You see, Carol lives on for me in so many memories, as I am sure she does for you.
>
> Here it is Easter season, and my Mom set out a large, white ceramic rabbit. This is not just any 'ole' bunny, but one with his head tilted in an inquiring way, with huge eyes and large flopped ears. This rabbit was a gift from Carol when we were about 11 or 12 years old, and we enjoy it on our coffee table every Easter. He brings back special memories.
>
> Every day when I go into our laundry room to iron whatever I will be wearing that day, I watch the time on a clock Carol gave me for my birthday when I was ten or so. Again, this is not just any 'ole' clock! It is a very large 'wrist watch' in bright red, yellow and blue! I kept it in my room for years until my Mom bought new cherry furniture. Although it no longer matched, it was too cute to sell in a garage sale ... besides Carol gave it to me ... so we hung it in the laundry room. Some great memories are attached to that clock.

Then of course, I have pictures of Carol and me at different occasions as we grew up ... over birthday cakes, etc. However, my best memories are in my head and in my heart. Those are of our overnight visits when we spent endless hours whispering and giggling through the night. Also the weekend trips to visit your relatives when we rode four-wheelers and loved every minute of being tomboys! This was probably the most awkward and difficult time of my life, and I recall having 'gappy' teeth, braces, and having frizzy hair. But ya'll loved me and included me in your family and I appreciate it. If I failed to say thanks then, let me do so now.

Later, of course, ya'll moved to North Carolina. I thought this was exciting because I had visited Hendersonville with my family and loved it. Naturally, I was a little envious that Carol had an opportunity to be the 'new kid' for a change. We enjoyed letters and occasional calls for a time. We also visited during your trips back to Mississippi.

My next specific memory was when Carol spent the weekend with me and we made our 'debut' at the Homecoming dance. Carol arrived so grownup and sophisticated. Even my parents wondered where the tomboy went ... and where did this refined young lady come from! We no longer ran yelling through the house, but actually talked like civilized

people! We had a great time, and although there were outward changes, Carol was still her funny, loyal true-blue self.

You see, the friendship we shared was one that no matter how much time passed between visits, we could just take right up where we left off and chat endlessly. And so went this friendship through our last visit ... last summer. We caught up when she came to my house ... I learned of her plans for medical school, and she listened as I told her of my teaching plans. We talked school, life and boyfriends. It was great.

Needless to say, I was shocked to hear of her illness. But even when I called and talked to her on several occasions, she was upbeat and positive. You know, I really believed she would beat that cancer. Even though I am sorry I was unable to visit during her illness, I am glad that my memories are of her good times. Her zest for life was so contagious; to this day, I can hear her cheerful voice and her constant chuckle! I can see her as I enjoy my Easter bunny that has become even more precious, and I think of her when I watch my red, yellow and blue clock. There is no doubt that those in Heaven are enjoying her company!"

While in Petal, Carol participated in organized sports. First, she tried T-Ball in the Hattiesburg recreation department. What she lacked in talent, she made up for in

enthusiasm. In T-Ball, the ball is placed on a "tee", a plastic pipe which holds the ball stationary at slugger height. The player then whacks the ball and takes off for first base. The players in the field retrieve the ball and throw it home. Rarely did the home team make three outs in an inning. Instead the rules required that the team at bat take the field once the team batted around. Additionally, everybody on the team played and batted. Instead of fielding nine players, fifteen might be in the field at the same time.

The great thing about T-Ball was that nobody really kept score. It didn't matter who won. The teams were there to have fun and develop some athletic skills. As a result, Carol and her teammates had a blast. So did the parents. Each game brought some new twist to the game. On the rare occasion when the batter hit a fly ball, the players in the field covered their heads with their gloves and scattered. Once the ball hit the ground, they ran back and picked up the ball to make their throw home.

Elaine and I often laughed at some player in the field, perhaps even Carol, who ended up chasing a butterfly or watching ants at work instead of "keeping their head in the game". There was one game in which a hitter was unable to hit the ball forward into the field. Instead, he hit it backward every time. He took a mighty cut at the ball on the tee, only to swing under the ball and hit the tee instead. Then he immediately pulled his bat backward as vigorously as he had swung forward. The backswing caught the ball as it dropped, and punched the ball toward the backstop. The batter did this several times before he managed to hit the ball into the field.

On another occasion, a batter got his bases confused. When he hit the ball, he ran the circuit backward! He ran to third, then to second, and so on. The coaches laughed and gave him the run, then patiently explained how he should have run the bases.

T-Ball was a wonderful introduction to sports. Carol learned the true spirit of athletics - to give your best effort and to have fun. She followed this tenet all of her life.

Carol's next athletic effort was soccer. Once again, she played in the Hattiesburg system. This time her team consisted entirely of Petal kids. Carol's dear old Dad wound up as coach. I knew as much about soccer as I did about nuclear physics, but I was willing to help if it gave Carol and her friends an opportunity to play and grow.

Soccer was almost as entertaining as T-Ball. After I visited the library and studied all about soccer strategy, I tried to teach the team to play the positions. I selected the strikers, who were the offensive wing of the team. Their job was to take the ball to the opponents goal. The mid-fielders were the switch-hitters. When we had the ball, they helped the strikers attack the opposing team's goal. When our opponents had the ball, they helped defend against their attack.

The defenders stayed back and intercepted the other teams strikers when they advanced toward our goal, and the goalie stayed in our goal and stopped the ball when an opponent took a shot.

In theory, I designed the "perfect" strategy. No one could beat us! In application, however, things didn't go quite as I planned it. When the game started, our

players decided to use the "swarm" method. Everybody on both teams gathered around the ball and kicked until somebody hit it and made it move. Then the swarm moved to the ball's new location and kicked again.

Once again, our main goal was to have fun and to get some exercise for the kids. Carol had fun, but she discovered that she was not destined to be a soccer super-star. She decided to return to the diamond. I can't say I was disappointed.

As Carol grew older, she moved from T-Ball to softball. At first she played on a team where her coach pitched to her when she was at bat. This was the next step in developing the "hitter's eye". Later, she stepped up to the regular softball system, where the opposing pitcher pitched the ball. Carol grew to be pretty good. She could hit the ball well, but she was not very fast. She had become rather chubby, and her mobility was not what it could have been. She did become one of the best fielders on the team. Since she could catch better than most of her teammates, she played first base.

We were pleased at Carol's activities. This helped her to get some good exercise and develop reliable muscle skills.

Elaine and I took up a new sport as well. Now that we were away from our old bowling buddies, we lost our desire to continue bowling. We decided to try tennis. I had learned tennis in college. Elaine played with me and learned the game very well. Typically, Elaine's natural athletic ability allowed her to become competitive with me very quickly. This game allowed us to get some exercise which we sorely needed, and to have some fun together as well. Carol eventually convinced us to get her a racquet and she took up the game, too, learning

almost as quickly as her mother. Tennis eventually became the sport in which she earned a varsity letter.

Tennis led to one bad episode in my life however. One December day, Carol stayed with Christina while Elaine and I travelled the half-mile to the tennis courts for a game. After a warm-up, we played a set. At one point, when I charged the net, Elaine hit a very good passing shot. As it whizzed by, I lunged for it. Later Elaine teasingly accused me of diving for the shot. Even I am not dumb enough to dive on an asphalt tennis court. Nevertheless, I lost my balance and fell on my shoulder. I knew I had banged it up severely, however, I didn't think I was seriously injured.

As a precaution, we decided to go to Hattiesburg's urgent care center for an X-ray. When Elaine called the Hart's to explain, Carol became very upset. She apparently believed that I was seriously injured. She had to come to the house to hug me (gently) and see that I was awake and okay. I worked hard to be jovial and lighthearted to put Carol at ease.

When the X-ray was completed, the doctor told me I had a separated shoulder. I must have been dazed, because I thought he was talking about a dislocated shoulder. I was relieved until he started talking about surgery! I got serious in a hurry.

The next week, I had an operation on my shoulder at Forrest General Hospital. Arthroscopic surgery was not commonplace then, and the surgeon sliced my shoulder from front to back. I was impressed that Brother Hogan came from church to sit with Elaine and Carol during my surgery. When Carol became restless, he took her down to the cafeteria for a snack. Brother Hogan was a special

pastor and friend. I will always be grateful for the devotion he offered to our family.

I spent two nights in the hospital - one night before the surgery and one night after the surgery. If they had made me stay one more night, they would have had to tie me down to keep me there. I decided then and there that I did not like hospitals - especially from the patient's point of view.

I spent the next month with my right arm strapped to the trunk of my body while my shoulder healed. When the doctor released my arm, it was frozen at the shoulder. I could barely touch my forehead with my fingertips. For the next month, I underwent physical therapy to restore the range of motion that I once had. I accused the physical therapists of trying to undo all the doctor had done. I thought they were trying to tear my arm off at the shoulder! In fact, they were doing their job. At the end of a month, I had most of my old range of motion back. As I continued to work over the next few weeks, I was able to restore my shoulder almost completely to its old mobility.

When Carol was eight, her grandmother wrote a poem to commemorate her birthday and to recall the joy of her arrival.

MY FIRST GRANDCHILD

I waited and waited
and anticipated
the birth of my first grandchild.

'Twas on a cold wintry day
the news came my way,
I was to have my first grandchild.

"Twas the first of July
when she finally arrived,
my beautiful first grandchild.

She grows sweeter and sweeter
each time that I see her and I love her,
 my first grandchild.

Eight short years have passed
who would have thought it would last,
the thrill of my first grandchild.

 Bernette Hooker

Carol loved to participate in the
activities at Carterville Baptist Church.
She enjoyed Sunday School and worship service
on Sunday mornings and Discipleship Training
and worship service on Sunday evenings.
Wednesday night brought prayer meeting and
activities such as GA's, a young girl's
mission study. She revelled in being a part
of a group learning about God.
 During the summer, she enjoyed
children's camp. This was a week long
activity which involved having the kids
travel to a nearby camp, where they stayed in
rustic cabins, swam, and played games.
Incorporated into all the activities were
lessons involving Jesus and His love. One
year Carol came down with a bladder
infection, which caused her great pain. It
was time for children's camp, however, so she
hid her discomfort from Elaine and me. Off
she went. That night we got a call. One of
the female counsellors had discovered Carol
crying while she was trying to urinate and
figured out the problem. We arranged to go
get her and carried her to the doctor for

some medication. It was difficult to chastise her for loving church activities so much.

Eventually, Carol talked with us about her beliefs about salvation. She had reached the stage in her spiritual development where she was prepared to accept Jesus as her savior. We talked with Carol about her beliefs, then we asked Brother Hogan to talk with her also. We were satisfied that Carol understood the steps of salvation: conviction, repentance, asking Jesus for salvation. She made her profession of faith. The next Sunday she walked down the aisle and publicly announced her salvation at the age of seven. We were so proud!

With the University of Southern Mississippi so close. Elaine decided the opportunity to work on a Master's degree was just too great. She spent her summers studying across town at the USM campus. After a few summers, Elaine walked the aisle to receive her Master's of Education degree, while Carol and I sat in the audience bursting with pride. That year I was chairman of the deacons at Carterville. Tradition called for the deacon chairman to present all the graduates in the church with a gift and shake their hands. I went through the high school and bachelor's degree candidates, presenting their gift with a big smile, and handshake and a "congratulations". When Elaine came forward, however, no way was she getting just a handshake. The congregation "oohed" and "aaahhed" as I gave her a big hug and a kiss.

Over the years, Carol continued to have a nagging problem with tonsillitis and bronchial troubles. Every winter we trucked her to the doctor to get some medicine for an inflamed throat or worse. Dr. Love, her

85

pediatrician, suggested we consider a tonsillectomy for her. We prayed and asked God to guide us. We finally decided we had to give the tonsillectomy a chance to improve Carol's health.

We scheduled the surgery at Forrest General Hospital in Hattiesburg. A week before the surgery, we took Carol to meet with one of Forrest General's staff. She sat down with Carol and talked about the surgery and how it would feel. She also took us on a tour of the hospital, showing Carol what her room would look like, and what the operating and recovery rooms would look like. All of this was designed to alleviate Carol's anxiety, of course. It worked very well. No doubt Carol was nervous when she checked into the hospital for the surgery, but she knew what to expect and she was prepared. The surgery went like clockwork. After a short recovery period, Carol felt fine. The tonsillectomy helped alleviate Carol's problem with tonsillitis and bronchitis.

Carol also developed a sense of mischief. On Saturday and Sunday mornings, Elaine always cooked a nice breakfast, while on weekdays, when everyone was scurrying about we relied on cereal, pastries or some quickly prepared breakfast. One Saturday or Sunday morning, I forget which. Elaine fixed pancakes.

I love pancakes. I love to pour a generous helping of pancake syrup over the top and dig in. Elaine always gives me the first stack, and I eat while she cooks a stack for herself.

On this particular morning, Elaine gave me the first stack, as usual. I loaded them up with syrup and took a big bite. Something tasted funny. In fact, they were terrible! Being a good husband; however, I decided to

be quiet and force the pancakes down. I had eaten about half of my serving when Elaine took her first bite.

She froze in mid-chew. "Do your pancakes taste funny?" Elaine asked.

"As a matter of fact, they do." I said.

We spent the next few minutes puzzling over what the problem might be. Finally, Elaine took the sugar bowl from the cabinet and touched a moistened finger to its contents. When she tasted it, she said, "This is salt!"

Carol had been sitting at the end of the counter struggling to control her mirth. Now she burst out laughing. Carol had replaced the contents of the sugar bowl with salt. It's a wonder my veins didn't lock up, with all the salt I had eaten!

Since it was just a prank, and nobody got hurt, Carol didn't get into much trouble as a result of her mischief. She was fair game for a practical joke or two of ours after that, however.

Of course, now I had to explain why I had eaten half of a stack of pancakes made with salt instead of sugar without saying a word. Actually, I think I got a couple of "husband points" for not criticizing my wife's cooking.

Despite Carol's participation in sports, she gained considerable weight. By the time she was nine years old, she was very chubby. She came by this problem naturally. I have always had a weight problem, as has my mother. I firmly believe that some people inherit a propensity for obesity. That is not to say that the propensity can't be overcome with the application of will power. But for some people, such as Carol, controlling her weight was difficult.

While we were at Petal, Forrest General Hospital offered a weight control program for overweight kids. Elaine, Carol and I discussed the program and decided to enroll Carol. The program called for the child to attend with one parent. Since I was the overweight parent, I was the logical choice. The program taught us to plan a program of exercise, healthy eating habits, and positive mental attitudes. The program actually worked. Carol lost down to her desired weight goal. The program helped me, too. It took me longer, but I lost quite a bit of weight, too.

Carol was very proud of herself. She looked better and felt better, too. She managed to keep her weight down for about two years, then it began to creep back. We have found that it is difficult to keep weight off once a program like Forrest General's is completed. Carol and I both experienced this problem.

Eventually, Carol gained all her excess weight back and then some. For all of the remainder of her life, obesity was a challenge for Carol. Since her cancer occurred in her digestive system, I have wondered if her weight had anything to do with it. Of course, there is no way to know. There are many obese people who haven't gotten cancer, and I am grateful for that. There are also many slim people who have gotten cancer, and I regret that. We gain nothing from anguish over "what if" suppositions. If Carol's weight was a factor in her illness, so be it.

Carol had always done well in school. While at W.L. Smith Elementary School, Carol continued that practice. Mrs. Betty Hodge was her sixth-grade teacher, and in the spring of 1988, she wrote Elaine and me a

note to tell us of her impressions about Carol:

This school year has passed the half-way mark and I don't want it to pass completely before I report personally to you my observations of Carol. She is so talented that it would be hard to single out the thing that she does best. I know you are aware of her abilities. To me, the thing that does set her apart from other multi-talented kids is her enthusiasm for projects, causes, concerns, friends. She is always so full of anticipation to get into doing and helping that she is bubbling over. I am happy to have had this year to work with and know her.

Mrs. Betty Hodge
1987-1988

Tina Phillips was a classmate of Carol's at W.L. Smith Elementary School, which housed the 4th through the 6th grades. Tina was in the 6th grade, a year older than Carol. She and Carol were also friends at church. One day, Tina committed suicide.

Carol was shattered by the news. Elaine and I were confused. We could not comprehend why a twelve year old person would want to take her own life. We did not know what Carol told us later, that Tina had begun abusing alcohol. At that tender age, she must not have known how to deal with such a problem.

The event was a life-changing experience for Carol. She asked me to take her to the funeral, and I did. We then travelled with the funeral procession to the cemetery and

watched from a distance as Tina was laid to rest. Carol was silent. I tried to talk with her, to draw her out, but she was not able to verbalize her thoughts.

Throughout her teenage years, Carol crusaded against the abuse of alcohol and drugs. She often pointed to Tina's suicide as the point in her life where she became committed to fighting these evils.

My career called again, and my feet grew restless. I believed it was time to climb another rung in my career ladder. I applied for a branch manager position.

The manager's position in Columbia MS, about thirty-five miles from Hattiesburg and Petal, opened up, and I hoped that I would get that spot. Our trio was happy in Petal, and Columbia was close enough for commuting. Thus, we wouldn't have to move. It was not to be. Another person was selected for Columbia.

Instead, God chose to move us again. I was selected to fill the manager's spot in the Hendersonville, North Carolina office about five hundred miles from Petal; and, wouldn't you know, I was instructed to report the first week of January in 1988. Since Elaine and Carol needed to finish their school years in Petal, I moved to Hendersonville alone, and we faced another five month separation. No one looked forward to that; but we had done it before, so we steeled ourselves once again.

I drove to Hendersonville on a Sunday, leaving a teary-eyed wife and daughter in the driveway. That was a long ten-hour drive, and I had wet eyes for a while myself. The first week I was in North Carolina, we had a fourteen inch snowfall. I could see we would have some adjustment to make from the Mississippi weather.

Social Security had hired a relocation company to help with employee moves. Between January and June, we arranged for the company to purchase our house in Petal and to move our furniture to Hendersonville. Over spring break, Elaine and Carol came to Hendersonville, gaining a chance to look at their new home and to do a little house-hunting. By the end of spring break, we had found the house we were looking for. It was a two story house (actually one story with a finished basement), with three bedrooms, an extra room for my office, and a fireplace. It was located on a quiet cul-de-sac on the north side of town. We signed the contract, and had the house purchased by the time Elaine and Carol moved in early June.

RUGBY
THE TURNING POINT

"My grace is sufficient for you,
for My power is made perfect in
weakness." Therefore I will boast
all the more gladly about my
weaknesses, so that Christ's power
may rest on me. 2 Cor. 12:9

PRAYER OF ST. FRANCIS OF ASSISSI

Lord,
make me an instrument
of Thy peace.
Where there is hatred,
let us sow love;
where there is despair,
hope;
where there is sadness,
joy;
where there is darkness,
light.
O Divine Master,
grant that we may not so much
seek to be consoled,
as to console;
not so much to be loved,
as to love.
For it is in giving that we are
pardoned,
it is in dying that we are
born again
to eternal life.

I am not sure whether it is better to
have a moving company move your furniture, or
to move yourself. When we moved to Vicksburg
and Petal, we rented U-Haul trucks, loaded
our own furniture and moved ourselves. It
was hard work, but at least we were involved
in doing some productive physical labor.

When the moving company pulled up to our door, we could only sit by and watch while they packed up our lives like so much cargo. They obviously knew what they were doing, but we held our collective breath many times while they loaded some precious item of ours.

There was one guy that we nicknamed "Samson", because he was big and strong. He often picked up a large piece of furniture all by himself and carried it to the truck. He earned his nickname when we saw him carrying a mattress off our bed (in a box) on his back. It reminded us of the story about Samson carrying off the gate at Gaza on his back.

The movers got everything safely to Hendersonville and safely unloaded into our new home. They even got that great big queen-sleeper sofa into the house with no harm done. (Samson didn't carry THAT piece of furniture by himself!).

Elaine and Carol knuckled down to unpacking all the boxes and storing everything in its proper place. As with all moves, it took a while, but eventually they had the house looking like a home.

Hendersonville is a beautiful town. The city has a population of about 8,000, while the county population is 80,000. It is located on a flat plain, 2200 feet above sea level. Peaks of the Blue Ridge Mountains surround the town, giving one a view of mountain peaks from anywhere in the city. Main Street has been restored to look like a village from the 1920's or so. As a result, Hendersonville is a very popular stop for tourists as they visit the nearby mountains.

We quickly began our "new home" routine. On weekends, we struck out, looking for some new location to visit. We drove twenty miles east to the Hickory Nut Gorge and picnicked

on the banks of the Rocky Broad River, a rushing mountain river which flowed over large rocks and boulders. The sound of the rushing water was hypnotic. We sat on boulders at the river's edge and listened to the song of the waters.

After lunch we journeyed to the top of Chimney Rock Park and hiked the trail out to Hickory Nut Falls. A few years later, Michael Mann made a movie (starring Daniel Day Lewis) called <u>The Last of the Mohicans</u>. The last twenty minutes or so of the movie was made along the very trails we walked at Chimney Rock Park. In fact almost all of the movie was made at sites within thirty miles of Hendersonville. The view of the mountains and of Lake Lure from the park was enchanting. We quickly fell in love with the west North Carolina mountains. The movie <u>Dirty Dancing</u> was also filmed at Lake Lure.

On another day, we headed west to the Pisgah National Forest. Our first stop was at Looking Glass Falls, an eighty foot high waterfall. The Davidson River is the water source for the falls, making a sheen of water as shiny as glass.

We went a little further upriver and found Sliding Rock, where the Davidson River flows over a smooth rock surface at an angle of thirty degrees or so, making a perfect natural water slide. Carol and I changed into old jeans and old tennis shoes, while Elaine picked a viewing spot near the bottom. Carol went first, sliding down into the pool at the bottom of the rock. I took off right after her. About half-way down, I realized the water was going to be very cold and that I didn't really want to slide into it.

Too late! When I hit the frigid water, my breath fled. I gasped for air, trying to get my frozen lungs to work. For a moment,

Elaine thought I has having a heart attack. I wouldn't have disagreed. Eventually, my lungs went back to work. I decided I'd had all of Sliding Rock I wanted. I joined Elaine in the spectator section, while Carol made several more trips down the rock. When Carol's skin turned blue, we decided that was enough for the day.

We filled our summer with many such trips, visiting the Biltmore House in Asheville, Graveyard Fields on the Blue Ridge Parkway, Whitewater Falls in next-door Transylvania County, and so on. There is nothing so peaceful as standing atop a mountain peak and looking toward the horizon where other mountain ridges, swathed in a blue haze, fold together like fingers interlaced in prayer. We decided that God had made the western North Carolina mountains as evidence for anyone who doubted that He had created the universe. An area of such beauty could not have appeared by accident. No, God made these mountains, and no one could convince us otherwise.

Elaine searched for a teaching job in the area; however, things didn't go as easily as they had in Vicksburg and Petal. No math teaching positions were available. Elaine provided some income by substituting in the county school system and by teaching night classes at Blue Ridge Community College. This helped us get through the inevitable budget crunch that comes with a move. The work she did as a substitute also helped her establish her credentials with the principals in the area. After a couple of years, a position at West Henderson High School opened and Kholan Flynn, the principal, offered the job to Elaine. Of course, she took it.

Carol, in the meantime, enrolled at Rugby Junior High School in the fall of 1988.

Rugby had a reputation as a good school, and it was only about a five minute drive from our house. Since Carol was making the transition from elementary to junior high school, I thought this would work well for Carol's move from Petal to Hendersonville. Since she would be changing schools anyway, the adjustment should be easier.

What I failed to consider was that the transition Carol would have made in Petal would have been with her friends. Her classmates at Petal Junior High School would have been the same classmates she'd had at W. L. Smith Elementary. By moving to Hendersonville, Carol had left all her friends behind and now had to make new friends.

Carol was an extrovert, and made friends easily, but Carol was in that peculiar stage of development which occurs in the pre-teen years; and the transition was hard on her.

A young person reaches a stage in his or her development, perhaps when the hormones kick in, where she has to stretch her boundaries. She has to challenge her limitations, to test the lessons she has learned from her parents and teachers. She is growing and changing physically. She can do things she wasn't able to do before. Sometimes a person in this stage will rebel against parental authority and try to strike out on her own, at least symbolically.

This can be a trying time for a parent. We have to allow our child to expand her activities and thinking, while still exerting some influence on her development. In some cases, the child will lash out against her parents or other authority figures and will, perhaps deliberately, strive to alienate herself from her parents. She is only trying

to become her own person, but she just doesn't know how - not yet, anyway.

In most cases, I believe, the young person will work through this stage and drift back into the values that she has grown up with, as she becomes more mature. In some cases, however, she will choose to remain stubbornly independent into her twenties or beyond.

Carol went through a stage like this during her Rugby years. She strove to learn about herself and to find a path that was uniquely her own. She had to decide if she would accept the Christian values that Elaine and I had taught her during her younger years, or to establish values that were contrary to ours. This was a traumatic time for Carol, and we suffered with her. We tried to allow her to develop her own personality without allowing her to go completely "crazy".

I have often wondered if Carol's rebellious stage was triggered by our move from Petal to Hendersonville. Certainly having to give up her old friends and make new ones put a strain on her. However, I also believe that Carol would have experienced this developmental stage even if we had stayed at Petal. Perhaps it came sooner, or perhaps it was more harsh because of our move. But that is something we will never know.

Paradoxically, even as Carol went through her own trials, she also worked to help her friends go through their own rebellious stages. She found herself coaching friends who toyed with the temptations of alcohol and drugs, steering them toward the very same Christian values we had taught her. I believe this involvement with her friends helped Carol to choose her

own path, a path that was pleasing to God and us.

Carol told us there were three groups at Rugby. The "Preppies" were those affluent students who dressed well, and were high on the social ladder. The "Skateboarders" were those who were obsessed with the wild rides offered by skateboards and rollerblades. The "Harleys" were those who were already in the throes of their rebellion. They dressed in leather or black, wore odd jewelry, and tended to defy authority. When Carol started at Rugby, her first friends were among the Harleys.

Carol adopted a style of dress that allowed her to fit in with her new friends. She dressed in black. She bought jewelry that also corresponded with that style. One item was a ring that displayed the Harley eagle. She also made an earring out of a necklace. She allowed one end of the chain to dangle from an ear, reaching almost to her waist. Another item she wore (although she thought we didn't know about it) was a single black leather glove with the fingers cut out.

Carol also pulled a trick on us. She told Elaine she needed some india ink for a project at school. Elaine innocently bought it. Carol then took the ink and a needle and fashioned a homemade tatoo, a cross, on her ankle. We didn't know she had done it until years later. She wore socks when she could to hide it from us. I guess that goes to show that we were not as attentive as we thought. Well, anyway, it was a small cross.

Carol also began to experiment with heavy metal music during this period. She played tapes of heavy metal bands and "head banging" music.

Elaine and I had to decide how we would handle this turn of events. Should we flatly

refuse to allow Carol to dress the way she had chosen? Should we refuse to allow her to play the music she preferred? We didn't want to provoke an all out battle over Carol's lifestyle. We wanted her to be her own person. But we also realized the danger of allowing her to spiral off into a world of dangerous behavior unchecked.

We believed we had taught Carol well. We believed that if we appealed to Carol's sensibilities, she would not stray too far. We decided to allow Carol to choose her own style of dress, as long as she didn't try to dress obscenely. Fortunately, Carol was too smart for that. We also decided that we wouldn't refuse Carol's wish to play the undesirable music; however, we did closely screen the lyrics on the music she chose. Any tapes with lyrics that were obscene or vulgar were vetoed.

We also did something else. We talked with Carol a lot, and we listened a lot. We talked about our concern about the music she liked, and about the style of clothing that she wore. We told her that we didn't approve of those things, but we would allow her to do those things if she chose to, within the constraints that we had specified. I believe that our action allowed Carol to realize that we respected her as a person, and that we wanted her to make her own, mature choices. I believe that our action caused Carol to think more carefully about the choices that she made. Eventually, our trust in her paid off, but that payoff was still some distance away.

Shortly after Carol moved to Hendersonville, the county recreation department opened a non-alcoholic club for teenagers, called Checkers. The club was located in the basement of a building on

Spartanburg Highway. The county hoped to provide a place where Henderson County's teenagers could come to have fun without being tempted to use alcohol or drugs. Checkers became a haven for the Harleys. It served soft drinks, chips, pizza and other snacks. The club had a dance floor (and played hard rock music), and had a game room with a pool table and pinball machines. Carol enjoyed going there. Natural leader that she was, she eventually wound up serving on the teen board for the club and policing the patrons.

At Checkers, Carol was able to see the effects of rebellion on the lives of her friends. Since the club didn't allow alcohol, some kids were challenged to try to sneak in liquor. As a board member, Carol participated in barring them from the club. Several times, she had to call the police to pacify an unruly teen. She also had an opportunity to observe some teenagers who had allowed their bitterness to taint their enjoyment of life, and to observe those who would never cease their rebellion. I believe her experiences there gave her the wisdom to prevent her own rebellion from going too far.

Each Sunday we visited churches in the area, looking for our new church home. We visited Main Street Baptist Church, Mud Creek Baptist Church, and First Baptist Church. Not long after, we received a cordial visit from Brother Max Smith, the pastor at Main Street Baptist. While we were visiting on our back porch, Bothers Wally Shamburger and Bill Wilkinson from First Baptist drove up! The five of us sat and chatted for a while, making it a very enjoyable visit.

Eventually we decided on First Baptist. FBC was a very friendly church, as were all those we visited. Carol really enjoyed the

youth program at FBC, and we found Mrs. Lula
Mae Briggs' Sunday School class educational
and uplifting. I was reminded of my vow
never to join a First Baptist Church, because
they were always so "big city" and
impersonal. Now God was leading me to eat my
words! Once again, He had led us to a
growing, Spirit-filled church which would
allow us to mature in our relationship and
service to Him.

Brother Rich Liner was the pastor. He
was a very kind, intelligent man. He wore
his hair in a pompadour style, and suits that
fit his body like a glove. He had a volatile
temper, but to his credit, he controlled it
admirably.

Wally Shamburger was the minister of
music. His reddish complexion made him look
as if he was always on the verge of blushing.
His bright smile made us feel welcome. He
had a talented brigade of vocalists and
musicians at his command, and he did an
excellent job of praising God with FBC's
music program.

Bill Wilkinson was the minister of
education. He had come to FBC from Columbia
Mississippi, a small town thirty-five miles
from Hattiesburg. Bill lent a touch of
"home" to our new church surroundings.

Steve Briggs was the children's
minister. He also coached the men's softball
team. I tried to play for the first couple
of years at Hendersonville, as I had at
Petal. I found, however, that my feet were
getting slower, and my joints were feeling
more brittle, so I gave up the sport in favor
of playing tennis and hiking with my family.

Jim Pearce was the youth minister. His
slender frame, dark eyes and hair and
Romanesque nose gave him a stern appearance.
His bark was worse than his bite, however.

As youth minister, Jim dealt with Carol and
her activities quite a bit. The two of them
quickly established a rapport. Perhaps it
was because each was frank in his or her
behavior. Each was willing to be honest with
the other in a caring, accepting way. Thus,
Carol was able to vent some of her
frustration and anger in her discussions with
Jim, and he was able to empathize with her
feelings. He was also able to tell Carol
where she was disobeying God's word and
encourage her to alter her behavior.

We didn't know this at the time, Jim
told us later, but Carol would sometimes
wander into the gym at church and punch the
walls until her knuckles were bloody. We
knew Carol was angry (at what we didn't
know), but we didn't know she was that angry.
Jim shared a few of his memories of Carol
with us:

> I first met Carol in the 7th
> grade. I believe that Carol had
> recently moved from Mississippi to
> North Carolina. It was to be my
> privilege - and challenge to be
> Carol's Youth Pastor for the next
> eight years.
> The first thing that I saw in
> Carol was anger. I don't know if
> Carol even knew with whom she was
> angry, but she was angry! I
> remember days when she would come
> into the office to chat and later
> would leave and beat her fists on
> the walls of the gym. Carol was
> into black leather, chains, music
> that was not wholesome and friends
> that were not a help.
> Carol stayed this way for over
> a year but a gradual change started

to happen. From the start I challenged Carol to get rid of anything that would hinder her in the race of getting to know Christ better. When we first started talking through the hurts of her life she was mad at me to say the least. There were times that she would storm out of my office and threaten never to return. She told me later that she would tell others what a jerk I was and to stay away from me. In time God softened her heart and she started listening to the Holy Spirit and changed.

As Carol got involved in the Youth Group and the RAD (Rugby Against Drugs) program she began to soften. It became apparent that Carol was a leader in whatever she became involved. She immediately wanted to be involved in any ministry activity that the Youth Group was doing. Many times we went into the prisons around Western North Carolina and I watched amazed as Carol boldly shared her relationship with Jesus Christ and the mistakes she had made in her growth.

I also sat back in amazement as Carol reached out to those in the group who seemed to be hurting the most - even though she was hurting. In Carol"s junior and senior years in High School she started to develop multiple physical problems which caused her a great deal of pain - but in the midst of the pain she would give and give. I watched Carol give on

Island Outreach trips when she was totally worn out. She truly was drawing on God's strength and giving it to others.

I also remember after Carol went to college the intense desire she had not only to make a difference on her campus but to come back to the Youth Group and help others who were about to go the same way she did. She reached out to the roughest ones and tried to point them to Jesus. Even when she was in extreme pain she talked her daddy into bringing her to the Youth Retreat at Teen Valley Ranch or the current Disciple Now.

During the last Disciple Now that Carol helped with I remember her in tears sharing her love for Jesus and how He had taken her through the horrible pain. She shared that she may not be healed, but she still trusted God with her life regardless. None of us knew at the time that she would go home to be with the Lord soon after.

As to Carol's college life, I was so impressed with the desire she had to make a change in lives on her campus. Carol set out with a desire to get a Christian presence more prevalent there and caught a lot of flak for it. She called me many times late at night to tell me what God was doing in specific people's lives on the campus, or to tell the progress on getting a Christian Club started or to tell me of the struggles of being a part-time Youth Minister at

a little church near the college. Carol learned a lot of tough lessons about church life there but her faith in Jesus Christ was not shaken regardless - even when she was beaten up by a youth group member, or when she received threatening calls after a youth group member committed suicide.

When I first met Carol she seemed to truly hate her parents (as many teens seem to). She would tell me all sorts of horror stories about them and pretty well had me convinced that they **WERE** horrible people. As we talked together I began to challenge her to pray for her parents and her relationship with them. I challenged her to honor them and do only what they would put their blessing on. I did not believe that she would do this as most young people that I had also challenged did not try it. She took the challenge and immediately made a public commitment that from that point on she was not going to do anything that did not have her parent's 100% blessing. She faced some very tough choices after that commitment, but if her parents were at all hesitant about something she wanted to do she chose to honor them instead of thinking she knew what was best. I really believe that it was this commitment that led to the joy that began to fill her life and the fruit that began to be exhibited through her life. Soon after making the commitment she began to lead friends and

teachers to a personal relationship with Jesus Christ. I will never be the same having known Carol for a few short years. She was the perfect example of the one that the Lord Jesus would leave the ninety-nine to go after – the one who went into a far land and had to eat a lot of pig slop before the loving arms of Jesus took her back in. I think that the thing that impressed me most about Carol was the incredible desire God gave Carol to honor her parents.

I will never be the same because of my path crossing with Carol. She was an example to me of how God can change the angriest young person – of what God can do with someone who is available to Him – of the blessings that follow when a young person decides to honor the Lord and their parents in obedience, and of the compassion that God wants to pour through all of us to hurting people who don't seem to know that they are REALLY searching for the unconditional love of the Heavenly Father and a personal relationship with Jesus Christ.

There was another person who had a positive influence on Carol during this period. Glenda Lancaster was the guidance counsellor at Rugby. Carol wound up working with "Mama" Lancaster quite a bit. Glenda, in turn, saw Carol's potential and encouraged it to blossom. Of course, she did that with all the students at Rugby.

Carol Hooker came to me like a whirlwind one day during school and said, "This is what we need to do to get the drug prevention club going." I did a little double-take and sat down to listen. Carol had carefully thought through plans to promote the program and wanted to get started "immediately.

Carol always had a sense of urgency about her and her enthusiasm was catching. None of us could be slovenly while Carol was around, and eventually the dream of helping students stay drug-free began to take shape.

After bringing America's Pride drug prevention program to Henderson County, naming our club at Rugby Junior High was the first task.

Carol helped me put together a contest which got the entire school involved. She did all the leg work and finally the name "Rugby Against Alcohol & Drugs" (RAAD) was chosen. Carol became our spokesperson on radio, at community clubs, at schools, on TV and always when we had to request financial support each year from the County Commissioners. She could speak impromptu or write inspiring speeches that could literally move an audience to action. When she spoke at the PRIDE convention in Texas, many who hear her could not believe that she wrote the speech underline, without input from adults.

When PRIDE had a performing team, Carol was faithful to come each Saturday morning to practice. I was always amazed at how she was the catalyst to keep the group going - plus inspiring big fundraisers to pay our way to national conferences over the county.

Because of Carol's hard work and tenaciousness, the PRIDE drug prevention program has been the tool to touch many young lives and cause them to think twice before they give in to that first offer to use alcohol or other drugs.

Whatever Carol decided to do or accomplish, she plunged headlong into it and things got done. I could sit back and watch things happen after a planning meeting. Never before Carol came into my life or since have I met or worked with another person who could accomplish so much in such a small amount of time.

Carol had a deep abiding faith in God and was never afraid or inhibited to share it. The students at school knew where she stood and respected her for standing up for what she believed in. Only when we get to heaven will we begin to know how many lives were changed by Carol.

To make sure students in the future remember Carol and the work she helped start for the students of Henderson County, each year a member of PRIDE will be given the Carol Hooker Award who demonstrated

outstanding leadership in drug prevention and education.

Even while Carol struggled with her own problems, she was burdened with worries about the problems she saw others experiencing. Perhaps she recalled Tina Phillips' suicide, or perhaps she saw what alcohol and drug abuse were doing to her friends at Rugby and at Checkers. In any case, she talked with Mrs. Lancaster about her concerns. With Mrs. Lancaster's encouragement, she and Erin Smith, another Rugby student, decided to start a club whose focus was a stand against alcohol and drugs. They decided to call it RAAD, for Rugby Against Alcohol & Drugs. With Mrs. Lancaster's help, they chartered it under the auspices of the national America's Pride organization. America's Pride worked nationally for the same goals that RAAD worked for locally.

The October 21, 1989 Hendersonville Times-News ran an article about the fledgling organization. Here is an excerpt from that article:

> Carol Hooker, an eighth-grader at Rugby Junior High School says it makes her feel bad to go out on weekends and see fellow students "drinking and smoking."
> She says she feels the pressure to go along, to be part of the group. She says all teens do. She says it makes her feel bad.
> So, after her class gathered to watch President Bush's recent address to students on alcohol and drug abuse, Hooker decided to do something about it. "I just thought it would be nice to go to

school and not have to worry about drugs," Hooker said Friday.

She and a friend, Erin Smith, formed RAD - Rugby Against Drugs - a group of 32 students that meets regularly to set goals, plan drug-free activities and just talk and laugh like normal kids.

The students approached the Henderson County Commission and obtained funds to help them operate. They gathered other students and parents and planned a year's activities. They planned a budget and scheduled activities to raise the finances to meet that budget. It was an ambitious program, especially for a handful of junior high students, but they made it work. They held activities at Checkers for those who would come and hear their anti-drug pitch. They choreographed skits set to music which portrayed anti-drug themes. They spread the "gospel" of drug and alcohol avoidance around the Rugby campus. At the end of the year, they attended the national Pride conference in Orlando. Carol continued to lead activities in RAAD and America's Pride throughout her years at Rugby.

While I found Carol's rebellious period a handful, Elaine had fits with it. Temperamentally, Elaine and Carol were a lot alike. Each had a stubborn streak a mile wide, and a temper with a short fuse. Since both were on a school schedule, they spent a lot of time together in the afternoons following school dismissal. As a result, they clashed often.

Like most pre-teens and teenagers, Carol went through a period where everything her parents said or did was, by definition, wrong. If Elaine said the sky was blue,

Carol would disagree. I know Elaine's patience was tested during this period.

After about a year, or so, Carol found a couple of avenues to focus her abilities. The first was public speaking competitions and other extra-curricular school activities and the second was church youth activities. Through these, Carol eventually found some focus for her life and began to put her anger behind her.

During her second year at Rugby, Carol discovered that the Optimist Club organization sponsored an oratorical competition. Participants competed in a local competition first. Winners moved on to a district competition, those winners competed at the regional level, regional winners competed at the state level, and state winners competed nationally. Carol was intrigued.

The Hendersonville Optimist club's competition was one weekday evening at the Duke Power building. Each competitor was to speak for five minutes. Penalties were assessed if the speech was too short or too long. The judges also evaluated composure, clarity of speech, and content.

The three competitors were isolated so each could not hear the others' speeches. I accompanied Carol and sat in the small audience. Each competitor presented his or her speech, with Carol speaking last. Here is the text of her speech:

"THE DREAM IS ALIVE"

"In 1987 alone, over 500,000 teenagers and children were alcoholics. Over 12% of our population have used marijuana on a regular basis, and over 20

111

million people have tried cocaine
in the United States. There are
over 500,000 heroin addicts in
America today. The illegal drug
trade in this country brings in
over 80 million dollars yearly. We
can't even estimate the money
brought in world wide because of
the secrecy of their trade.

"65% of people in one car
accidents that result in death were
drunk when they crashed. One out
of every two Americans will be
involved in an alcohol or drug
related accident in their lifetime,
and one out of every two thousand
drunk drivers are caught. On an
average weekend night, 10% of the
drivers on the road are drunk. 80%
of alcohol related accidents occur
between 8:00 PM and 8:00 AM. Drugs
hurt economically. Money that we
could use on education, the
homeless, and other projects is
soaked up in the fight against
drugs.

"Drugs hurt us socially. We
are losing so many people to drugs.
People overdose on drugs, and drug
dealers and users are killed by
other people in the drug trade. We
are losing good police officers and
government officials to the battle
against drugs.

"But there is a positive side
to this issue. Non-users are
coming together to fight drugs.
Whether you know it or not, when we
say no to drugs, we join in the
battle against drugs.

"In large cities, people have formed hot lines, providing a number that a drug addict can call for counselling and help with his problem. Rap centers are also a tool in the drug war. Buildings are now being used to allow teenagers to come together and talk, listen to music, play games and have fun in a drug-free atmosphere.

"Many addicts are homeless, because so much of their money is spent on drugs, and they have no place to sleep. Crash pads are places where these homeless addicts can come to sleep, get a good meal, and receive counselling to help them kick their habit.

"What can we do?

"1. Educate - tell your friends that if they say yes to drugs, they can and will become addicted.

"2. Teach - Teach everyone how to say no. It's greatto be educated about thedanger of drug use, but if they don't know how to resist the peer pressure and say no, they probably won't be able to resist.

"3. Offer Alternatives - Show your friends that fun and drugs have no connection. Show them that you will have fun and you can have fun without drugs.

"4. Provide Help - If someone you know is on drugs, then provide

encouragement for them to become drug-free. Most of the time, they started on drugs to be accepted. Don't reject them because of their habit.

"5. Organize - Start a drug-free program in your area. If people see that you are going to make a stand against drugs, then they will stand with you.

"The change doesn't start twenty years from now, or ten years from now. It starts right now, with you! When you decide to make a difference, you start to win the fight against drugs."

While I could see Carol was nervous, she did well. I was not surprised when she won the competition. Carol was ecstatic.

Carol threw herself into preparing for the district competition. This was held at the Fletcher Fire Department building. Once again, there were three competitors. Carol's competition was somewhat more poised than the local competition had been. However, once again Carol won the day. She now moved on to the regional competition.

The West North Carolina regional competition was held at North Buncombe High School. This competition involved eight competitors, and all were good. Carol did a terrific job, speaking eloquently and forcefully. This time, however, she placed second. Since only the winner advanced to the state competition, her first foray into public speaking competition was at an end. She discovered that she could speak well in public, and that she enjoyed it. This

discovery opened a door for her to accomplish much during the remainder of her life.

Youth activities at church also provided an opportunity for Carol to focus her life. There were many such activities. In addition to youth trips during the summer and at Christmas, the youth piled into a bus each Wednesday evening and went to a secluded spot for intensive Bible study. Each fall, they travelled to Spruce Pine for a weekend retreat known as "Teen Valley Ranch". In February, a weekend was set aside for Disciple Now. During this weekend, college students or young adults met with groups divided by grade level. Brad Estes, an engineering student from Georgia Tech made an especially forceful impact on Carol.

Jim Pearce and the youth leaders found opportunities to talk to Carol and help her to "get her head on straight."

Perhaps the rebellion that pre-teens and teenagers go through results from a search for some direction in their lives. They need a goal, something - or Someone - to guide them. Those who don't find Him, are destined to struggle through a morass of confusion.

After a great deal of soul-searching, Carol decided that her original profession of faith at Carterville Baptist Church may not have been genuine. She decided to walk the aisle again at First Baptist and to undergo another baptism. It is possible that her original profession was not genuine. Perhaps she had made a decision based on what she thought we, her parents wanted for her, or because one of her friends had made a profession of faith and she copied her friend.

It is also possible that Carol's original profession of faith was genuine, and that she had merely backslidden during her

"rebellious" period. If that were the case, her second baptism served as a source of rededication of her life and highlighted a new commitment to Jesus Christ.

One thing is sure, this was a turning point in Carol's life. There were still times when Carol "acted out", demonstrating behavior reminiscent of her struggle with self-control. However, she did undergo an observable change. She began to focus more on prayer, Bible study, and developing a walk with God.

Carol had many friends during her junior high and high school years. One of her closest friends during this time was Kathy Barba, a dark-haired young lady from Fletcher. Carol spent many hours at the Barba's house, and Kathy spent many hours with us. Kathy wrote a letter of solace after Carol's death. Here is a portion of that letter:

> Carol was such a special woman. I didn't have the privilege of knowing Carol during her college years, but I did know her during our junior high and high school years. She had a love for life and a love for God that always left me awestruck and amazed. She touched my life, as she did with many people, and for that I am eternally thankful.
>
> It is because of Carol and her witness to me that I am now studying to be a minister. She gave me something no one can take away from me. And that is Jesus Christ and my relationship with Him.

Thank you for allowing her to be a part of my life. She has and always will be a bright, beautiful light in my heart. She truly was one of God's children.

As part of the youth program at FBC, Jim Pearce led each person to evaluate many factors in their lives and how God would play a part in it. For example, Carol worked on her role as a student and her role as a friend of her classmates. She resolved to be honest in her schoolwork. She also resolved to be supportive and encouraging of her friends.

Another area of life that Carol considered was her future as a wife and mother. Her study of God's word led her to decide that she should not participate in pre-marital sex. She decided that abstinence was the best kind of birth control long before the "True Love Waits" campaign became popular. She even wrote a letter to her future husband as a commitment that she made to God and to that future husband, whoever he might be. This is what she wrote:

To my future husband:

I think this is really odd writing a letter to you considering that I am only in the seventh grade and I have no clue who you are and I am not even old enough to date yet. But Jim said that this would be a good way to really think about how important it is that I save myself for marriage - so here goes.

I get kind of scared when I think about getting married and finding that person to spend the

rest of my life with. I guess I get scared because I do not want to screw this up. I want to be the perfect wife (whatever that is) and the perfect mom and I get scared to think that I cannot be perfect in either one. You should know that I do not expect you to be perfect. I guess I do not expect it because I know that it is impossible for either of us to be the perfect anything. All I really expect and want from you is that you love God first and then me. Everything else that I want is included in that one single wish. If you love God first I know you will respect me and love me as well as be gentle and all of the qualities I desire.

As for me, I want you to know that I will be giving you a gift that I have never given before. I will be giving you my virginity. I plan on saving myself for you and only you and I pray that you, wherever you are, are doing the same for me. Our wedding night will be so beautiful as I will be the most vulnerable to the man that I have committed my entire life to, you. This probably means that I will be scared that first night as well as unsure of what we are doing, but I think we can figure that part out together.

I also will be saving my heart for you. It is so easy to get caught up in relationships that hurt the heart. It is also really easy to take love for granted and use the words "I love you" too much

in too many relationships. I commit to you that I will not give my love away too much and damage my heart. I will be smart in my relationships from now on and make sure that when I give you my heart that it is not torn and bruised and calloused from years of abuse. A part of this commitment is that I will only say "I love you" to those that I really mean it to and I will only date those people who fit the standards that God and I have set. By setting my standards and by standing by those I know that I will protect myself from a lot of heartache.

The standards that I have set are the following:

He must love God and be in a growing relationship with Him.

He must be active in church and some sort of Bible study.

We must be friends first.

He must have a pretty good relationship with his mom.

My dad must approve of all guys I date.

We must pray together.

We, as a couple, will never go farther than kissing on any date, no matter how long we have been dating. If he cannot handle this or commit to this - we will not date.

All of the above are standards that I have set for myself in dating to protect my heart and virginity for you.

I am praying for you that you will remain strong until the day we

are married. I look forward to our
lives together and I will do what
I can to save us any future
heartache. I love you!!

> Sincerely,
> Your future wife

So, Carol entered her freshman year, her
last year at Rugby, with an eye toward her
future. While she still dealt with vestiges
of a rebellious spirit, she had turned the
corner and now worked from God's plan.

From the time she had taken up the sport
at Petal, Carol had enjoyed tennis and she
continued to improve in her skill. During
the '90-'91 school year West Henderson High
School added women's tennis as a new sport.
As a freshman, Carol was eligible to play on
the team even though she was still at Rugby
Junior High. She was enthusiastic about the
opportunity to add athletics to the many
activities she had on her agenda.

Jane Wood was West's new tennis coach.
Slender and athletic, Coach Wood had played
college tennis before coming to West as an
English teacher and coach. Coach Wood may
have had doubts about Carol's ability to
play, as large as Carol was, but she gave her
a chance.

It turned out Carol was surprisingly
nimble for her size. She also had two things
in her favor. She had a sizzling forehand
drive, and she didn't play "excuse me"
tennis, like some of the players did. When
someone hit a shot to her, she banged it
right back. By the time West's first game
arrived, she had established herself as one
of the two best players on the team.

During the season, Carol and Effie
Loukas battled for the number one seed on the

team. They liked each other and played off each other's competitive spirit, enabling each to develop a level of skill which they might not have reached otherwise. When all is said and done, I have to acknowledge that Effie was a little better than Carol and deserved the number one ranking she held most of the year.

West's first game was against A.C. Reynolds High School in Buncombe County. I left work early and picked Elaine up when school dismissed. We rushed to the Reynolds campus and settled into the bleachers, ready to root the Falcons on to victory.

The practice in high school tennis was to have the players call the lines, much as any two tennis players do when they play together on a Saturday afternoon. This was necessary because the schools couldn't afford to pay officials to call each of the nine matches (six singles, three doubles) that were played in a meet between two schools.

Carol was set to play against Reynolds number two seed. Shortly after the game started, Carol hit a forehand drive which bounced twice before the Reynolds player returned it. When Carol challenged the call, her opponent denied that it had bounced twice. I was incensed, and rushed toward the court. Fortunately Coach Wood intercepted me and convinced me to return to my seat. I have always been embarrassed to see parents lose control at their children's athletic events. Now I found myself behaving the same way. I returned to my seat, shame-faced, but I was still angry at the cheating that went on in Carol's match. Carol was also rattled by her opponent's behavior. She lost the match, and West lost the meet to Reynolds.

Fortunately, Carol's experience that day was the exception. For the most part, the

team's opponents were honest and friendly, and they enjoyed the season. At the end of the year, West had won 5 meets and lost 10. Not so bad for their inaugural season.

Carol continued to focus on her schoolwork at Rugby while playing tennis. She found the inspiration to excel at her schoolwork as well as athletics. She was admitted into the academically gifted program in math, and did well in that program.

Carol discovered the Future Homemaker's of America public speaking competition. It was called an illustrated talk, and required the participant to prepare visual aids to go along with her speech. Carol joined the FHA organization, and made plans to compete. She chose to speak on the importance of recycling. She prepared a poster which displayed the various recyclable items (paper, aluminum cans, plastic bottles, etc.). She arranged to speak to various groups in the county to hone her skills. I chauffeured her to the Henderson County Democrats meeting, and to the Tracy Grove Home Demonstration Club. She also spoke to a number of other organizations before the actual competition began.

Carol won the local competition and advanced on to the regional and then the state competition, qualifying at each level for advancement to the next level. Next came the national competition, to be held in Washington D.C. Carol was excited about travelling to our nation's capitol and competing there. Several other students from Rugby had also qualified in other categories, so Carol travelled with them and the teacher sponsors.

Shortly after she arrived at the hotel, Carol called me, sounding very upset. It seemed the hotel room had a mini-bar, stocked

with alcoholic beverages of various kinds. A couple of Carol's classmates planned to raid the mini-bar and drink the alcohol.

If they had, I knew they would get caught. The charges for items obtained from the mini-bar would show up on the bill, and they would have some explaining to do. But that would be after the fact, and Carol wanted to prevent them from drinking. I agreed with her approach. I suggested that she talk with the teachers and with the desk clerk at the hotel.

A short time later, Carol called back to tell me that the mini-bar items had been removed from the students' rooms. At first the desk clerk had pooh-poohed Carol's concerns, stating that it would do no harm for the students to get the alcohol. When Carol explained that she knew it was illegal to sell alcohol to minors in D.C. just as it was in North Carolina, and told the clerk that she was going to call the D.C. Police. She suggested he think about what explanation to give the police when she told them he had refused to remove the alcohol.

Faced with that prospect, the desk clerk removed the alcohol after all. The students who had planned to get the alcohol accused Carol of being a goody two-shoes. Carol knew that she had made a stand for the right thing. She had done what God had expected of her, and she was comfortable with that. So was I. I was proud that Carol had the courage to make a hard and unpopular decision when she had to.

The national FHA Hero competition allowed one competitor from each state. Each competitor received either a gold, silver or bronze medal. The gold medal went to those who had performed best, silver to those who were slightly below that level, and bronze to

the remainder of the competitors. Carol won a gold medal.

With that honor, Carol completed her tenure at Rugby Junior High School. She graduated in June 1991 and prepared to move to West Henderson High School that fall to begin her sophomore year. This should be interesting, I thought. Elaine and Carol at the same school. I wonder if it will survive?

WEST

Consider it pure joy, my brothers,
whenever you face trials of many
kinds, because you know that the
testing of your faith develops
perseverance. James 1:2-3

TRUSTING
I do not understand it
but I just keep trusting my Good
 Shepherd
because I know He will not lead me
anyplace He does not want me to follow.
 Alice Marquarde

Carol enrolled at West Henderson High
School in August 1991. West is large, with
an enrollment of 1000 students occupying a
sprawling campus atop a knoll east of Haywood
Road. It is 1/4 mile north of Rugby Junior
High School and a country mile above the
junior high lifestyle, at least to most new
West High students. Carol was no exception.
She thought she'd arrived at Shangri-La.

Carol discovered something that most
parents dream about for their kids. She
discovered that learning was fun. She
decided that her mind was her meal ticket,
and she resolved to make the best of it. She
tackled her studies with a vengeance. She
learned more than dates and formulas; she
learned philosophies, principles and
concepts. She learned more than what and
how; she learned why. After she learned her
assigned lesson, she picked her teachers
brains to learn more. To say we were proud
of her is an understatement.

Along with her studies, Carol stayed
active in church activities and athletics.
She attended church with us on Sundays and
Wednesdays. She participated in all the

125

youth activities the church offered. In November, she travelled to a "dude ranch" in Spruce Pine, where Jim Pearce led the FBC youth in "Teen Valley", a weekend of intense Bible Study and discipleship training. The following February, Carol participated in Disciple Now, a weekend retreat held at parents' homes, which also included Bible Study, prayer and discipling.

During the fall of '91, Carol played her second year of tennis. She and Effie Loukas again fought for the top spot. Carol fantasized about earning a college tennis scholarship. She was already worrying about financing her college education, and she thought tennis might be a way to do it. In fact, Carol wasn't quite that good. Plus, if Carol undertook the science preparation that would be required to enter medical school, she wouldn't have the time to practice and play college tennis. I'm sure Carol knew this, but there was no harm in dreaming.

Now that Carol had "graduated" from Rugby, she was no longer a member of RAAD; however, Glenda Lancaster enlisted her help as a student advisor. She continued to participate in RAAD meetings and fund-raisers, and to handle public relations appearances for the club. She also prepared to help the junior high students make the transition from junior high to high school without losing the commitment to be drug and alcohol free. Carol discovered that the temptations which assaulted high school students were much worse that those which targeted junior high students. High school students had more freedom and mobility, and thus more opportunities to fall prey to drugs, alcohol and those who hawked them.

During her years at Rugby, Carol attended a couple of national Pride

conventions. While there, she made an impression on the national leaders of the organization. As a result, she was invited to sit on a student panel at the 1992 Pride convention in Houston Texas. Each of the five students on the panel gave a brief speech to the ten thousand students and parents attending the convention. This was a tremendous honor! Here are some excerpts from that speech:

"Hi, my name is Carol Hooker. I am a sophomore at West Henderson High School, and I'm from Hendersonville NC.

"I'm not going to stand up here today and tell all of you the statistics and the facts that we've heard so many times. I'm not going to tell you how many teenagers are going to die today due to drug and alcohol problems. What I am going to tell you is what my heart would like to tell each and every one of you. The way that my heart feels about the conference, the war that I find myself in, and the way my heart feels about my friends who use drugs and alcohol.

"See, when I was 11, my best friend Tina was 13. And like many other kids we wanted to be accepted. Unfortunately for Tine, she would do anything to be accepted. As we grew up, she wanted to party with the high schoolers. She started going to parties and getting drunk. I didn't think much about it because I didn't know anything about drugs or alcohol. I only knew that Tina

was slowly committing suicide with alcohol. Soon, Tina had to have a drink just to get started in the morning. When she came in from school, to let loose, she would have another beer.

"Nobody saw her problem, because in our town, we weren't very educated about drugs or alcohol, and we didn't know what all was going on with her. It all ended on a Sunday afternoon when our pastor called my dad and said, 'Tom, your daughter's best friend committed suicide this afternoon.'

"I had to wake up to the fact that my best friend was killed by alcohol. That's what caused me to wage war on drugs and alcohol around my friends and my school.

"But it wasn't just alcohol that killed my friend. Part of the problem was alcohol, but part of the problem was ignorance. We didn't know about the dangers of alcohol, and we didn't see the danger signals of alcoholism in Tina's life.

"You see, we're all in the war, and we're all fighting ignorance. Each and every one of us has a specific role in this war.

"First, we have to start educating people. Teens will listen to us if we get in the classroom and say, 'I care about you.'

"We've got to stop saying, 'I want acceptance from my peers.' We have to start showing them the real way of life, which is being drug-

free because when they begin using drugs, they are committing suicide in a very slow and very painful way.

"Second, as teenagers, we've got to care about each other. So many times we teenagers tear each other down instead of building each other up. We've got to stop making fun of someone in class, because low self-esteem and the want of acceptance is what is causing people to use drugs nowadays. If we get out in our schools and tell these people, 'I love you, no matter what you do', then these people will decide they don't need drugs and alcohol, they need that love.

"The last youth role that we have to take is that we have to take care of each other. If one of your friends starts using drugs or alcohol, you have to risk making them mad at you. You've got to say, 'Look, you're messing up, and I want to help you.' We can't help everybody. We can point out their mistakes, and intercede for them, but it is their decision. But by caring about them, you can make a difference in their life, so we've got to start caring.

"Now for the adults who are here today. There is a very different role that you have for us. Whether or not I will admit it, most of the time there are a lot of adults I look up to. I see the lives they are living. I see how they handle struggles and

hardship and hurts. And I want, when I become an adult, to live my life the same way, because I see their inner strength.

"For you adults, we need positive role models in our lives. We need someone who will stand up and say, I'm going to be different. I am going to be the one who is going to stand up for you, and I'm going to help you. And, adults, we also need your encouragement. As sponsors or parents or friends, you need to encourage the young people around you. We are living in a very harsh world right now, where our friends are killing themselves, and we are hurting a lot because our friends may one day be in a coffin like my friend Tina was.

"So, now what do we do? We came to the conference, and we've been educated about the effects of drugs and alcohol. We've been educated about what we need to do. What happens when we leave here? You can leave what you've learned at the door of the conference center, and you can go home and make no difference at all in you home town.

"Or, you can take what you've learned, go back to your home town and tell others what you've learned about drugs and alcohol."

Carol encountered some perplexing difficulties in the spring of 1992. She began having difficulty with her respiratory system. She often became short of breath, and coughed and wheezed. Her family doctor

suspected an allergy problem and referred her to an allergy specialist.

The allergy specialist scheduled a battery of tests to determine if Carol was allergic to anything, and if so, what. Carol had to lie on her stomach on an examining table, while a nurse pricked her back with dozens of allergen specimens. When the doctor read the results, it seemed that Carol was allergic to practically everything! The doctor also administered a breathing test and discovered that Carol's lung capacity was diminished. He diagnosed a combination of allergy and asthma.

Of the fifteen million people who are afflicted with asthma, one third are under eighteen, the doctor explained. Generally, asthma is a respiratory ailment caused by an allergy "trigger". Something, we were never sure exactly what, caused an allergic reaction in Carol's immune system when she was exposed to it. In these cases, Carol's body generated histamines which caused her lungs to congest, resulting in the wheezing and shortness of breath. The bronchial tubes leading to Carol's lungs constricted, and Carol felt as if she were suffocating. Carol described the feeling as like trying to breathe through a straw.

The doctor prescribed several courses of action. First, Carol had to take allergy shots. These shots contained small portions of the things Carol was allergic to, and was designed to "desensitize" Carol, so her response to these allergic triggers would be less drastic. Secondly, Carol had to wear a mask to cut down on the amount of allergens she inhaled. The mask she wore looked a lot like a surgeons mask. While she did not wear it all the time, she wore it quite a bit during her sophomore year. The buildings at

West were being renovated, and there was a
lot of dust floating in the air around the
campus. While Carol hated wearing the mask,
she knew it was necessary. After about a
year or so, the doctor permitted Carol to
scale back on her use of the mask, much to
Carol's delight.

Mr. Joe Houdek, a janitor at West
Henderson High School, was new on the job at
West when the school renovation began. He
recalls how things were going then, and how
Carol impacted his life:

>I will never forget the mess
we faced at West Henderson High
School when the school was expanded
and renovated. We were told how
wonderful the school was going to
be when the construction was
completed, but what we faced each
day made that thought difficult or
impossible to imagine.

>I was a new custodian at the
school, and each day I faced a
terrible ordeal as I attempted to
sort through all of the
construction debris in an attempt
to make the school presentable for
the next day. Carol always seemed
be there encouraging everyone she
met although her allergies probably
made this ordeal worse for her than
anyone else. Carol seemed to
attract people to her like a
magnet. She would listen to their
problems and concerns, and she knew
just what to say to make their
situation better. She was a friend
to everyone, students and faculty
alike, and everyone seemed to seek

her wisdom that went "well beyond her years.

One day I was complaining about how terrible the construction was and I said that I really could not cope with the situation I was facing anymore. Carol said something that has remained with me and has motivated me to continue working at West for what has now become seven years. She said to me that I was the most important person in the school and that the school could not survive without me.

I will never forget the way Carol encouraged me and motivated me to get through those 'tuff times'. The construction debris is now gone and our school literally glistens and sparkles. West High has won each and every award that Henderson County has presented for school cleanliness and safety. Carol is part of the legacy of our school, and she has, in many ways, made it become what it is today. Everyone who met her was touched by her in some way and being touched by her has helped us become what we are today.

The house we had purchased used electric ceiling heat, which we found expensive and inefficient. In 1988, we installed a Buck stove in our fireplace and used it to heat the house. When Carol's respiratory trouble began, we feared that smoke and ash from the stove might also aggravate Carol's asthma, so in 1992 we switched to a heat pump.

Lastly, the doctor prescribed two bronchodilators for Carol to use. Also known as an inhaler, the bronchodilator is a "thingamabob" that Carol pressed to squirt a fine mist of medicine into her throat. She then inhaled deeply, drawing the mist into her lungs. This helped to keep her bronchial tubes dilated and reduce the suffocating sensation that came with the asthma attacks. Later, the doctor added a nebulizer to Carol's arsenal. This machine was about the size of a student's backpack, and had a clear plastic hose extending from it with a mask at the end. Carol placed a small amount of medicine in the nebulizer. When she turned it on, the machine produced a mist, which Carol inhaled through the mask. One nebulizer session lasted about ten minutes and also served to keep Carol's lungs functioning properly.

By the time tennis season rolled around in the fall of her junior year, Carol realized her lungs wouldn't allow her to compete anymore. She continued to whip her mom and dad regularly, but she just couldn't hold up to train and compete at the high school varsity level. Carol joined the Fellowship of Christian Athletes. She continued to serve with this club throughout her high school career, as her letterman status allowed her to. During her junior and senior years, she served as president of the FCA, leading the club in weekly Bible studies, leading in prayer at school athletic events, and maintaining a high profile in the community as a Christian athlete.

An annual event the Christian community sponsored was "See You at the Pole". On a specified day throughout the nation, students and teachers met at each school's flagpole for devotion and prayer. Carol looked

forward to this day as an opportunity to make a bold stand for Christ. As FCA president, she participated actively.

Carol also joined HOSA (Health Occupations Students of America) in her junior year, a program comprised of students planning for careers in a health related field. As a doctor "wannabe", Carol fit the bill. West also had a health occupations program which was offered to juniors and seniors. At the end of the two year program, participants who passed a qualifying examination were accredited as certified nurse's assistants (CNA's). That qualified them to work as nurse's assistants in hospitals, doctors' offices, or nursing homes. Many CNA's went on to obtain nurse's certifications, or like Carol studied to be doctors.

To help its members develop the skills to excel in their professions, HOSA sponsored competitions which extended from the local level to a national championship. "Researched Persuasive Speaking" was one category. Carol's love of public speaking made this an obvious choice for her. In this program, the contestant researched and wrote a paper on a given subject. At the competition, he or she presented the paper to the judges, then delivered a timed speech covering the material in the paper. The judges graded the competitor on the quality of the paper and the quality of the speech. Carol's first attempt in this category was in her junior year, and she finished second in the regional competition. A good effort for her first year, but not quite good enough to qualify for the state championship.

Carol was also invited to join the National Honor Society. This organization recognized students who exhibited leadership,

integrity and scholastic excellence. Carol was rightfully proud to be accorded such an honor. She was almost making straight A's (except for a B she got from that terrible AG Geometry teacher - Mrs. Hooker), and holding leadership positions in every organization she joined.

In fact, she went the extra mile to incorporate her studies and extracurricular activities into her spiritual world. When her science class studied a topic based on evolution, one assignment was to write a paper which included some of those teachings. Since her grade in class depended upon her accurate rendition of the subject material, Carol wrote the paper. At the end, however, she included an addendum explaining her belief in God's creation of the universe. In this way, Carol got the "A" she wanted, yet made her point that she did not accept the theory of evolution as a fact. Later the teacher and Carol discussed evolution versus creationism. Carol volunteered to debate her, but the teacher declined. She suspected that Carol was too well prepared, and didn't want to clash with her.

Part of Carol's work during her junior year included taking the SAT tests and planning her applications to the colleges and universities she considered for her college career. She did her usual thorough research in this area. A paramount consideration was the availability of scholarship money. Elaine and I had scrimped and saved to have some money available for Carol's college expenses. As we discussed our options, and evaluated the schools that Carol liked, we concluded that Carol would need scholarship help if she went to a private school. If not, a state university would be necessary for our budget to work.

136

Carol's choice for a state university was the University of North Carolina at Chapel Hill. It is an excellent school, as are all of North Carolina's state schools. Carol's reservations about UNC-CH were primarily based on the size of the classes, especially the survey and core classes she would have to take as a freshman and sophomore. UNC-CH is so large that these classes would have several hundred students in them. Carol had developed a love for the interaction between the student and teacher. While reading a book and listening to a lecture would help provide some knowledge, Carol knew that having a professor available for a one-on-one talk or a discussion in a small class would be so much more beneficial, especially for a knowledge-sponge like Carol. So she leaned toward smaller schools. She applied to Duke and Winston-Salem, but she didn't really expect to go there. She also applied to Covenant College in Chattanooga TN and to High Point University in High Point NC.

Seniors in the Health Occupations program are required to spend two hours a day working at the hospital in a nurse's assistant training program. In the spring of her junior year, she asked for a car, arguing that she would need one to get to the hospital in the morning and then to get from the hospital to school. We discussed our options at length, and finally agreed that Carol was right. She had gotten her license shortly after her sixteenth birthday, and was intent on expanding her horizons as all teenagers do.

Having a teenager with a driver's license is a mixed blessing. At first we restricted her driving to times when one of us was with her. As she demonstrated

responsibility behind the wheel, we allowed more freedom. Thus, the mixed blessing. During her childhood and early teen years, when Carol needed to go somewhere, Mom or Dad had to be the chauffeur. As most parents know, this can be a real time burden. Now that Carol was a driver, she didn't require help. Now Elaine and I could sit at home and bite our nails until Carol arrived safely. Carol was a responsible driver, however, and we learned not to worry (too much) when she was out on the road.

Now that we had agreed Carol needed a car, I began shopping for one. I decided the best course would be to look around on my own. When I found a car I thought was suitable, I planned to take Carol to see it and test drive it. I knew that Carol would fall in love with the first thing on four wheels. This would cause two problems. First, it might not be a safe and dependable car, and second it would be difficult to dicker with the salesman while Carol sat behind the wheel chanting, "Vroom!, Vroom!"

My method did have its drawbacks. Carol didn't know I was shopping (if she had, she would have insisted on coming along), so she thought I was stalling. Maybe, she feared, I planned to renege on my deal. So, she was getting angry at me.

Before things got too bad, I found what I was looking for. Sitton's Auto Sales had a 1987 Oldsmobile Calais which looked pretty good. It was "dusty rose" in color, front-wheel drive, and had an automatic transmission, air conditioner and a radio/tape player. I thought it might do. I didn't want Carol to wind up with a little sub-compact if we could help it. I preferred a mid-size car which would fare better if she got in an accident. I realized we might not

be able to afford what I wanted, but the Calais was within our price range. I took it to my mechanic who proclaimed it suitable, and I agreed on a price with the salesman. Now, all we needed was to have Carol vote yes.

At lunch, I talked with the salesman and arranged to have Carol test drive the car after school. When I got back to work, I called home and left a message on the answering machine directing Carol to go to Sitton's and look at the car. As I suspected, it was love at first sight. The deal was done, the car was purchased, and old Dad avoided the parental dog house once again.

Senior year in high school is a memorable experience for any person. Carol was no exception. She wasn't worried about graduating; her grades placed her near the top of her class. She devoted her time to winding up her high school career and preparing for college. She found her Health Occupations work at Pardee Hospital fruitful and rewarding. She continued excel in her other classes. She found AP calculus especially challenging. Ms. Linda Soble, her teacher, was a great motivator and a great encourager. Carol enjoyed her time in Ms. Soble's class and her hard work paid off. The scores she made at the end of the year allowed her to "test out" of her college math requirements. She got credit for six hours of college math without having to take the courses. She tested out of the college English requirements as well.

Carol developed a habit of writing letters to God to express what was in her heart. On August 15, 1993, she wrote such a letter:

Dear God,

Thank You so much for the ways You have been working in my life. You have really been teaching me how to reach out to people and how to really love other people by just truly loving myself. Thank You also for putting growing Christians in my life to encourage me to grow and challenge me to go deeper in my faith.

I will be honest and say that I am frustrated by some things. I am tired of having problems breathing. I want to be able to breathe normally all the time rather than struggling to breathe a lot. I am also ready to feel good physically again. I want You to teach me how to finally be patient and to wait on You to heal me and for me to learn how to lean wholly on You rather than on my own personal understanding of everything. I <u>need</u> to learn to be dependent upon You for <u>everything</u>. <u>Please</u> teach me how to do that. Please teach me to look only to You and no one else for joy, guidance, peace, love and all of the things You desire for me to have and tell others.

Thank You so much for what you have done, are doing, and will do in my life.

I love You!

In the fall of 1993, Carol complained of frequent stomach upsets and heartburn-like symptoms. She often felt bloated and gassy. Her family doctor referred her to Dr. Stamm,

a gastroenterologist, for an upper GI series. This test allows the doctor to examine the esophagus and stomach for problems. Dr. Stamm didn't find anything significant. He believed Carol might be starting an ulcer. He prescribed Tagamet, a strong prescription medication for ulcer treatment, and cautioned Carol about avoiding stress. The Tagamet seemed to help.

Most students arranged to have their senior portraits made by a photographer who came to the school. Carol decided she wanted to do things differently. She went to the Glamour Shots studio at the Asheville Mall and had her pictures made there. The afternoon was a wonderful experience for her. The studio provided a hairdresser and make-up artist who did a make-over for Carol. Then she spent a half-hour in a photo shoot. She changed into several clothing ensembles provided by the studio. First, she wore an evening gown, then she changed into a dressy blouse and pants, and lastly, she wore a Western style outfit - cowboy hat and all. She had a blast, and she loved the pictures, as did we. She gave one of the pictures to the yearbook staff for use in their publication.

Carol decided to compete in the Researched Persuasive Speaking contest with HOSA again, so she started work on her research paper. She chose as her topic "Health Care and the White House." The Western North Carolina regional competition was held at Southwest Community College at Sylva. When she returned from the trip, she proudly informed us she had been awarded first place, and had qualified for the state championship.

On our next trip to visit family in Mississippi, we detoured by way of Jackson,

Tennessee to allow Carol to visit the Union University campus. Union is a small Baptist college, well respected in West Tennessee and North Mississippi. It was so small it reminded Carol of a small community college or a large high school, except for the dorms. The classrooms were located in two large buildings with dorms flanking the classrooms. Since it is privately funded, the tuition is pretty high. Carol didn't expect to go there without scholarship help. After the visit, Carol decided Union wasn't the place for her. Which was just as well, they didn't offer much scholarship assistance.

HOSA's state competition was held in Greensboro NC during the first week of February. The competition ran during the week, with the awards ceremony on Friday night. High Point University notified Carol that prospective scholarship recipients would be interviewed on campus the next day. Carol travelled to Greensboro with the HOSA team and stayed with them in the Holiday Inn during the competition. Elaine and I travelled to High Point on Friday afternoon and checked into the hotel there. We then made the thirty minute trip to Greensboro to pick Carol up after the awards ceremony.

Carol greeted us with a big smile. She had won the state competition, and had qualified to compete in the national competition in Nashville in June. She was ecstatic. She, Becky Varnadore and the rest of the HOSA club would have to raise the funds to pay their way, however. That would be a big job, but it was "do-able". Carol rode with us to High Point, where she settled down for a good night's sleep. She needed to be rested and refreshed for her scholarship interviews the next day.

High Point University sponsors a program known as the Presidential Scholars program. Each year, two entering freshmen are awarded four year full-tuition scholarships for their work at High Point. Several others receive partial scholarships ranging from $2000.00 per year to half-tuition. The university brings all the candidates in to the campus on one Saturday for a battery of interviews and a "get-to-know-you" session. The university wants the students to feel good about the school as well as having the school feel good about the students.

Saturday dawned cold and icy. Elaine and I drove Carol to the campus. Carol was to go to the Millis Center for her regimen, while Elaine and I investigated the campus. When she got out of our van, however, she stepped on a patch of ice and slipped down. Fortunately, she wasn't hurt, but she did split the seam of her dress. Elaine had enough foresight to bring a needle and thread. The two of them found a restroom to make repairs, while I fretted outside. After the repairs, Carol attended an indoctrination session involving all the candidates, then each person was given a schedule for the day's activities. Each candidate participated in one panel interview in the morning. The panel consisted of two professors and one upperclassman from the Presidential Scholar program. This panel asked Carol questions about her college plans, her goals, and her commitment. Carol asked questions about life at the university. Carol then accompanied a High Point student on a campus tour. After lunch, provided by the university staff, Carol participated in another panel interview. The day ended with a "rap" session involving several candidates and several High Point students. The High

Point students talked about campus life and answered more questions from the candidates.

While this was going on, Elaine and I took a self-guided tour of the campus. High Point University is a small but stately school subsidized by the Methodist Church. The focal point of the campus is Robertson Hall, a tall, spired building in the center of the grounds. Fanning out in a semi-circle on each side of this building was the library, administration building, campus center, and the science building. Dormitories comprised a rank behind these buildings. Across a small glen was another dorm and the Millis Athletic Center. All in all, we liked the place. Carol did, too.

Carol thought she made a good impression on the interviewers. She wouldn't know the outcome for several weeks, but she was confident that she would get some kind of scholarship help. Even more importantly, she liked the students and professors she had met. She thought she would enjoy attending class and participating in school activities. High Point was still in the running.

A couple of weeks later, Carol made another scouting trip. This time she travelled alone. She had been invited to Covenant College in Chattanooga TN. Covenant is a Presbyterian college atop Lookout Mountain. The small campus has a beautiful view overlooking the Tennessee River and its surrounding valley. This invitation involved a series of scholarship interviews similar to the High Point University trip.

Carol called us when she arrived, to let us know she had made the trip safely. She would spend overnight in a dorm room with a couple of Covenant students. The next day she was scheduled to meet with the scholarship committee, which would be

conducting the interviews. She would spend the next night on campus, then travel back to Hendersonville the following day.

There was more in store for Carol than scholarship interviews. The next afternoon a storm front moved in, bringing snow and ice. It was a big storm, dumping its frozen cargo on the campus all night.

Carol called to report that, while the interviews went well, she was not as impressed with Covenant as with High Point. She told us that at High Point, she, the professors and the students "just clicked". That wasn't the case at Covenant. Unless something happened to change her mind, she wouldn't attend Covenant.

She also told us about the storm, and warned us that she probably wouldn't drive back tomorrow, not in the morning, at least. Elaine and I agreed. We certainly didn't want Carol driving down the side of a mountain on icy roads. As it turned out, Carol stayed three more days on the Covenant campus. It took that long for the ice and snow to melt enough to allow Carol to leave.

While Carol was cooling her heels in Chattanooga, she got a letter from High Point University. We called her to let her know about it, and she asked her Mom to open it. It was from Dr. Jacob Martinson, and it advised Carol that she had been awarded a full Presidential Scholarship to High Point University. It was valued at about $48,000.00! I think we could have heard Carol's cheer of delight without a phone. She was happy. Mom and Dad were very happy. Mom and Dad's bank account was very, very happy.

That settled it. The scholarship was what Carol needed to tip the decision-making scales in favor of High Point. She had been

145

praying that some door of opportunity would open to show her which way she should go, and she felt this was it. Carol was not much for "testing" God by asking for a sign, but she did ask God for guidance. Her relationship with God led her to believe that this was His answer. I agreed with her assessment, as did Elaine. Now, all we had to do was get Carol home.

Carol called before she left for the trip home. We asked her to call us again when she reached the bottom of Lookout Mountain. We believed that was the most dangerous stretch, and wanted to know once she had successfully traversed it. Carol agreed. Since we had driven to the top of Lookout Mountain a couple of times, I knew the descent took about fifteen minutes. A half-hour later Carol had not called, and we got worried. Ten minutes later, the phone rang. Carol was at the bottom of the mountain, and safe. She had driven extra slowly and carefully. we couldn't blame her for that.

We were right in thinking the mountainside descent would be the most dangerous part of the trip. The remainder of the trip was no piece of cake, however When she arrived home, Carol told us that she ran into another snow storm in Knoxville. She continued to drive carefully, and made it through. Getting that front wheel drive car had paid off.

Spring arrived, and the end of school approached. Like all seniors, Carol had to deal with the mixed emotions of joy over her graduation and the bittersweet sensations of saying goodbye to West and her classmates. The last few weeks of school were filled with accolades for Carol. In addition to the scholarship, she received the following

honors: DAR Good Citizenship Award; ABC Leadership Award, Health Occupations II Award; Fellowship of Christian Athletes Award; Rotary Club Leadership Award; West Henderson High School's Principal's Citizenship Award.

Grandma and Grandpa Hooker arrived for Carol's graduation, along with my sister, Pam Stephens, and her family. West traditionally holds its graduation ceremonies outside in the football stadium, weather permitting. If it rains, the ceremony is moved into the gymnasium. If that happened, only Elaine and I would be allowed to attend, since the gym wouldn't hold many people. Prayers by the families of graduates are an annual ritual, no doubt joined by the principal and faculty. I sure was praying. I hoped my parents and family would be able to attend. I didn't want them to have come all this way only to hear us describe the ceremony.

Our prayers paid off. The weather threatened, but the rain stayed away. Graduation was held in the football stadium. I am sure it was like hundreds of others taking place over the country that night, but this on was special to us. Our daughter was graduating! We were so proud.

Carol was scheduled to travel to Nashville the following week to compete in HOSA's national public speaking competition. The three of us usually took our vacation during this week, so we planned to make the trip with Carol and have that be our vacation. At the last minute Terry Parker, the operations supervisor in the Social Security office and my second in command, became ill. So I had to cancel my plans. The state HOSA organization was sending a bus to the session, and Becky Varnadore and Carol hitched a ride on the bus.

They stayed at the Opryland Hotel, one of the fanciest in Nashville. Carol enjoyed the trip, and presented her speech with her usual professional demeanor. When the final standings were announced, she had finished fourth. Not bad! Fourth in the nation!

Elaine and I were proud of her. We knew our job as parents was not over. We would always be Carol's parents, and would be available for advice and comfort. But we knew Carol was moving into a new stage of her life. She would live on her own at college. She would be independent of us, and we would rely on her wisdom and maturity, and on the guiding hand of the Holy Spirit. We believed Carol and the Holy Spirit would handle the job very well.

During the summer, Carol took a job as a CNA with Dr. Volk, an associate of the Hendersonville Pediatrics group. His office was located in Fletcher, about ten minutes from our house. Carol was made for the job. She got to work with kids. She was very proficient at performing such tasks as taking temperature, blood pressure, etc. on a child who didn't feel well. All the while she talked soothingly. If they were old enough, she involved them in a conversation to take their mind off their discomfort. The nurses at the office taught her to operate various machines in the office, and before summer was over, she was a dependable member of the office team. She arranged to work in the office over the holidays and summers as Dr. Volk needed her.

As the end of the summer neared, Carol and her dentist agreed that now would be a good time to have her wisdom teeth removed. It turned out Carol's mouth was a little to small for them. I teased Carol, telling her that I didn't understand. She had such a big

mouth, why didn't she have room for her wisdom teeth plus a bunch more? I made sure I was out of range of her right hook when I said that.

Carol had the dental surgery. After the surgery, her dentist gave her a pain killer to help with the discomfort. She was really knocked out.

The next day, Carol acted bizarre. She was disoriented, and on a couple of occasions, she seemed to black out, but her eyes were still open. This was a little too unusual for routine wisdom teeth extraction or for the pain reliever she had been given. We took her to her family doctor, who was concerned about the results of his examination. He referred her to a neurologist. He feared that those open-eyed black-out spells were petit mal seizures.

Dr. Taylor, with the Mountain Neurological Clinic, ran an electroencephalogram (EEG), a test to evaluate brainwave activity. The test was to be run at Pardee Hospital. Carol was apprehensive about the test. Obviously, the doctor was worried about something, or he would not have ordered the test. In order to rule out all possibilities, Dr. Taylor also referred her to a cardiologist to make sure that Carol's heart was not involved. The cardiologist, Dr. Goodman, had Carol wear a heart monitor for a week. She had EKG patches on her body, with wires running to a small monitor about the size of a Walkman portable tape player. This monitor was connected by radio (or cellular phone line) to the cardiologist's office, so he could monitor the output.

Marianna Dockery, the middle school youth minister, gave Carol a journal for

graduation. Her only entry was for July 10, 1994:

> July 10, 1994
> This is my first time to ever officially keep a journal, so I probably won't do really well. But that is OK. This is an extremely rough time in my life with a lot of things going haywire. I go on Friday to see Dr. Taylor, a neurologist, for a possible seizure disorder. OK, fun! To say that I am scared would be the understatement of the century. I don't think I have ever been so scared in all my life. I guess it is the thought of something being wrong with my brain - that is most definitely not cool! But anyway, I'll just have to wait and see. I also have a heart monitor which is a pain in the butt. I hope that the problem is a heart problem and not a brain one - I know that makes no real sense, but whoever said I make sense? Well, I will hopefully be back tomorrow.

Dr. Goodman ruled out a heart condition. Elaine and I accompanied Carol for the EEG to offer moral support. The nurse applied sensor pads to Carol's scalp. She had pads on her forehead, the base of her head, and on the top and sides. Carol then lay down on a bed while the nurse attached wires to the sensor pads. During the test, Carol had to lie quietly in a dark room while lights were flashed at different speeds and intensities.

When Carol finished, the nurse brought in a very young girl to receive the same test. Carol could tell that the girl was scared out of her wits. Carol sat by her bed and talked quietly and reassuringly to her while the nurse attached the pads and wires. She explained that she had just completed the EEG, and that it didn't hurt a bit. She also asked questions and encouraged the girl to talk about unrelated things. By the time the nurse was ready to begin the young girl's test, she was visibly more relaxed.

Carol was like that. Even though Carol had a lot on her mind, she still took time to offer comfort to someone in need.

Carol returned to Dr. Taylor's office a week after the EEG. Dr. Taylor explained that he had found a small anomaly on page five hundred and something of the thousand page EEG. This was enough to convince Dr. Taylor to diagnose epilepsy and prescribe anti-seizure medicine. It could have been worse, but it was bad enough.

The seizure medicine was Depakote. Standard procedure for epilepsy patients at the time was that they be suspended from driving until they had gone for six months without a seizure. Once this period was over, they were allowed to return to driving. I believe the current procedure specifies that the epilepsy patient has to go for a year without a seizure before they can resume driving.

Carol was not at all happy about that. She had looked forward to having the freedom to drive around High Point and the High Point University Campus once she entered school there. Instead, she wouldn't be allowed to do this. She would also be unable to drive to Dr. Volk's office for the rest of the summer. Since Elaine was out of school for

the summer, she was elected to chauffeur
Carol back and forth to work. We agreed to
drive Carol's car to the campus for her. She
would be allowed to have classmates drive her
around campus or town as needed. We made her
cross her heart and promise not to drive the
car herself. As far as we know, she did not.

FRESHMAN YEAR
HIGH POINT UNIVERSITY

Give thanks in all circumstances.
1 Thess. 5:18

"It is not enough to have a good
mind. The main thing is to use
it well."
 Rene Descartes

The middle of August arrived -- time for
Carol to go to college. She hadn't been
incapacitated by the asthma or epilepsy, so
she looked forward to starting her college
career. The asthma did slow her down
sometimes. She still had to use the
bronchodilators, and occasionally the
nebulizer, but on the whole, that wasn't a
significant drawback. Her only problem with
the epilepsy was that she wasn't allowed to
drive. She hadn't had any seizures, and the
Depakote seemed to have that problem under
control. She had to visit Dr. Taylor's
office when she was home on fall break or
holiday break, so he could run blood tests to
monitor her condition, but that wasn't a
problem either.

We were to move Carol to High Point on
a Saturday. We loaded her car and our van
down with her computer (I was a very generous
father. I gave her my old computer so I
could buy a new one). We also loaded a small
refrigerator and microwave, as well as
clothes, books, etc. The two vehicles were
loaded to the brim.

By leaving at about 6:00 AM, we made the
three hour drive easily, arriving at 9:00.
The campus teemed with other parents
delivering their freshman. Carol's dorm room
was set up for two students. There were two
beds (which could be stacked bunk-style,
although Carol and her roommate decided

against that), two desks and two closets. A bathroom intervened between Carol's room and the room next-door, to be shared by the occupants of both rooms. To my eyes, the room was little larger than a small closet. I didn't see how Carol would be able to pack all of her stuff in the room, much less that of her roommate.

Elaine and Carol searched for nooks and crannies to store stuff, while I unloaded the vehicles and brought the goods into the dorm. I have never seen anyone so adept at creative use of space as Elaine. She always packed the van when we went home at Christmas, or for any visit, finding tiny little crevices to put small items. We could almost move all of our household goods in the van! Well, I did say almost. Shoes and canned goods went under the bed. Books and folding clothes went in the corners of the closet, while hanging clothes went on the closet's hanging rail. Item by item was shoe-horned into a niche somewhere.

I got the job of connecting all the electrical and electronic hardware. The TV, refrigerator, microwave and computer all were wired and tested. Eventually, everything was done. There was even room for Carol's roommate's stuff! I was impressed.

It took us all day to unpack the vehicles and set up the room. As late afternoon approached, we wandered to the campus center to get our bearings and to check out the rest of the campus. I knew Carol would fit right in, but at the moment, she looked a little overwhelmed. Fortunately, wise souls on the High Point staff had planned a picnic style dinner in front of the campus center. We wandered through the line, stacking paper plates with chicken, potato salad and chips. By the time

we had finished dinner, Carol had connected with a couple of other freshman and had begun her network of friends.

Now all that remained was to say goodbye to Mom and Pop. After dinner, we wandered back to our van and stood around clumsily for a few minutes, not sure what to say or do. Eventually we each hugged Carol, and she hugged us. We gave goodbye kisses and final instructions. Elaine and I piled into the van and drove away, waving to Carol standing in the parking lot. The first half-hour of our drive home was in misty-eyed silence, as we fought against the tears that all parents must deal with on a day like this. No doubt Carol was having her own little cry back in her dorm room.

One of Carol's first friends on campus was Jamie Henton, a young freshman from Florida. Jamie remembers her first day at High Point this way:

> I do not think I could ever tell you what Carol meant to me and the High Point community. Carol was the first person (besides my roommate) that I met when I came to High Point. If it wasn't for her, I probably would not have come out of my room for a week. I was really homesick, but Carol managed to snap me out of it. Carol had a tremendous impact on my life. As for the HPU community, things will never be the same. Things changed dramatically (for the better) once Carol made her mark.

When Carol was attacked by a distraction such as homesickness or loneliness, she fought back by getting busy. This time was

no exception. She waded into her schoolwork and the responsibilities of campus life. As a Presidential Scholar, she was automatically enrolled in the school's honors program. In fact, one of the stipulations of retaining the scholarship each year was that she remain eligible for the honors program. Carol had no objection. One of her goals was to graduate with honors, so she would have pursued success in that program even without the scholarship.

Part of her participation in the honors program included joining the Odyssey Club. This organization consisted of members of High Point's honors program, and provided an avenue for them to apply their creativity and to cultivate friendships. The club participated in service projects, held social activities, and offered suggestions on how to improve campus life. The Odyssey Club held one seat on the Student Government Association legislative body. Carol was elected to fill that seat.

In addition, she was elected to represent the freshman class on the SGA council. That didn't give her two votes, but she had to wear two hats. She had to consider her responsibilities to both the freshmen and to the Odyssey Club when she voted on a measure. Actually, Carol held the opinion that what was best for the university was usually best for the two organizations she represented. In a sense, then, she represented the entire student body.

Early on, Carol impressed her classmates and professors as a level-headed mature young lady. She earned the respect of those with whom she worked.

Just as in high school, Carol probed beyond the surface of the subjects she studied. She involved her professors in

debates about the topics they taught. Since High Point University was affiliated with the Methodist Church, it was not surprising to find religion as one of the required courses for incoming freshman. Dr. Hal Warlick, the university chaplain, was Carol's instructor in this course.

Dr. Warlick was a little more liberal than this fundamentalist Baptist girl was accustomed to. She and Dr. Warlick talked long and hard about the subject that was near and dear to both their hearts. Once again, as in high school, when Carol had to write a paper, she reported what Dr. Warlick had taught, then added an addendum to state her own opinions. When the semester was over, neither had been swayed by the others arguments, but they were not enemies. Each was able to "agree to disagree" in areas where their convictions differed.

Carol's freshman year was not without its difficulties. Any freshman will tell you that life in a college dorm is a unique experience to those who have just left the safety of their parents home. Even though High Point was sponsored by a religious denomination, and even though alcohol was off limits on campus. Some students sneaked it in. Other students, free of curfew and the other restrictions of home, stayed up all night and played music or TV all night. This is nothing new to a dorm living situation, it was just new to Carol.

Carol was a night owl. She enjoyed staying up late and sleeping as late as she could in the morning. Late for her, however, was something like midnight. For some of her dorm mates, late was 3:00 or 4:00 AM. While Carol enjoyed the social atmosphere of dorm life, she knew her purpose for being there was to study and perform well in her classes,

so she tried to get a reasonable amount of sleep and a reasonable amount of study despite her neighbors' cacophony.

As cold weather began, Carol's respiratory problems worsened. She had to use her nebulizer frequently, and she ran a low-grade fever. Finally, she went to the emergency room at the hospital, where she was diagnosed with "walking pneumonia". She was given medication and sent back to her dorm with a warning to take it easy. She found a local doctor - Dr. Anthony Alexander - of the Piedmont Internal Medicine Clinic in Thomasville, located just outside High Point. Dr. Alexander became a trusted medical advisor during Carol's college career.

After a brief period of improvement, Carol's pneumonia recurred. This time she had to go into the hospital for four days. Carol was impressed by her classmates concern as they visited her hospital room with cards and warm get well wishes. The professors at High Point were also very understanding. Carol had established herself as a hard-working student, one who studied and learned her material. Therefore, they were willing to work with her, giving her some leeway in the deadlines on her assignments and papers. Carol came through as usual. She completed her work and finished the semester on the President's List, a spot she occupied during her entire college career.

The spring semester started in January 1995 with two events, one good and one bad. The good news was that Carol had completed her six months without a seizure, and was recertified to drive. Of course, Carol was elated at this news. She could now drive her own car. While she had enjoyed a good bit of mobility by allowing her classmates to drive her in her car, (this gave her car-less

classmates some mobility, too), she was still somewhat restricted because she'd had to accommodate the schedules of those who drove for her. She was careful to only choose responsible classmates for this job.

The bad news was that Carol had to make another trip to the hospital with pneumonia. Dr. Alexander was concerned about Carol's susceptibility to these respiratory infections. He decided to run some tests. At last he discovered a cause for Carol's illness, neutropenia.

Neutropenia is a blood disorder, and results in extreme vulnerability to infections, usually in the lungs, mouth, throat, sinuses and skin.

Blood consists of billions of cells. While there are many different types of blood cells, the most common are red cells and white cells. The red cells carry oxygen from the lungs to the rest of the body. The white cells work to protect the body from infections and from illnesses caused by invading bacteria and viruses. One of the three most common types of white blood cells are neutrophils, which combat bacteria in a person's body. Neutropenia occurs when a person has an insufficient number of neutrophils in his blood.

All of us are attacked by foreign cells all the time. We receive minor little cuts or scratches, which introduce bacteria into our bodies. We inhale all sorts of bacteria and viruses. We rub our eyes with contaminated fingers, etc. Most of the time, we don't get sick because our white blood cells, including our neutrophils ward off the danger by killing the foreign cells. When a person has too few neutrophils, his body is unable to fend off the invading cells. Since one of the points of invasion is through the

lungs, that person often gets pneumonia or some other type of respiratory ailment.

This was Carol's situation. We immediately wondered if there was any connection between the asthma problems that Carol had endured for the last three years and the neutropenia. Dr. Alexander considered that a possibility. However, he was unable to make a definite connection between the two. He said some people are born with neutropenia, some people can get the illness after a viral infection, or as the side effect of a drug. Many cancer patients who undergo chemotherapy have to deal with neutropenia, and in some cases, nobody knows what causes it.

Some people have chronic neutropenia, and have to deal with recurring episodes. There is a disease known as Cyclic Neutropenia, where the disease recurs once every twenty-one days. Fortunately, Carol did not have that kind of problem. Dr. Alexander prescribed a series of treatments, occurring over a period of about six weeks. These treatments, if successful, would build Carol's neutrophil count up to an acceptable level. I never heard Carol mention the type of medicine by name, but I believe Carol was receiving "granulocyte stimulating factors." In any case, at the end of the six week period, Carol's neutrophil count had climbed to an acceptable level. As long as Carol was a patient of Dr. Alexander's he continued to monitor her neutrophil count.

However, Carol's medical problems didn't go away. Later that spring, Carol complained of pain in her knee joint. On a couple of occasions, she fell without warning. At first I feared that these were epileptic seizures, despite what Carol said about knee pain.

Carol assured me these were not seizures. Dr. Taylor's monitoring of the chemical levels in her brain indicated everything was okay. Carol's most convincing argument was that she wasn't experiencing any of the symptoms of a seizure. Usually, when a seizure approaches, the person receives a sensory warning of some kind. He will notice an unexplained odor, or will see a colorful "aura" around things or people, or will have some other sensory signal. Carol had none of these. In addition, after a seizure, the person is disoriented for a few seconds to a few minutes. This didn't happen to Carol, either.

It seemed that Carol's knee was just collapsing without warning and for no explainable reason. Carol returned to Dr. Alexander. He ran some tests, and in the meantime, instructed Carol to walk with a cane to support her weak knee. To help her classmates overcome their discomfort at seeing Carol hobble around campus leaning on a cane, she gave the cane a name. When a friend approached, she would introduce "Ernie" to her friend and continue with whatever conversation had been underway.

Carol called us when the initial test results came back. She sounded worried. Dr. Alexander had narrowed the possibilities down to two -- leukemia or lupus. He would run another test the next day, an ANA test, which would rule out one of the diseases. When I asked if Dr. Alexander had an opinion about what the findings might be, Carol said he thought it was lupus.

Elaine and I were calm when we talked with Carol, reassuring her, as always that whatever the outcome, we could handle it with God's help. After the phone call, Elaine and I ate dinner, quietly discussing the news

that Carol had brought. Elaine suggested that I call the Sunday School class prayer chain to get everyone praying.

Our Sunday School class, like many at the church, had a prayer chain. When something occurred that required prayer, the person who needed the prayers would call the person at the top of the prayer chain. That person would call the second person, and so on until everyone in the class had been called. Bob Irwin, our teacher, was at the top of the chain.

I had been calm while talking to Carol, and I had been calm while talking to Elaine. When I called Bob, however, the dam broke. I cried like a baby. Poor Bob didn't know what I was trying to say, I was blubbering so. He waited patiently until I could get myself together. Then he listened as I told him of Carol's plight. The two of us prayed. Bob went on to call the rest of the class and get everyone involved in prayer for Carol and for our family.

Carol was to undergo a test for ANA cells. ANA (anti-nuclear antibodies) are present when lupus is active. Given the choice between leukemia and lupus, we agreed that lupus was the better option. If God saw fit to cleanse Carol of all illness, of course, we wouldn't object. Elaine and I fretted and prayed all day long. One hundred eighty five miles away, Carol fretted and prayed, too. I know that many of our Sunday School class members fretted and prayed right along with us.

Carol called the next night and told us that the test for the ANA cells was positive, she had lupus.

Systemic Lupus Erythematosus (lupus) is an autoimmune disease whose primary victims are women of child-bearing age. An

autoimmune disease is one which causes the body's immune system to turn against itself. The disease is very hard to diagnose because there is a wide range of symptoms, and the appearance of the symptoms may vary from one person to another. Some symptoms which occur are fatigue, arthritis, weight loss, rash (especially the "butterfly rash" across the cheeks and bridge of the nose), malaise, fever and sensitivity to light. The butterfly rash makes some people look as if they are wearing a mask - like a wolf's mask. That's what gave lupus its name.

The diagnosis of lupus is contingent on a positive ANA cell test and on the appearance of symptoms in at least two organ systems. Thus when Carol had trouble with her knee (which developed into arthritis), that coupled with the asthma/neutropenia/pneumonia in her pulmonary system, caused the doctor to suspect lupus, and the blood tests confirmed it.

No one knows exactly how or why some people get lupus. Some think it is hereditary. Carol's only relative with lupus is a great-aunt with discoid lupus. Others think it is caused by environmental factors. Still others think that some people have a genetic predisposition to lupus, hereditary in nature, and that the lupus is "turned on" by an environmental trigger such as a virus, an illness, stress or something like that. In any case, we are not sure why Carol wound up with lupus in addition to all of her other problems.

Lupus can affect a person's skin, joints, kidneys, nervous system or heart. If the disease invades the kidneys, nervous system or heart, it can be disabling or even fatal. When Carol's lupus was diagnosed, it was only in her joints.

About this time, Carol was feeling a little bit "picked on". At the age of eighteen, she was having to deal with asthma, epilepsy and lupus. Elaine, Carol and I tried to develop some spiritual understanding of why Carol was beset with so many physical maladies.

The first question that one usually asks when something like this happens is, "Why is God doing this to me?" We tend to think that God has undertaken some sinister torture, and that He is directly instigating our troubles.

We knew better than that, of course. God is not the originator of pain. While we don't understand why we have to undergo trials such as Carol's, we do understand that God loves us and doesn't want us to suffer such pain. We, humankind, do have to live with the consequences of our actions, however. Our conclusion was that disease, and the pain it causes, is a result of the irresponsible lifestyles that humankind has lived for centuries, and that God will not routinely spare us from the repercussions of those lifestyles. Sometimes, He does choose to miraculously heal someone, but we were not sure we had the right to claim that miraculous healing. We would have to accept it on God's terms.

Greek mythology tells of a person named Pandora, who was given the safekeeping of a mysterious box. She was told not to open the box or dire things would happen. Of course, she was unable to resist. Her curiosity got the better of her. She opened the lid and peeked in. When the lid opened, all the terrible afflictions of the world, which had been imprisoned in the box, escaped. Thus pain, illness, suffering, greed, and so on, was loosed on the world. So, that is how these things came to be.

Not really. I believe the Greek myth springs from the Biblical story of Adam and Eve. When the two original citizens of Earth succumbed to temptation and disobeyed God, they began the journey along the path which would be followed by billions of their descendants. As God promised in Genesis 3:16-19, our lives will be filled with pain, toil and trouble. Now we have to deal with the results of that sin.

We decided, then, that God didn't specifically choose Carol to bear all these problems. Because of His foreknowledge, He knew that these things would happen to her, but He also knew that Carol would use her hardships as a ministry for Him and a demonstration of His love. So, He allowed Carol to live with asthma, epilepsy and lupus. Romans 8:28 says, "All things work for the glory of God." Carol decided that her job was to find some way to glorify God in her distress. And that is what she did.

Dr. Alexander arranged for Carol to receive weekly shots of medication designed to relegate her "active" lupus to "inactive" status. In the meantime, Carol continued her schoolwork. She planned her day to allow for frequent rest periods. She tried to avoid stress as much as possible, and she made sure that she shared a message of God's love, even while she traversed the campus on crutches or with her cane, "Ernie".

Her witness paid off at the end of the school year. During the spring semester, Carol took her first sociology course. Her professor was not a Christian. Like many sociology professors, he held a humanistic point of view. That is, the "rightness" or "wrongness" of an act is relative, it is influenced by a person's situation at the time of the action. Therefore, a crime could

be "right" if the circumstances indicated it. He and Carol debated their differing points of view all semester. As usual, Carol wasn't belligerent in her arguments. She just presented her philosophy in a calm and loving manner. She emphasized that God was a God of love, but that He had to expect us to accept His Way, and none other.

The professor required each student to keep a journal during the semester, recording their impressions of the class discussion and the reading assignments. Here are Carol's entries for a couple of those days:

> January 12, 1995 - Class today was wonderful with free expression of feelings regarding the people and issues at hand. The ideas behind the naturalist perspective were quite interesting although I personally do not agree. I believe that there are some things that cannot be explained and these are called miracles. Unfortunately, I disagree with your statement that "Jesus never really walked on water." The reason I say unfortunately is because of those people who have been misinformed. Jesus has/had (both) the capability of doing such miracles and He did to prove that He was the Son of God. Miracles still occur today as the direct result of Jesus' still working today. Whether we choose to accept the fact that the grace and mercy of God is really unexplainable.
>
> I personally am still working on the idea of "I love you" being a power/control issue. What

happened to the idea of unconditional love that some of us still have for people? That kind of love is not one of power/control but rather love regardless of how you feel about me. That is still going on today and does not fit this theory/model.

February 28, 1995 - Class today included a discussion of deviance and how deviance changes our society. While you would argue that without deviance we would not have the means by which to judge our values and morals, I would disagree (not that the fact that I would disagree with you is odd or anything!). You probably know exactly what I will argue. There is a wonderful way to determine morals and values. In fact, you could say this is a guidebook by which all these morals and values are clearly defined. This guidebook is the wonderful Word of God - The Bible. When one chooses to open this book with open eyes, open ears, and an open heart, answers to moral questions, problems, questions, etc. can be found as the Master leads His child through life. I know you would disagree with me, but the purpose of this journal is for me to express my opinions and so I have.

At the end of the year, the professor invited Carol to lunch at a nice restaurant in town, and Carol drove them there in her car. The professor complimented Carol for her hard work during the year, in spite of

her illnesses, and for her persistence in "sticking to her guns" during their debate. Like many professors he enjoyed a good difference of opinion, intelligently argued. Carol thanked him, and assured him that she would continue to pray for him.

While driving Carol back to the campus, the professor suddenly asked Carol to pull her car over to the side of the street. "I want to accept Jesus as my Savior." He said tearfully.

Right there on the side of a High Point street, Carol and the professor prayed. He accepted Christ as his Savior. Now Carol knew why she had been given this burden of illnesses, and she now knew the afflictions were worth it.

Carol decided to devote the first half of her summer to working ahead on her degree. She enrolled in courses in sociology and political science at the University of North Carolina at Asheville. The UNCA courses would transfer to High Point University and would add six more hours of credit toward her degree.

She was still bedeviled by the lupus. Her knee gave her considerable pain, and she had to struggle to overcome fatigue and keep going. Dr. Alexander wanted her to use a wheelchair. He thought that would allow her to recuperate better than walking on crutches or on a cane. She borrowed a wheelchair from the church. She would store the wheelchair in the trunk of her car, drive to UNCA and wheel herself around campus. She also used the summer to help Marianna Dockery with the middle school youth at First Baptist.

For her first day of classes at UNCA, Carol chose a comfortable T-shirt with a Christian slogan on it. When she wheeled into her political science class, her

professor greeted her with a sneer. "You're not a Christian are you?" he asked.

"I sure am," Carol answered.

"Well, don't think you are going to save me. I don't want you witnessing to me or trying to 'save my soul'," he said. He went on to brag about how he smoked pot frequently, and how he did what he wanted, when he wanted.

Carol promised not to harass him with testimony or with a lot of Bible verses. That wasn't her style. She wouldn't impose herself on him if he didn't want to discuss his spiritual condition. She did promise him that she would pray for him. The professor responded that praying wouldn't do any good.

The next Monday, Carol rolled into the classroom, where the professor met her inside the door. "You've been praying for me haven't you?" he asked.

"Yes, I have," Carol responded.

"What did you pray for?"

"I prayed that the next time you smoked pot, you would get so sick you would never want to touch the stuff again," Carol said.

"It worked," the professor said. He explained that he had "toked" that weekend and had become so sick he couldn't even keep water on his stomach. While he was struggling to recover, he suddenly realized that his illness was the result of Carol's prayers. This realization meant he had to acknowledge that God existed and that He was powerful enough to evoke his illness.

After class Carol and the professor talked at length. Eventually, the professor admitted that he was lost, and asked Jesus to become his Savior. Almost overnight, his attitude changed. He disposed of his stash of pot, and he lost his antagonistic attitude. It would take a lot of maturing as

a Christian to get rid of all of his quirks, but now he had eternity to build his relationship with Jesus.

It is interesting to see how God's hand worked as the result of Carol's obedience to His guidance. As the summer progressed, the professor's wife accepted Jesus as her Savior. This, of course, was a direct result of the professor's conversion. I believe that the changes in those two lives also influenced other lives as well.

The dust hadn't settled yet. While Carol was in the political science class, she met a young woman who was involved in a Satanic coven in the Asheville area. She was very troubled. As Carol ministered to her during the summer, she came under the conviction of the Holy Spirit and eventually accepted Christ as her Savior. There were potential repercussions from her decision; however, she feared that some members of the coven might try to do her harm. In addition to praying for her well-being, Carol and the professor sought a place of refuge for this woman until her safety could be assured. Working with a pastor in Asheville, they secluded her in a safe place. They were confident that, after a short period of time, the danger would fade, and it did.

Elaine and I had wondered why Carol was so driven to attend school that summer, when she was already ahead of schedule on her degree (because of the advance credit she received in her math and English work). Now we realized that God required her to be in Asheville for these people who needed His salvation. That was reason enough for us.

I got bit by the poetry bug when Carol's nineteenth birthday arrived. My mother had written a poem or two, so I tried my hand at it:

ON CAROL'S 19TH BIRTHDAY

Some say evolution's predilection
Is the sublime point of view,
But there was no random selection
When God created you.

Clearly from the outset a miracle
 had begun.
A star, chosen from the nighttime
 sky,
It was a bright one, just the right
 one,
Became the twinkle in your eye.

A dollop of solar warmth
From the sun's central position,
Became the source of growth
For your sunny disposition.

Another physical characteristic
Beseeches our attention.
Its nature is mountainistic,
Its location we won't mention.

We must confess our analysis
Of the quality that defines you
Is the fount of love from Jesus'
 soul
That falls upon those around you.

God in His love has honored us
To be your parents, we say.
God bless you, watch you, and keep
 you,
Is the fervent prayer we pray.

Carol's exciting summer wasn't over.
One of the summer youth activities at FBC was
a project known as "Island Outreach." In
this program, high school and college

171

students and adults formed a team which travelled to a Caribbean island to minister to an underprivileged church and community there. While Carol had been in high school, Elaine and I were reluctant to allow Carol to make these trips. We knew that Carol was mature enough to handle the trip, but we weren't sure it was in God's will for her to go, at least not yet. We feared that she might look on the trip as a vacation rather than a ministry opportunity. Carol had been disappointed, but she accepted our will in this matter.

Now, as a college freshman, Carol approached us again about this ministry. The three of us discussed it, and prayed at length. We agreed that Carol should go. We believed that the time was now right. The Island Outreach team would travel to Sandy Point, a small village on the island of Abaco in the Bahamas about two hundred miles northeast of Miami.

The trip would last for two weeks, including the time required to travel by church bus to Miami and to fly to Abaco. The team headed south the last week of July. It included Jim Pearce, FBC's youth minister and team leader, and Charlie and Ann Clayton and their daughter Christina. The men on the team would complete some renovations on the church, and would be headed by Charlie. John and Cristy Giddens were also on the team. Cristy would head up the ladies' team, who would conduct a Bible school for the children in the community. Other team members were Tima Duncan, Vickie Sanders (aka Sugarmama) and her son Andrew, Barry and Debra Wilson and their children Lydia and B.J., Christopher Smith, Johnathon Woods, Pam Ward and Jason Rhodes.

When the team arrived in Miami, they boarded a "cloud-hopper", a small twin-engine seaplane, for the trip to Marsh Harbor, the largest city on Abaco. From there they travelled by bus to Sandy Point.

Sandy Point was a small, poverty stricken village located on a narrow strip of island at the north end of Abaco. The houses were old and poorly maintained, most were painted mint green. Fishing was the only source of income, and money was hard to come by. Hope was a word not frequently used there.

Seafood, of course, was a food staple. One of the most prolific dishes was conch. Eating conch was as common in Abaco as eating chicken is common in the rural south. It was served a variety of ways: Fried conch, baked conch, conch salad, etc. Unfortunately, Carol discovered she was not very fond of the dish. She had to adjust to this new delicacy while on the trip, as the other team members did, no doubt.

The team unloaded its gear into one of the houses near the church. They would sleep on the floors, using sleeping bags or inflatable mattresses. The men went to the church to assess their job. They decided to repair the roof, which was in very serious condition. They would also repair the small bell tower, and add a cross atop the structure, and they would repaint the fellowship hall and refinish the doors.

That night the exhausted team settled into bed for a good night's sleep. They quickly discovered that the house was possessed by roaches and insects large enough to star in a horror movie. When the lights were turned off, and everybody was quiet, they could hear the beasts scurrying around

along the walls and corners. They didn't sleep as soundly as they had hoped.

The next day, the team began its tasks. Over the next week, the men worked on their renovation, while the women led in Bible school. At first, the community was uncomfortable around the team, they had never seen so many white faces. By the end of the first week, everyone was friendly with each other and having a good time.

The team also spent a portion of each day in Bible Study, prayer and fellowship, sharing stories about their lives and about the blessings they were receiving on the mission trip. Carol talked a little about the trial that she was going through with lupus and her other physical problems. She told the team that God had given her a passage from the Bible to encourage her during her struggle: "All this I have spoken while still with you. But the Counselor, the Holy Spirit, whom the Father will send in my name, will teach you all things and will remind you of everything I have said to you. Peace I leave with you, My peace I give to you. I do not give to you as the world gives. Do not let your hearts be troubled, and do not be afraid." John 14:25-27 (NIV).

That Saturday, the team took a boat trip to a nearby inlet for a swimming party. Carol got too much sun, which was dangerous for her lupus, and it made her sick for a while.

While the team was doing its work, something else was going on in the Caribbean. A storm was building toward hurricane strength. Tropical storm Erin wended its way from the southeast toward the southern tip of Florida. Eventually, its wind speeds reached seventy-five miles per hour, hurricane strength. As hurricanes go, Erin was a small

one, but even small hurricanes pack a big punch.

Elaine and I, and no doubt the families and loved ones of the other team members, tracked the path of Erin closely. From all indications, it would pass south of Abaco. Sandy Point would get some wind and rain, but not much else.

This was not to be. At the last moment, Erin lurched northward, and Sandy Point found itself right in the bullseye. The center of Erin would pass directly through the village. In Hendersonville, everyone started some serious praying. In Sandy Point, the team moved its belongings into the church, storing them in the choir loft. The storm surge was expected to exceed ten feet. This meant the narrow strip of island would be flooded, including the floor of the church.

The island's many palm trees began waving in the ever-increasing breeze as Erin's first gentle caresses arrived. Gradually, the caresses became slaps. The palm trees whipped about in the wind. At the church, the windows rattled in their frames, and the doors trembled like palsied old men. The mission team huddled in the choir loft, praying and swapping stories. Each tried to encourage the other as they waited out the storm.

Erin grew stronger still. The doors flexed, struggling to break free of their hinges. The men bolstered them with furniture, hoping to help them outlast the storm.

After hours that seemed like days, the wind subsided. An eerie calmness settled over the island. The peril was only halfway over. Sandy Point was in the eye of the hurricane.

The team ventured outside into the mute landscape. Trees lay scattered over the terrain, their roots exposed, victims of the storm. Water stood in small ponds formed by the wind and rain, deserted by the leading edge of the tempest. A portion of the road had been washed away. Small boats lay stranded on the soil, washed there by the storm surge. It was bad, but it could have been worse.

Erin's first winds had struck from the southeast. When the storm's trailing edge arrived, the winds struck from the northwest. The team retreated to the church's choir loft again, huddling there as the storm again buffeted the island. After more hours that seemed like days, Erin left the island for good. The storm surge had not been as bad as predicted, and the interior of the church was not significantly harmed. The newly repaired roof had suffered fresh damage, but the men used the time they had left to repair the repairs.

At last, departure time arrived. The team was saddened at the thought of leaving their new friends, but looked forward to getting home and resting. As they prepared to depart, one of the teenage mothers asked Carol to take her daughter to the United States with her, and to raise her as her own.

This was a real sacrifice for the mother, but she made the request because she knew her daughter would have a better life in the U.S. It broke Carol's heart to tell her that she could not. Not only was it illegal, Carol was not equipped to become a surrogate mother. God had other plans for her.

The team flew back to Miami, and pointed their bus northward. When they arrived home, Carol crashed on her bed and slept for two days. The first week of August was over. It

was almost time to return to High Point University.

> For God did not give us a spirit of
> timidity, but a spirit of power, of
> love and of self-discipline. So do
> not be ashamed to testify about our
> Lord, or ashamed of me his
> prisoner. But join with me in
> suffering for the gospel by the
> power of God.
> 2 Timothy 1:7-8

ONE

> I am only one, but I am one.
> I cannot do everything, but I can
> do something.
> What I can do, I should do and,
> with the help of God, I will do!
> Everett Hale

As Carol's sophomore year began, she had
completed most of her core curriculum
courses. Since she planned to enter medical
school upon graduation from High Point, she
would also need to have completed the pre-med
curriculum. Her courses for the fall 1995
semester were a behavioral science practicum,
general biology, literature, physics, and two
sociology courses.

Carol's freshman dorm experiences
convinced her to try another tack during her
sophomore year. There was a small dorm, The
Annex, located in the center of the campus,
which housed about two dozen female students.
The Annex was designated a "quiet" dorm.
Therefore stringent rules were applied to
ensure that the high noise and activity
levels found in most dorms were avoided. The
residents of the Annex were generally serious
about their studies. Carol applied for
admission to the Annex, and was accepted.

She was assigned a small private room near the back door. The Annex was much quieter than the other dorms, and the residents were more mature than most of the other students.

Keith Corbitt was the upperclassman who served as Annex Advisor for Carol's dorm:

> I had the chance to know Carol as an Annex Advisor, Circle K member, SGA member, but more importantly as a **friend**. The four years I spent at High Point University were greatly enhanced during my sophomore year, the year I met Carol. We had a chance to work together on many community type projects; and I'll never forget the love and passion she put into everything she did. Especially when she was doing something for others. I will always consider Carol one of the nicest human beings I've ever met, and I'll always consider her my friend.

Carol had been taking medication for her active lupus for six months now. Dr. Alexander arranged for the lab at the Bowman-Gray School of Medicine in Winston-Salem to monitor the ANA level. Finally, in the fall of 1995, her ANA level fell to within the inactive range, and her condition was labelled "inactive". That meant she didn't have to take the weekly medication anymore. She still had to avoid excess sun exposure, rest frequently, and avoid stress. The first two she could do. The last item, I worried about. I feared that her health problems, along with the demands of college work and the way Carol pushed herself to achieve so

179

much would cause her stress level to be higher than it should. I could do nothing more than caution Carol to take care of herself, however. She had to do the rest. In reality, she did do a pretty good job of watching it most of the time.

Carol had been involved in the Baptist Student Union at High Point since her enrollment. During her sophomore year, she campaigned for and was elected to the post of Christian Growth Chairman for the State BSU. As I understand it, this is kind of like the position of outreach director in a Baptist church's Sunday School program, except it covered all the BSU organizations in the state. Carol worked with the State executive committee in helping the North Carolina BSU organization to operate, plus she worked with individual BSU chapters on various college campuses trying to improve participation and attendance in their programs. While Carol did help the programs accomplish quite a bit, she was disappointed by many groups who only wanted to pursue social activities without trying to improve its members' relationships with Christ. A couple of the State officers she worked with had only captured their positions in order to put an impressive title on their resume, and did not try to help the State organization achieve its goals. This disappointed Carol, as well. While most of those with whom she worked were serious about their task and their relationships with Christ, those who weren't were discouraging to her.

In November 1995, Carol attended Hendersonville First Baptist Church's Teen Valley retreat at Spruce Pine once again. She served as an unofficial counsellor, and shared her experiences with her health challenges with the participants. She used

this as an example of how to continue to praise God in spite of difficult times. On the last day of the retreat, Carol climbed on one of the buses for the trip back to Hendersonville. Once she arrived there, she planned to hop in her car and drive to High Point. It would be a long day.

As the bus wended down a curvy mountain road, its brakes failed. The driver struggled to maintain control of the bus. He was unable to stop at the intersection at the base of the mountain and the bus plunged across the road, coming to rest in the middle of a pasture.

Nobody was seriously injured, although there were a few bumps and scratches. Carol was riding in a seat near the front of the bus. When it jumped the ditch separating the road from the pasture, she was thrown forward, then hurled backward against the seat back. She was sore, but that was all, or so she thought. She didn't feel like driving to High Point, so Elaine drove Carol's car while I followed in the van. After depositing Carol at the dorm, Elaine and I returned to Hendersonville in our van.

Later that night, Carol called to tell us she had gone to the hospital emergency room with severe pain in her lower back. The ER doctor discovered that she had bruised kidneys. Since that is one of the susceptible areas for lupus, I feared the lupus would return and attack Carol's kidney's. If kidney failure occurred, she could die, or at least have to undergo dialysis. Fortunately, that didn't happen. Carol just had to take some medication for pain. After a few days rest, she was okay again. The church's insurance took care of the medical bills for this incident; we were grateful for that.

Carol searched for some type of ministry that would allow her to work with people undergoing crises. This was more than just an exercise in the application of her studies in sociology. She also wanted to make a difference in people's lives by sharing their concern and by providing some avenue of hope for them. Carol knew that avenue of hope would be God. She could only open the door, it would be up to the person in crisis and the Holy Spirit to use it. Carol chose the High Point Crisis Pregnancy Center as her place of ministry.

This was a Christian organization whose goal was twofold. First the center wanted to counsel women (usually unmarried, but not always) who found themselves in an unwanted pregnancy. Second, the center pursued an educational program to encourage young women (and men) to abstain from pre-marital or extra-marital sex.

Since Carol had undertaken a pledge to remain a virgin until she was married, she knew she could buy into the center's goals. She volunteered with the organization and completed their training program. Carol developed a counselling philosophy which was acceptable to the center. When she counselled a pregnant woman, Carol first encouraged her to carry the baby to term. She discussed the options available to the pregnant woman, including keeping the child once it was born, or giving it up for adoption. For teenage mothers-to-be, she encouraged telling the parents early, even volunteering to help the young mother break the news.

Some women, despite Carol's encouragement chose to have an abortion. Even though Carol knew this was the wrong choice, she decided not to abandon the young

mother who selected this option. Carol knew the woman would inevitably have emotional repercussions with which to deal, and if she did not condemn her and her choice, she might still have a chance to witness to the woman. A baby's life would be lost, and that broke Carol's heart, but she wanted to try to help salvage the woman's soul if she could. Some might criticize Carol's method as condoning the mother-to-be's choice to abort. I disagree. Carol did all she could to encourage the mother-to-be to carry the baby to term. If she chose to abort the baby, Carol knew that was a mistake; but everybody makes mistakes. When the woman caught in adultery (John 8:1-11) was brought to Jesus, He did not condemn her (although He certainly did not condone her actions), instead He acted to bring her to forgiveness. Carol attempted to follow Jesus' example. She tried to apply the WWJD principle, and in Carol's opinion, Jesus would try to use the woman's mistake to bring her to the foot of the cross.

The second area in which Carol at the Crisis Pregnancy Center was abstinence education. Carol developed a program for young women which was designed to show that abstinence was a viable option in today's world, and to encourage the young women to accept that option. Carol travelled to churches in the area, meeting with girls in youth groups and presenting her program. Basically, the program involved covering some Biblical principles of abstinence, then sitting down with the girls and just having a heart-to-heart talk with them, explaining that her own choice was to remain a virgin until she was married, and answering questions from the girls. This was an extremely successful program, because Carol's

approach was open and frank, and the girls were more willing to listen to another young person's beliefs, rather than a mom or some older woman.

Carol also presented this program to young women in schools. She had to modify her approach to make it seem less based on religion. Carol was able to make the same Biblical based points, only she didn't quote any scripture to make them. In the informal discussions, she always let it be known that she was a Christian, and her Christianity was the driving force behind her philosophy.

Most of the teachers and school administrators supported Carol's approach, and were pleased to have her present her program. Over time, Carol became an integral part of the Crisis Pregnancy Center's operation. The basis of Carol's success, of course was her ability to relate to the individual.

Some people are engineers; they build things. Civil engineers build roads and bridges. Electrical engineers build power systems and computers. Aeronautical engineers build airplanes and rockets. Carol was a personal engineer. She built relationships.

That's why she wanted to become a doctor. Some doctors are like biological engineers; they build methods to combat illness. They deal with patients only because they are hosts for illnesses. Their focus is on the illness, not the person. Carol didn't have that approach. She wanted to become a doctor not to fight an illness, but to heal a person. Her focus would have been to make the person whole, if it meant getting rid of the illness, that's what she would do. Carol's decision to major in sociology as an undergraduate was to allow her to address her sick patients' emotional

health while also addressing their physical health.

Carol's "personal engineering" skills were what made her so successful in her work at the Crisis Pregnancy Center, and in her witnessing to lost people. With the Holy Spirit's help, she could look inside a person's soul and see where they hurt. She didn't just witness to someone because that is what a Christian is supposed to do, she witnessed to them because she knew Jesus was the only One who could help their hurt. She didn't just minister to someone's needs because it was a "nice" thing to do, she ministered to them because she really wanted to help make them better. She wanted to see them fed if they were hungry, and she wanted to see their emotional suffering salved by the love of Jesus.

She was empathetic. When she talked to a woman who was in a crisis pregnancy, she was really able to imagine how she would feel if she were in the other person's shoes, and she was able to determine what words would help her fear, or what prayers would help her through today, so she could face tomorrow. No doubt this empathy was a drain on Carol's energy, but asking her to forego her work at the CPC would have been like asking her not to breathe. She just couldn't **NOT** do it.

When Carol enrolled at High Point, she joined a service sorority. Alpha Delta Theta was a Christian based sorority, whose role was to help women grow in Christian relationships and in relationships with each other, and to perform service tasks on the campus or in the community. Carol thought this was just what she needed. Her first year in the sorority went well, and she looked forward to continuing her participation. During her sophomore year;

however, the group adopted an activity that did not have Carol's approval, and it resulted in a breach which lasted the rest of her life.

As a service project, the sorority decided to promote avoidance of unwanted pregnancies by distributing condoms on campus. They felt that this was a Christian approach because it would reduce the number of unwanted pregnancies and thus the number of abortions. Carol disagreed. Carol believed that the distribution of condoms indicated that the sorority condoned pre-marital sex and/or extra-marital sex, and this was not what Christ wanted them to do. Carol believed the proper approach to reduce unwanted pregnancies and thus abortions was to promote abstinence. When she was unable to sway the majority of the sorority members, Carol renounced her membership. She was severely disheartened by the incident, and she never participated in the sorority again.

In addition to all of her health problems, Carol had bad luck in other areas, as well. Carol called and woke me early one Saturday morning, almost hysterical. It took me a few minutes to get her settled down and coherent. When she was able to talk to me, she told me that she had gone out to her car and found that someone had smashed into it during the night. The trunk and both rear quarter panels were bashed in. I told her to call the campus security force, and then to call the High Point Police Department. I wanted the police involved since sometimes the campus security folks didn't want to "cause trouble" by getting the local law enforcement agency involved. I also told her to get her camera and make pictures of the car from all angles, to document the damage. As it turned out, the campus security was

planning to call the police. That would have been necessary for insurance purposes anyway. The officer from the High Point Police took Carol's report. He told her that this would be treated as a hit-and-run, since the person had not reported the accident to the authorities and had left the scene. That is a felony. The person who hit Carol's car didn't know it, but he or she was in big trouble.

The police officer did his job thoroughly. By using pieces of broken tail light from the offending car, he determined that the car was a Jeep Wagoneer. If it happened to be a student who was living on campus, finding the car shouldn't be too much of a problem.

That was the case. The police found the Jeep in another parking lot on campus. The student who hit Carol's car had fought with his girl-friend and had floored his car while backing out of a parking space across the street. He rammed Carol's car, then in fear or anger, he just drove off without reporting it to anyone. Carol supposed he thought he wouldn't be found. He was charged with felony hit-and-run by the police. Apparently he had been involved in one or more accidents before, because his father asked Carol to allow him to repair her car without going through the insurance company. He wanted to do that to keep the insurance premium from going up or from having his insurance cancelled. Carol feared that she might run into trouble if the repair work was not done satisfactorily, so she insisted on having the insurance company involved. That was the right thing to do.

Carol didn't find out what happened to the student in court, but she did learn that he was expelled from school. She knew that

was bad news for the young man and his family, but she could only wish he had taken the responsibility for his mistake at the outset. While it would have cost him the money it took to repair Carol's car (which it did anyway), he would not have run into trouble with the law and with the school administration. Some people have to learn lessons the hard way. Carol was not unsympathetic to his plight, but she just wanted him to be responsible for his actions.

The incident wasn't over. The expelled student was in a fraternity. Some of his fraternity brothers decided Carol shouldn't be allowed to get away with getting their pal in trouble. They made harassing phone calls, trying to rattle her. It worked. Carol was disturbed by the calls at all hours of the day and night. She was unable to sleep. The calls weren't obscene, but they were threatening and abusive.

Carol was unsure what they wanted to accomplish. Their frat brother was gone, and the calls wouldn't bring him back. Perhaps they wanted to drive Carol from school, too. If so, they underestimated her. Carol refused to back down. She talked with the university officials. One night, Carol stayed with a friend while a female administrator stayed in Carol's room and documented the calls. The university identified the callers and expelled them from school, too.

Again, Carol regretted that they were punished, but she believed that they had brought the punishment upon themselves. If they hadn't harassed her, they wouldn't have been expelled.

Carol continued to have episodes with heartburn and upset stomach. The stress from her other health problems, compounded by the

stress from having her car wrecked and being harassed by the fraternity brothers led her doctor (and us) to believe the problems were just a side effect of the stress. The doctor described an disorder called GERD, gastroesophageal reflux disease, which causes symptoms like Carol described. In this disease, gastric fluid from the stomach creeps up into the lower esophagus. The acidic quality of the gastric fluid causes irritation, resulting in heartburn symptoms. This made a lot of sense to us. The doctor continued to prescribe medicine to ameliorate the symptoms.

Carol followed her usual practice of making her belief in Christ known in subtle ways, then allowing the Holy Spirit to use her as He saw fit. During the fall semester, another of her sociology professors came to know Christ as a result of her witness. Once again, the professor's conversion created other opportunities for the Holy Spirit to work. The professor had invited a guest speaker, a professor from nearby University of North Carolina at Greensboro, to discuss homosexual issues with Carol's class. Of course, the UNCG professor was gay. After the class, the sociology professor, the UNCG professor, and Carol went for a cup of coffee. Before long, their discussion turned to the issue of Christianity and homosexuality. Carol knew she was on the hot seat. If she condemned the homosexual professor's lifestyle, he would turn away and not hear the Holy Spirit's message. On the other hand, Carol would not lie and try to make the professor think that homosexuality was acceptable to God.

There is a proverb often quoted by Christians which says that God loves the

sinner but hates the sin. This is true, and always has been. Carol first explained how God, the Creator, loved His creation. That means everyone from Charles Manson to Hitler -- everyone. Carol went on to say that everyone was a sinner. Every person that God created has done something that is outside His will. Charles Manson's and Hitler's transgressions were obvious, but everyone else had sinned, too. Billy Graham had sinned. Carol had sinned. The UNCG professor had sinned. Carol then explained that God was a forgiver of sins. Carol, as a Christian, had been forgiven of her sins. She then described the process of repentance and salvation. At last Carol explained that God looked upon homosexuality as a sin, and that while God loved the professor, He didn't want homosexuality to be a part of his life.

Carol was very aware that God had made His children with a free will. She understood that not everyone would live the life that God wanted for them. She acknowledged that. If God weren't going to **make** them change their lifestyle, Carol had no business trying to make them change either. That doesn't mean that God or Carol approved, but that Carol realized the only person who could change is the person himself. Carol described this understanding in a letter she wrote to one of her friends (about some other mutual friends) at school:

> After you left I thought about you and some of the struggles you are feeling right now both with Kara and with Mark (as well as with other friends). I do not think that you are feeling this as much with Dawn because of her faith and desire to serve the Lord and her

apparent search to do the will of God.

It is so hard to see friends hurting and looking for an answer in the wrong places or seeing friends that you want to have a vibrant relationship with the Lord be content with less that what they could have. The frustration comes when you see the problem and they do not. It hurts so much to see them continue in their pain when there is so much more out there. BUT a very hard lesson to learn is that because we love someone, we must give them CHOICE.

This lesson was so hard for me to learn because I loved my friends so much and I wanted them to find an answer to their hurts so badly. But all I can ever do is stand at the edge of the cliff and warn them as they look over the edge. If they want to jump, really I cannot stop them and if I do I will hurt them more than help them. God does the same with us. He stands there and says, 'I love you and because I love you and want the best for you, I want you to have this eternal life. I do not want you to thirst anymore. All you have to do is to take this gift that I am holding out to you.' Now the gift is not ours until we take it into our hands from His. HE NEVER FORCES THE GIFT INTO OUR HANDS. He gives a choice because He loves us and love requires that sometimes we allow people to make a mistake if that is what they choose to do.

Standing back while someone walks over a cliff is the hardest and most awful thing to watch - in the same way watching someone make a choice that may not be the best thing is tremendously hard on the observer. You can see the rocky bottom - but if the jumper is not careful all they see are blue skies. No matter how much you tell them that there are rocks at the bottom, they will never realize this until one of two things happens: 1) they jump and hit the rocks, or 2) they stop and look down.

I have with this letter a book by Max Lucado - he is my favorite author. The chapter I want you to read is entitled 'The Choice'. We have to give people choices and the ability to make mistakes - then be there to help pick up the pieces and put them back together with the glue from God.

With our friends that are spiritually immature - all we can do is demonstrate by our lifestyle the difference that walking in the Lord makes. We can also encourage them to grow in the Lord - BUT because we love them we cannot force fertilizer and a growing faith. If we do the only plant will be that of resentment and a mask that says, 'Life is wonderful and my time with the Lord was incredible,' and then the heart is as dead as it started and the faith has gone nowhere - just the illusion of faith.

(The book that Carol referred to is <u>In the Eye of the Storm</u> by Max Lucado, copyright 1991 by Max Lucado. Published by Word Publishing.)

The UNCG professor did not completely reject Carol's witness. On the other hand, he did not immediately accept her witness and accept Jesus as his Savior. Over the remainder of the semester, Carol and he met and talked several times. By the end of the semester, the UNCG professor had asked Jesus into his heart.

Carol's spring semester courses included general biology, business computer applications, an elective course in education for learning disabled students, and physics. The beginning of the spring semester was surprisingly calm. Carol had no serious recurrences of any of her diseases. The epilepsy was under control. While she still had occasional bouts of heartburn, that was minor compared to what she had been through the last several years, and the asthma had subsided. The neutropenia was gone, and she hadn't had an episode of pneumonia in a year. We held our breath. The prospects of a healthy year were almost too good to be true.

I had fallen into the practice of making a new years resolution each year which stated, "This year all of Carol's health problems will vanish. This is going to be a good year." Of course, this resolution was coupled with a prayer, too. Elaine, Carol and I were beginning to hope this year's resolution might come to pass.

By the end of February, however, Carol noticed several discolored spots on her legs. She first believed these were moles. But they were irregular in shape and color. To be on the safe side, she went to Dr.

Alexander and asked him to take a look. Dr. Alexander didn't like the looks of the spots, either. Just to be safe, he cut them off and had them biopsied. When the test results came back, they were positive. Carol and Dr. Alexander were glad they caught the cancers early. There was no indication they had spread beyond the small tumors Dr. Alexander had excised.

At about the same time, Carol noticed that her joint pain was recurring and that she was having more trouble with fatigue. Another ANA level test confirmed that the lupus had come out of remission. Carol had to resume that medication, too. She had to pull "Ernie" - her cane out of retirement to help with her walking, since her knee joints were prone to collapse without warning. Elaine and I were disappointed but not surprised, and neither was Carol. Stress is a powerful factor in lupus, and Carol had undergone her share of stress during the past few months, what with the car accident, and the threats from the fraternity brothers. The lupus added another facet to its attack. In addition to attacking her joints, particularly her knees, the doctors also found some of the ANA cells which attack kidneys and the heart.

Carol decided to come home for the weekend to get some rest and some TLC from Mom and Dad. God had it planned that way. That was also the weekend for Disciple Now, and Carol had a chance to visit with some of her old buddies and get some TLC from them as well.

God had another plan for Carol's trip home. When Carol visited one of the Disciple Now sessions, Jim Pearce asked Carol to stand up and talk to the youth about her experiences during her trials. Carol hobbled

up to the microphone and shared her heart with the group, talking about the trials of her illnesses and of the episodes involving her car and the harassment from the frat brothers. She then went on to emphasize that God was still with her, giving her strength to deal with all these problems. She promised her listeners that God would stand by them through any tough times they might have, too.

Sal Oliveri was present that day. He was a professional musician whom Jim had asked to perform at Disciple Now. Sal was a Christian who used his music as a ministry for God. At one time, he was the keyboard player for Wayne Watson, a contemporary Christian singer. Later he moved to the same position for the Christian group 4Him. Sal remembers that day:

> Carol was an amazing young woman. Each time we spoke she always had something good to say, even though she was facing many difficulties. I'll never forget the last time I came to Hendersonville for a Disciple Now, back in February of '96. Carol shared her testimony in front of all the students. She stood there with such steadiness and assuredness of God's love for her. She was honest and admitted she didn't understand why her path was so difficult, but that God was faithful. The entire group, including myself, was brought to tears as we witnessed a child of God stand in the power of His might. I walked away from that time with something I will always

hold onto. Carol left a deposit of the Lord in people when she spoke to them. I can't even imagine all the lives she touched. What a reward she must be enjoying right now!

Carol's success as a public speaker convinced Dr. Jacob Martenson (Uncle Jake), HPU's president, to have Carol represent High Point University in a national contest at Harvard in April 1996. Dr. Martenson arranged for Carol to stay in a friend's condominium near the Harvard campus. Carol placed first in the competition, much to the chagrin of the Harvard competitors and their Ivy league cohorts. Carol's win earned $50,000 for High Point University, which was used for materials for the Sociology department and the library. Carol had repaid High Point the cost of her scholarship in one weekend.

Carol was exhausted from all that she'd had to deal with this year, but she was no quitter. She kept plugging. Even while taking medication for her lupus and dealing with everything else, she continued with her studies. When the semester was over, she had made straight A's. Her overall GPA for her first two years was 3.83.

Carol's degree requirement included an internship. She had to work a specified number of hours in a sociology related job. The university's purpose was to expose its students to the practical applications of their studies. The students could then see how the principles they were learning applied in the real world. This also helped the students make sure they were in the right field for their personality. Carol agreed with this concept. She would have loved to

take the summer off and rest after her hectic year, but she wanted to get that internship under her belt. She didn't want to wait until her last summer before graduation to get this done.

She first planned to work in a pediatrician's office in Hendersonville, studying the changes in the behavior of smoking adults when a new child was added to the family. This was to be a non-paying internship, but since she would be staying with us, her expenses would be minimal. She couldn't complete negotiations with the doctor, so her plan fell through.

She learned of a small church near Lexington, North Carolina which needed a summer youth worker. She called and talked with the pastor and with Dr. Ramke, her university advisor at High Point. Both agreed this would serve her university requirements well. The pastor, Steve Martin, also liked Carol's approach, and felt that she would meet the church's needs. Carol went for an interview with Brother Martin, and with the leadership of the church. The next Sunday, the church voted to hire Carol as their summer youth minister. So Carol began her summer working at Churchland Baptist Church.

Carol had always believed that an alternative to a career in medicine might be working with youth in a church environment. She wasn't sure if that was what God had in store for her. She really believed that medicine was God's calling, but this would be an opportunity to discover if she was cut out for church ministry. I know she had been positively influenced by Jim Pearce in this area. She also admired Marianna Dockery, who worked with the middle school youth at FBC. Elaine and I had our qualms about having

Carol work in a church ministry, but we accepted that if God called her, that was what Carol should do. We knew how difficult it would be for a woman career minister in a Baptist Church, but if anybody could do it, Carol could. We would just have to leave that up to Carol and God.

Churchland is a rural community located in the North Carolina Piedmont between Lexington and Salisbury NC. It still held its rural flavor, although many of its residents now worked in industrial jobs. One nice aspect was that this was a paying job. One of the church members, "Miss Idelia" Snyder, also offered Carol the use of a downstairs apartment in her house rent-free.

Steve Martin and Carol were kindred spirits. Each had a healthy sense of humor and a good work ethic. They hit it off right away. Carol moved most of her dorm furnishings to our home, taking only what she needed to function for the summer to Miss Idelia's apartment in Churchland.

Carol knocked out an ambitious summer program. She would have weekly sessions with the youth on Wednesday night, plus a generous number of field trips on weekends and weekdays. She planned a weekend retreat at one of the nearby lakes, using the lakehouse of one of the members. She planned a summer camp activity at Camp Caswell, a Baptist camp on the Atlantic coast. She also took the youth to a minor league baseball game. The Charlotte Knights planned a game for local church groups and staged a contemporary Christian music concert after the game.

On Sunday mornings, Carol delivered a ten minute children's sermon for the young children in the church. She called the young folks down to the front and talked with them about some religious topic, often using an

object lesson or visual demonstration to make her point. Brother Steve was impressed that Carol always checked with him to make sure her children's sermon topic coincided with his sermon topic for that Sunday.

Carol's forte, of course, was in relationship building. She knew that standing up before a church full of kids and talking was not what made a relationship real, not with her or with God. She had to sit down in one-on-one situations and get to know these young people. She had to find out what their dreams and hopes were, and what their fears and doubts were. Then she could help them to see how Jesus could bolster those dreams and hopes, and how He could allay those fears and doubts.

Carol made visits to the homes of each of the members of the youth group. She got to know them and their families. She was able to establish a rapport which helped her minister to the kids, and helped the kids grow in their relationship with God. One example was Mindy Allen, a high school student who came to admire Carol and whom Carol helped in her ministry.

Not all of Carol's efforts were successful. Throughout the summer she worked with one young boy whose home life was traumatic. He had turned to drugs and alcohol for solace. Carol tried to bring him around to the realization that he was destroying his life, and that his future was to continue the cycle of a devastating home life like that in which he had lived. He tried to break loose, but he just wasn't able to, and he wasn't strong enough to lean on God to help him. As a result, he rejected Carol's efforts to witness to him.

Late one night he called Carol and asked her to come and talk to him. She could tell

he was distressed. What she didn't know was that he was also high on drugs. When Carol met him, he attacked her, punching her in the stomach. Carol was not one to play possum. She fought back, breaking his nose with a strong right cross. Before the night was over, the boy had been arrested and placed in a juvenile facility. Later, he committed suicide by hoarding his medication and giving himself an overdose.

Ten years before, Carol's friend Tina had killed herself because of her enslavement to alcohol. Since that time, Carol had battled Satan for the lives of those who would succumb to the lure of drugs or alcohol. Sometimes Satan won.

With the visits that Carol was making, and with the various youth activities; Carol was on the go quite a bit more than she had been at school. She noticed that her right knee bothered her a lot more. She decided to go back to the doctor and let him examine it. He discovered a small malignant tumor behind her right knee. The doctor referred her to an oncologist, who scheduled a regimen of radiation therapy. Because of the pain and limited motion of her knee, Carol had to use crutches to get around. Despite these problems, she continued to perform her duties at Churchland. After six weeks of radiation, the tumor in Carol's knee disappeared. Carol still had difficulty maneuvering because of the lupus, and the damage it had done to her knee joints, but like the Energizer Bunny, she just kept on going.

JUNIOR YEAR
HIGH POINT UNIVERSITY

Dear Friends, do not be surprised at the painful trial you are suffering, as thought something strange were happening to you. But rejoice that you participate in the sufferings of Christ, so that you may be overjoyed when His glory is revealed.
1 Peter 4:12-13

Endurance is not just the ability to bear a hard thing, but to turn it into glory.
William Barclay

In August 1996, Carol registered for courses in Organic Chemistry, another Sociology Practicum, Self & Social Moral Decisions, International Relations, Research Writing in Sociology, and Social Stratifications.

Dr. Ramke was impressed with the work Carol had done at Churchland, and gave her a passing grade in the internship. A grade wasn't given for the internship, only a pass or fail. In fact, Carol did so well, the church asked her to continue as a part-time youth minister during the school year. Carol loved the kids at Churchland, and certainly enjoyed the income the job offered. She agreed to stay on. She bade farewell to Miss Idelia and her apartment and moved her belongings back to her dorm room. Her plan was to work and study at school during the week and to return to Churchland on the weekends. She would take care of any church planning and administrative work on Saturdays and participate in worship on Sundays.

When she settled into her dorm room at the Annex, she discovered a new friend. Hala

Qubein, the sister of Hania, had arrived from
Jordan to attend school at HPU. Hala was
young and in a foreign land. She was feeling
quite a bit overwhelmed. Carol stepped in to
help her get adjusted. Hala remembers
Carol's assistance:

When I first got to High
Point, I was really homesick, and
all I could ever think of was home.
When I finally tried to make a home
at HPU, I had a few problems,
mostly dealing with my roommate
then. On one particular night when
things were anything but smooth
between us I was sitting outside
the library praying and crying,
when I felt as if I were being led
to the Annex. I felt really odd
going to see Carol, as we were
still not very close friends then.
I was even wondering how I would
get into the dorm as I didn't know
her number either; but I found her
and Tracy outside, and I hung out
with them for a while, laughing and
joking and trying to teach them a
few words of Arabic. After Tracy
left, I asked Carol if I could talk
to her. We went inside and sat
down, and I told her how my
roommate and I weren't getting
along very well, and how she
wouldn't even tell me what is
wrong, she would just snap at me
out of no where, which really hurt
me. I also confided in her, one of
the first people in fact, of how
homesick I was, and how I didn't
want to tell my parents because I
thought they would be disappointed

in me. Carol comforted me, and prayed with me and cheered me up. I wasn't used to praying with people like that, not about personal matters, but I felt comfortable with Carol. The next day I was not as homesick, but I was a little down, when I walked back to my room and found a little "happy" from Carol with a smiley face with candy for teeth and hair and a little card with a verse on it. It really touched me, and I finally felt that I truly found a friend at HPU. I still have that happy, and I always remember it as the start of making HPU a new home for me.

A few weekends after that, Tracy, Carol and I went to Ridgecrest together. I also remember having dinner with the two (Elaine and me) of you that weekend. The retreat was awesome, and what was even greater was sharing it with Carol and Tracy. We really became good friends then, and spent most of the time laughing and joking around together. That too was really weird for me. I make good friends with people, but it takes me a very long time, as I am shy and don't open up to people quickly. With both of them, being friends just came naturally. That was also the time I found out Carol doesn't like taking pictures. I love taking pictures of my friends, and Carol wouldn't let me. So one night as we were both in bed, I waited till she was almost asleep,

and jumped down from my bunk bed and took a picture of her. She opened her eyes, and said "You should feel real lucky that I am too tired to get up and hurt you!!".

The next day she got me back, and took a picture of me napping, or just about to wake up.

The fondest memory I have, probably for very selfish reasons, was the surprise party Carol had for me. I had just moved out of my dorm room into the infirmary apartments, and although I loved the people I was going to live with, she knew I wasn't too comfortable about the move, as I was leaving most of my friends on the hall to live on the other side of campus. I was also very uncomfortable with the way things were left with me and my roommate, as that was one of the first times my friendship was rejected, and probably the first time that I ever hated anyone. Thank God, I am over my hatred now, many thanks to Carol and the rest of my friends. But Carol knew I was unhappy and planned a surprise party for me. She invited most of my friends, brought cake, soda, plates and stuff and just showed up at my apartment. All I could do was cry. I was so touched that someone would care so much, and I knew then that friends like Carol don't come along everyday. Carol was always there for me. She was a very good friend, someone I could confide in, someone

who cheered me up and encouraged me greatly, and a wonderful example. I really do consider her as a big sister in Christ, and I learned so much from her and from her life and Christian example. These are but a few memories of Carol that I have, memories that I will always cherish.

She also discovered another new friend. Carol had tossed around the idea of starting a Campus Crusade for Christ group at High Point. She called the Campus Crusade headquarters in Florida, and was surprised to discover that another HPU student had been in touch with them. Ben Rooke is a gangly redheaded Tom Sawyer type from Atlanta. He has a ready smile and a warm relationship with Christ. He had contacted Campus Crusade with the same intentions as Carol. Their CCC contact introduced them to each other, and the two planned their assault on the campus. Since Ben was a freshman, he didn't have a lot of contacts. His outgoing personality helped overcome that problem quickly. Carol already had a cadre of Christians who had been involved in Bible study and accountability groups for some time. Using those friends, they established a core group from which the inaugural CCC organization sprang.

Carol also continued to be an active member of the local Baptist Student Union chapter. With all of her activities as youth minister at Churchland and with her responsibilities with the new Campus Crusade group, she decided not to hold an office during her junior year. She knew she would have her hands full with organic chemistry, along with the extracurricular activities to

which she was already committed. However,
she did participate with the BSU students in
the presentation of programs at local
churches. One of the things they did was
called a "Sermon on the Wall", where each
participant posted a Bible verse on the wall
in representation of how that verse had
affected his or her life.

The Crisis Pregnancy Center continued to
play a big part in Carol's activities. She
continued counselling young women in crisis
pregnancies, and she continued to speak to
groups of young people about the importance
of abstinence. Her abstinence program was in
demand in the High Point area, because Carol
was so well received by the young people to
whom she spoke.

During the fall of 1996, the doctors
were able to get Carol's lupus under control
again, declaring it in remission once more;
however, the lupus had done some damage.
Carol's knees were giving her fits. At Dr.
Alexander's recommendation, Carol went to an
orthopedic specialist at Bowman-Gray
Hospital. After running a battery of tests,
the doctor diagnosed a disease called
chondromalacia patella. This is a softening
of the bone and cartilage which makes up the
kneecap, resulting in severe pain and limited
mobility. The doctor recommended
arthroscopic surgery, which would involve
scraping away some of the soft cartilage to
allow proper mobility of the joint. Carol
planned the surgery to coincide with her
Thanksgiving holiday. That way she would
have several days to recover before she
returned to school.

The surgery was to be done on Tuesday,
the last day of classes. Tracy Snellbaker,
one of Carol's friends drove her to Bowman-
Gray from High Point while I drove there from

Hendersonville. I was in our GMC Safari van, and I had taken the back seats out so Carol could lie down on the drive home. The surgery was uneventful; everything went according to plan. Carol felt pretty groggy from the anesthetic, and she slept most of the way home.

At home, Elaine took Carol's inflatable air mattress and put it on the living room floor. From there, Carol could watch TV and be with the family during the evening hours. At night, she could sleep there and wouldn't have to traverse the stairs to get down to her bedroom. If she had any problems, we were nearby and could help her in seconds.

By the following Monday, Carol was able to get around with the aid of crutches, and she returned to school. After a couple of weeks, her knee was healed enough to begin physical therapy. She had to go through a strenuous series of exercises to restore her knee to full mobility. Carol attacked this task with the same verve with which she attacked every other obstacle. When she reported for her first follow-up exam, the orthopedist cancelled the remaining physical therapy sessions because Carol had worked her knee joint back to normal faster than expected.

By Thanksgiving, Carol realized she wasn't up to the demands of schoolwork and the demands of the part-time job at Churchland, too. She had also begun a study course to prepare her for the MCAT (Medical College Aptitude Test) which she would take in April. She knew her primary objective was to finish her degree work and prepare for med school, so she reached the difficult decision to give up her job at Churchland. She hated the thought of leaving "her kids", but she knew it was best all around. She promised to

207

visit occasionally, so they could keep in touch.

One thing Carol had wanted to discover from her work at Churchland was whether God might have a career in youth ministry planned for her. After her stint there, she realized this was not the future for her. Like most youth, and adults for that matter, Carol had only seen the glamorous side of the ministry work. She had only seen the popularity of the minister, and the "public relations" part of the job. She hadn't had a chance to get a look at the background work that went into the ministry. She learned about all the planning and paperwork that a minister had to do. She learned about the work that was involved in locating volunteers to chaperon youth functions and to assist in the routine operation of a youth ministry. As Brother Steve Martin acknowledged, Carol was excellent at these duties, but Carol realized that she was not destined to do this work for a lifetime. She decided that once she finished her medical training and began her career, she would become an adult volunteer in her home church, wherever that might be, but she shelved her thoughts of choosing the ministry as a career.

Christmas came and went, and a new semester arrived. Carol enrolled in Immunology, Organic Chemistry, U.S. & East Asia, Research Applications in Sociology, and Justice, Crime & Ethics for her spring semester courses.

My new year's resolution and prayer, as it had been for the last several years was that Carol's health would improve, and that she would at last be able to enjoy life without having to worry about all sorts of physical ailments. Alas, that was not to be the case in 1997, either.

Carol continued to have trouble with her knee joints. The knee that had the operation was better, but we now discovered the other knee would require the same operation. Carol scheduled the operation for spring break, so she wouldn't miss any class time. We repeated the routine of the outpatient surgery, the trip back home with Carol staying on the inflatable mattress in the living room. This time Elaine accompanied us. Also, the doctor used another type of anesthetic which left Carol more alert after the surgery. There was a drawback, however. The pain from the surgery hit her sooner. It was a good thing Elaine was with us on the trip home. She was able to comfort Carol while I drove. When Carol returned to school, she resumed the physical therapy, only this time on the other knee; and yet, she still made straight A's in her classes.

Carol continued to prepare for application to medical school. She studied for the MCAT test and completed the application paperwork. There is a system that most of the medical schools use which allows the med school applicant to send in one application, then the central clearing house (called MCAS) sends the applications to the schools specified by the applicant. That saves a lot of elbow grease. Carol appreciated that. A requirement in the application process is an essay about why the applicant wants to be a doctor. Carol wrote a moving essay:

Amanda Carol Hooker
Personal Essay

There are places in the human heart which do not yet exist and yet into them enters suffering that

they might have existence" Leon
Bloy. I quoted this morsel of
thought because of the significance
that it has to me and my life. To
be completely honest I cannot even
begin to tell you all of the
unusual circumstances and items
that have made me into who I am
today. I can say though that there
are few places that do not yet
exist in my heart and for that I
know I am a better person and I
believe I will be a better doctor.

As you look at my application
and see all of my background
information, I am sure the question
is lurking as to why I would choose
to major in sociology if I desire
to become a doctor. The reason is
founded in experiences as well as
personal belief. Physical illness
is so much more than just physical.
Unfortunately in the cases of many
patients there are aspects of that
person that demand attention
through physical manifestations of
diseases and symptoms. It is for
this reason that I wanted a
background in behavioral sciences
to help me understand more than
just the biological facet of
patients.

I personally have had all too
many experiences with doctors. The
ones that I remember and cherish
the most are the ones that treated
the physical symptom as well as
helped me deal with the emotional
and mental aspect and hardship of
being sick and being young. To be
honest, we still have no clue as to

what disease or pathology caused me to be so sick for so many years. My senior year of high school was tough to enjoy as I had to spend time on a nebulizer every other hour. Even as I was getting my CNA certification at the hospital, I would have to take breaks to go and get some medicine to help me breathe. We were pretty sure that I had a severe form of asthma, but as to what caused it or when it was going to improve we were all at a loss. Through college I have had bouts with several problems and even more tests done to find what is wrong. I have spent weeks in a wheelchair due to severe pain in my legs, pneumonia on several occasions, seizures, asthma attacks, physical therapy, knee surgery, and other procedures either for diagnosing purposes or to correct a problem. All along the way, due to my faith, I kept fighting and hanging in until the time where I am finally healthy.

I do not tell you all of this to make you feel sorry for me. I have never asked for nor desired any pity for all I have been through. I have also never asked for a special break or advantage because I have had such a hard time. I do tell you this because all of those things have made me into who I am.

I am an independent and strong young lady. More importantly I am a hard worker determined to show the world what I can do. I desire

to be a doctor because I know what a tremendous impact a physician can have on a patient. Unfortunately this tends to be a negative impact but I desire to be a positive influence.

Words cannot express the fear a person feels when they lose control of their body. It is true that really we do not have conscious control over the functions of our body, but yet we each feel that we do own some sort of control. When a person wakes up in the morning with a fever, a rash, a virus, a pain or the like a fear grips that person as the idea of the worst strikes. What if it is cancer? What if it is lupus? Arthritis? Pneumonia? Everything that has been normal changes as the primary focus becomes finding out what is wrong and fixing the problem. So they go to the doctor.

As they describe the symptoms, everything the doctor does and says is read as some sort of a message by the patient. Typically the doctor will explain that some tests are going to be done. Regardless of what the test is, it sounds so intimidating at that moment. The person at that point in time is looking for some sort of reassurance and consolation. We tend to agree that when the diagnosis is cancer that the doctor should appear sympathetic and supportive. Due to what I know, the doctor should show those signs way before the diagnosis.

Carol arranged to take the MCAT in April. Since the test was given on a Saturday, Carol elected to take the test at UNCA rather than at Bowman-Gray. She decided she would be able to rest more easily if she came home after the test. She wouldn't have to worry about preparing dinner, or other such chores. She also knew that Mom and Dad would be waiting with some encouragement after the nerve-jangling day. Carol was "psyched up" for the test. She had spent months preparing for this day. One drawback may have been that she had invested so much into this effort that she feared what would happen if she didn't succeed.

Elaine and I delivered Carol to the UNCA campus and gave her good luck hugs. We then went shopping in Asheville, returning at the end of the day when the test had been completed. We were amazed at the glassy eyed looks on the students who emerged from the testing room. Clearly, this had been a difficult test. Carol looked somewhat more composed than the others when she came out, but she did look like she had been in a fight with a dragon. She was worn out. On the drive home, Carol talked about the test. It was tough, but she knew she had given it her best effort, and she was comfortable with that.

The following month brought the end of school for another year. The juniors with the highest GPA's were selected to serve as junior marshals for the graduation ceremonies. Carol was pleased to be accorded the honor. The female junior marshals had to wear white dresses, so Elaine and Carol went shopping for one. They were surprised at how difficult it was to find a suitable white dress. Eventually, they succeeded.

The end of the school year also brought the annual awards day. Carol was delighted to be accorded the outstanding sociology student award. She was also inducted into the Order of the Lighted Lamp, one of the highest scholastic honorary organizations at the university. Membership in this organization required excellent grades, leadership, and citizenship skills. She was reaping the harvest for all the hard work she had put in during her lifetime.

Carol's early work on her internship now paid off. She had a summer with no pressing commitments. She could rest and try to get her body back in working order. She wisely chose to rest, take an easy vacation with Elaine and me, and "chill" for the summer months.

We travelled to Mississippi on a blistering June Friday to visit our old friends at Petal and Hattiesburg. We decided a little nostalgia was just the thing for our vacation this year. One of our plans was to visit a couple of our favorite restaurants from our Petal days. Our first visit was to Cuco's, a Mexican restaurant on Highway 49, right in the middle of Hattiesburg. The three of us had fallen into a habit when it came to dining Mexican. Elaine and Carol always ordered chicken fajitas, and I ordered a burrito. The food at Cuco's was just as delicious as we remembered.

On Saturday morning, Vickie Fennell Grinnell brought her two children to visit. Elaine and Carol took them to the pool while I read and rested in the hotel room. Vickie had been one of Elaine's favorite students while at Petal. Willie Hinton, our life insurance agent, brought some papers for us to sign. We were pleasantly surprised to learn that Willie had been elected to the

Petal City Council. We ate lunch with Vickie and her kids.

Later we went to Chesterfields, another of our favorite restaurants. We learned that the original building had burned, and the owner had built a new building on the same spot. Once again, we were not disappointed with the food.

After dinner, we crossed the railroad tracks into Petal and paid a visit to Brother Leland and Dona Ruth Hogan. We spent a pleasant evening rehashing old times and bringing each other up to date on events in our lives.

On Sunday morning, we visited Carterville Baptist Church for worship service. We laughed at all the doubletakes our old friends gave us as we walked to the sanctuary. When we were recognized, we received a handshake or a hug and a warm greeting. During worship, I sat at the end of the pew with Carol beside me, Carol's friend Whitney Jordan beside her, and Elaine on the far right of our group. Since it was Father's Day, Carterville's minister of music sang "Butterfly Kisses", a song which celebrates that special relationship between father and daughter. I cried in spite of my efforts to avoid it. Carol acted amused, but I knew she was touched by my emotion.

Carol and Elaine gave me a John Michael Talbot CD and a copy of Billy Graham's autobiography, "Just as I Am". I had hinted for Graham's book, and my efforts paid off.

Angel Durham Hickman came to visit Elaine that afternoon with her children and husband. Angel was another favorite student of Elaine's. That night, Whitney and Carol went out for a while to visit and chat. Whitney was a student at USM and was getting

serious about a young man. Carol really enjoyed the evening they spent together.

Monday morning, we stopped by the Hattiesburg Social Security office before heading to Navarre Beach, FL. We enjoyed visiting with some of the crew I had worked with years ago. Charlie Williams showed us some new training space the office had acquired, and brought us up to date on his family's progress. Renae Doleac also visited, bringing us up to date on her son Chris, another of Carol's contemporaries. Chris was a drama student in Winston-Salem, not far from High Point.

Carol was excited when we checked into the Holiday Inn at Navarre Beach because the desk clerk (a guy) was a TAZ fan. Carol loved the Tasmanian Devil, a Looney Toons cartoon character. She had found a kindred spirit in the desk clerk. The fact that he was nice looking didn't do any harm, either. We chose the Holiday Inn because we had always visited it during Elaine's spring break for a few days R&R. We liked it because it was off the beaten path and allowed us some quiet time. The area had grown some, but it was still not too busy.

We ate dinner at a nearby seafood place recommended by the desk clerk. It was more unique for its atmosphere than the quality of its food. After dinner we took a walk along the beach, then swam in the indoor pool.

On Tuesday, we took a morning walk, then went to a zoo a few miles back toward Pensacola. The zoo was a small one, but well maintained, and the animals appeared to be well cared for. Near the end of the morning, we approached a walled and windowed enclosure which, according to the sign, housed a gorilla. No gorilla was in sight. Carol peered through the window and the gorilla,

who had been hiding, jumped at her. Carol shrieked and jumped back. We all had a good laugh. It seems the gorilla entertained himself by frightening his visitors.

We ate lunch at a restaurant called "Cowboys", and rested that afternoon. We swam after our rest. We had a routine that we followed when we swam at hotels, too. After we all swam for a while, I went to the hotel room to shower and change. When I returned to poolside, Elaine went to shower and change while I stayed with Carol. Carol stayed in the pool as long as possible. The three of us took another walk before dinner. We decided to have a pizza delivered for dinner, another recommendation by the desk clerk. This guy should have been a tour guide. When the pizza arrived, we went to an enclosed deck overlooking the Gulf, where we ate while relaxing and enjoying the view. Pizza was one of Carol's favorite foods, and we all enjoyed dinner that night. Shortly after, however, Carol complained of an upset stomach. She was nauseated and bloated. Eventually, she threw up and felt better after that. At first we feared there might have been something bad on the pizza, but Elaine and I were okay. When Carol felt better after vomiting, we put our concerns out of mind.

Wednesday, we journeyed back to Hendersonville. Our trip took us through Atlanta, and we stopped to let Carol tour Emory University, the home of a medical school that interested her. She enjoyed walking around the campus. Before we left, she stopped in the bookstore and bought an Emory School of Medicine sweatshirt. We made it safely back to Hendersonville that evening.

Carol continued to have problems with nausea. By the end of the month, Carol's chronic upset stomach was enough to convince her to visit Dr. Tom Lugus for medical assistance.

Carol's symptoms: a bloated feeling, gas and nausea were "non-specific", they didn't indicate any specific illness. There are many problems which include these symptoms. Dr. Lugus considered several possibilities: a bacterial infection in the gastrointestinal tract, a parasite, or gall bladder problems. He started Carol on antibiotics as a precaution against the infection, and ran tests for parasites. He also scheduled tests to check for gall bladder disease.

The test results didn't indicate a parasite or gall bladder disease. The antibiotic also failed to improve Carol's condition. At the end of the month, we travelled to Mississippi to visit Carol's grandparents. I specifically remember that, on Saturday, when we visited my parents, Carol felt poorly all day. That evening I went to the front porch to smoke a cigar and Carol came out to tell me that she had thrown up yet again. For some reason, that episode was a turning point. Something was seriously wrong, although cancer still hadn't come to mind. Perhaps I saw the fear in Carol's eyes. Subconsciously, I knew that there was no simple solution for Carol's problem.

GRADUATION

> But they that wait upon the Lord
> shall renew their strength; they
> shall mount up with wings as
> eagles; they shall run, and not be
> weary; and they shall walk and not
> faint.
>
> Isaiah 40:31

I BELIEVE
Written on a wall in a concentration camp

> I believe in the sun
> even when it is not shining.
> I believe in love
> even when I feel it not.
> I believe in God
> even when He is silent.

AUGUST 1997

When the tests for infections, parasites and gall bladder disease failed to show results, Dr. Lugus ordered a MRI of Carol's abdominal area.

I was in my office on the morning of the MRI. When Carol arrived, I knew immediately that she was troubled. She struggled to keep from crying. I hugged her. She said Dr. Lugus thought she had Crohn's disease. Carol's first cousin Eric Stephens has Crohn's, an inflammation of the large intestine, and he had a difficult time getting it under control. Now, however, it is under control and he is doing okay. I think the weight of all the health problems she had struggled with over the years had come crashing down on her. She had dealt with allergies, asthma, neutropenia, epilepsy, lupus -- and now Crohn's. It was just too much for her to handle.

Dr. Lugus referred Carol to Dr. Tom Eisenhauer, a surgeon, who scheduled an EGD (esophagogastroduodenoscopy) to confirm the diagnosis and to plan a treatment regimen. Dr. Eisenhauer is a slender Pennsylvanian with a ready smile and thinning strawberry blond hair. Over the next several months, he was one of many medical professionals who helped all of us deal with the overwhelming obstacle of Carol's illness.

By now Carol was throwing up every day. This had to be very debilitating, emotionally as well as physically. If you have ever had an upset stomach with nausea, just imagine having those feelings every day. Just imagine how enfeebling it is to have to vomit every day, sometimes several times a day. Carol could not comprehend the idea of someone with bulimia throwing up without really having to.

The EGD was scheduled for the morning of August 5. In an EGD procedure, the patient is given a mild anesthetic. While sedated, an optical tube is passed through the mouth, down the esophagus and into the stomach. In some cases, the scope goes through the stomach and into the upper part of the small intestine. This allows the surgeon to visually inspect these areas for causes of the problem. In this case, Dr. Eisenhauer was to look in the stomach and upper part of the small intestine (known as the jejenum). I took off work, so Elaine and I could be there to encourage Carol. An EGD is an outpatient procedure, which allows the patient to return home within a couple of hours, usually the patient spends less that half of a day at the hospital.

Dr. Eisenhauer had encouraging news to report. Carol did not have Crohn's. He told us the lower portion of Carol's stomach, the

pylorus, was swollen shut. Therefore no food could pass through this blocked area into the small intestine. This was why Carol threw up all the time. The food in her stomach had nowhere else to go.

Dr. Eisenhauer believed the swelling was caused by peptic ulcer disease. He prescribed some medication for Carol which should help correct the problem. We began the first leg of an emotional roller coaster ride which extended over the next seven months. First, we would receive some good news, and our spirits were buoyed; then we'd get bad news and our hopes came crashing back down. I am sure the doctors rode the same roller coaster with us.

After a week, Carol's condition had not improved. If anything, she was worse. Dr. Eisenhauer scheduled another EGD. This time, the procedure would include a balloon dilation of the pylorus. This worked just like an angioplasty procedure for the heart. The doctor inserted a deflated balloon into the blocked area. When he inflated the balloon, the blockage was forced open. The balloon dilation didn't work either, and Carol still vomited daily. She was distraught. Nothing was working, and she couldn't get any relief. Dr. Eisenhauer continued to believe the ulcer medication would improve Carol's condition, given time.

Carol was running into another problem, however. Because she couldn't keep any food down, she was losing weight hand over fist. While she needed to lose weight, this wasn't the way to do it. Even worse, she was becoming dehydrated.

On Sunday afternoon, August 17th, we had held on as long as we could. When Carol threw up yet again, we headed to the emergency room. The triage nurse was having

a bad day. She gave us the impression that we didn't have any business wasting her time, since Carol's condition was no worse (in her opinion) today than it had been on Friday. She tried to get us to wait until the next day to see our doctor.

While I struggled to control my anger, I emphasized how difficult Carol's condition was. I think the nurse sensed my anger and dropped the subject. She obviously put us in a low priority category, however, because we spent the next two hours in the lobby waiting to be called for treatment.

Finally, Carol was taken back to the examining room. Within a few minutes the ER nurse determined that Carol was seriously dehydrated. The blood tests ordered by the ER doctor indicated that Carol's potassium level was dangerously low. This condition is known as hypokalemia. Because it can cause erratic heart function, it is life-threatening. The ER staff acted quickly to begin an IV to give Carol fluids and potassium. The doctor also admitted Carol into the hospital.

Carol spent almost half of the next six months in the hospital, although not continuously. Elaine and I were unwilling to leave Carol alone any more than necessary during these hospital stays. Through trial and error, we eventually developed a "shift" routine. Elaine's duties at school were less flexible that my duties at the Social Security office. Barring a real crisis, Elaine needed to be at school each day, while I could use vacation leave and sick leave to be with Carol during some or all of the day. Therefore, Elaine chose to stay with Carol at night, while I stayed with Carol during the day. To the best of my memory, Elaine did

not fail to stay with Carol for a single night while she was hospitalized.

Over the next ten days, while Carol received fluids and potassium to restore her body, Dr. Eisenhauer and Dr. Donald Varner, a gastroenterologist, struggled to find a solution. Dr. Eisenhauer still believed that peptic ulcer disease was the culprit. After yet another EGD, Dr. Varner suspected gastroparesis, a very rare condition where the stomach just stops working. It is a kind of paralysis of the stomach. Dr. Varner thought Carol might have encountered a virus or "bug" while on vacation which caused her stomach to shut down. This condition usually corrects itself after several weeks or months with medication.

The date for Carol to begin her senior year at High Point University passed. She called to arrange permission to report late, which was given with no resistance.

After much discussion, Carol and the doctors decided to insert a J-tube. This is a jejunostomy tube, which is inserted through the abdominal wall into the jejunum. This way liquid nourishment, such as Ensure, can bypass the blockage. This would allow Carol to receive nourishment without having it pass through the stomach.

The plan was to use the J-tube to keep Carol alive while she took medication to resolve the blockage. She would simultaneously take medication for peptic ulcer disease and for gastroparesis.

On August 27th, Carol was taken into surgery. During the surgery, Dr. Eisenhauer also performed an exploratory laparotomy. In this procedure, the doctor makes an incision and "looks around" inside the abdomen. When Carol returned from surgery, her incision ran from her belly button to her sternum. She

also had a foot-long red rubber tube extending from a hole in her stomach. during the remainder of her hospital stay, the end of the tube was connected to an enteral machine, which pumped liquid nourishment into the J-tube.

The day before she was discharged, the nurse taught her how to use the "bolus" method to feed herself. Carol would fill a 60cc catheter tip syringe with Boost, similar to Ensure (with the plunger taken out of the syringe). Gravity would draw the Boost through the tube and into Carol's small intestine. Carol would have to feed herself about six times each day using this method. She also had to give herself medication this way, and water, to avoid dehydration. In my mind, and in Carol's, this was monstrous. It was so difficult and tedious. We were overwhelmed by the difficulty posed by a failed GI system. It is so easy to take something like a working digestive system for granted. By the end of the next January, this process was just a part of our lives.

Carol was discharged from the hospital on Sunday, August 31st. Elaine and I had Carol's car and our SUV (in May we had traded our van for a GMC Jimmy) loaded with her stuff. We drove to the High Point University campus and unloaded the vehicles. About half of the campus (so it seemed) came to help. Carol had many friends. Each of them were there to welcome her back to school and to offer encouragement. Still, there were many somber faces among the students. They knew the difficult road Carol traversed. Each wanted to lift her spirits, but they just didn't know what to say. After unloading the cars, we went to Greensboro and spent the night in a hotel. Carol still vomited several times a day.

Graduation

SEPTEMBER 1997

The next day, we returned to campus and set up Carol's room while she began classes. Elaine arranged all of Carol's "stuff" into the nooks and crannies of her room, while I accompanied Carol to her classes. Carol didn't have the strength to hike from one end of the campus to the other during the allotted time between classes. I drove her around on Monday. She arranged for campus security to transport her in a golf cart beginning the next day. That would allow her to save her energy for classes, study and recovery.

Over the next nine days, we fretted at home while Carol struggled at school. Things were not going well. Carol was weak from her surgery, she was throwing up several times a day, yet still she maintained her class schedule. Gwendolyn Ruffin, a friend and dorm-mate of Carol's, was a big help. She assisted Carol in administering her nourishment and in taking her medication. Gwendolyn also helped drive Carol to complete errands when necessary.

Carol called me at work on Tuesday, September 9th to tell me she was going to the emergency room at Bowman-Gray. She was having heart palpitations, dizziness and difficulty breathing. Bowman-Gray's doctors ascertained that she was dehydrating, and her potassium level had dropped again. They agreed to let her go home after administering fluids and potassium, if she promised to see her doctor at her regularly scheduled appointment on the 11th.

She returned home to Hendersonville the next day, but she couldn't wait until the 11th to see Dr. Eisenhauer. By dusk on the 10th, the heart palpitations had returned.

We went to the Pardee emergency room, where, once again, Carol was admitted.

We held another consultation with Dr. Eisenhauer, and we agreed that a gastrojejunostomy should be done. This surgical procedure calls for the doctor to make a new hole in the floor of the stomach and a new hole in the wall of the jejunum. The doctor then connects the two holes, making a new path for the food to pass through and bypassing the blocked pylorus and duodenum.

After the surgery, Dr. Eisenhauer talked to Elaine and me. He told us the surgical procedure went well. He had a new concern, however. He discovered an enlarged lymph node. He took a biopsy, and promised to give us the results as soon as possible.

Elaine called me at home early Saturday morning (Sept 13th). Her voice was thick with emotion. Dr. Eisenhauer had just come by on his rounds. The biopsy was positive. Carol had cancer. I promised to get to the hospital as quickly as possible.

For the next ten minutes or so, I wandered dazedly around the house like a blind man, crying. I was very frightened of what the future might hold. I could only imagine what Carol felt.

Everybody gets cancer once, twice, maybe three times a year. An abnormal cell develops from a carcinogen such as nicotine or asbestos. Or perhaps a genetic "hiccup" causes the abnormal cell to develop. One of the problems with the fight against cancer is the uncertainty over how it starts. In most cases, that abnormal cell is defeated by our own immune system, and we go on our healthy, merry way. In a few cases, perhaps because of a suppressed immune system or because of some other reason. The abnormal cell

overcomes our immune systems defenses and begins to grow. Another person then becomes a cancer victim.

Cancer grows geometrically. One cell splits to become two. Two cells split to become four, then eight, and so on. In its early stages, cancer is almost completely undetectable. Only when it reaches a million cells or so in size does it become large enough to be identified by modern medicine's detection devices, and still the geometric progression continues. One million cells split to become two million. By now the cancer is growing rapidly.

Carol first experienced gastrointestinal symptoms in 1993. At that time, and for a long time thereafter, we thought she was just suffering from GERD, or stress related stomach discomfort. In retrospect, it is likely that the cancer had begun and was already making its presence felt. As discussed earlier, the stomach discomfort was non-specific. The symptoms did not point toward the likelihood of cancer, particularly not in the stomach or small intestine for a person as young as Carol. How many of us have had an unsettled stomach as a result of something we ate, or for any one of dozens of reasons. We had no reason to suspect that cancer might be the culprit.

Once the cancer begins to grow, it must have a blood source to continue its growth. It develops a cluster of blood vessels to supply blood and nutrients to the tumor. As the tumor grows, the blood supply systems grows.

Up until this point, if the tumor is detected, it can often be removed surgically. If the tumor is only in one location, and all of it can be removed. The next step in the cancer's growth changes that. At some point,

227

the system of blood vessels which has been nourishing the tumor becomes a cancer delivery system. The tumor releases cancer cells which are carried to other parts of the body. These cancer cells then form more tumors in other locations. Once the cancer spreads like this (metastasized) surgery is no longer the best means of fighting the cancer. Often the primary tumor is removed, but once the cancer cells spread, chemotherapy is often the treatment of choice.

Most likely the cancer started in Carol's small intestine, right where the gastrointestinal blockage was. However, the infected lymph node told Dr. Eisenhauer the cancer had metastasized, and had spread.

The next day, Dr. William Medina, an oncologist, came by. He is a tall man with soft, curly brown hair. His eyes are soft, too -- puppy dog eyes. His shoulders slumped a little, as if he was embarrassed at his stature. Dr. Medina was born in Columbia, South America, and grew up in Kentucky before establishing his oncology practice in Hendersonville. We were impressed by his professionalism and compassion. As with all of the oncology professionals with whom we worked, he was concerned with the emotional and psychological welfare of his patients. It must be difficult working with patients who so often succumb to their illness. Dr. Medina spent thirty minutes getting a medical history and explaining about the chemotherapy he would use. Later that day, Carol was moved to the oncology ward on the third floor, an area she would come to know well.

Carol stayed in the hospital until September 19th. After much discussion with Gart Evans, HPU's dean of students, Carol decided to withdraw for the fall semester.

She had already missed too many classes to reasonably expect to make up the work, and she was in no shape physically to consider returning, anyway. This was a crushing blow to Carol's hopes. She had devoted so much of her energy and hopes upon her college career and the future it promised for her. To admit that she was unable to continue was heartbreaking for her, and for us, too.

Carol had an expression she used to convey intense emotional pain. When something bad happened and she was crushed emotionally, she often said, "My heart hurts." No doubt this day, her heart was in agony.

On Saturday, September 20th, Elaine and I travelled to High Point and loaded Carol's things back into her car and the Jimmy. It was the hardest thing either of us had ever done, up to that point. While she carried armloads of clothes and books to the vehicles, tears streamed down Elaine's cheeks. Her heart was broken. I know she would have changed places with Carol if she could.

When Carol was discharged on September 19th, Dr. Eisenhauer scheduled outpatient surgery for October 8th to insert a vital port. Chemotherapy is potent stuff. When an oncology patient has to spend hours with an IV stuck in her arm and with the chemo coursing into her veins, her veins often collapse. The chemo just burns them up. To avoid this, the doctor often recommends the insertion of a vital port, or port-o-cath as it is sometimes called. This was a device which would be inserted into Carol's central vein, just under her collarbone. The chemotherapy would be administered through the V-P, thus saving the veins in her arms.

For the first three weeks, the gastrojejunostomy worked well. Carol was able to eat again! It had been so long since she had eaten, her stomach had shrunk. She could only eat small amounts. Also certain textures of food still made her sick for some reason. For example, the soft, mealy texture of bread would still cause her to throw up; however, that was a small price to pay.

Carol and I went to Dr. Eisenhauer's office on September 23rd for a follow-up on the surgery. Carol excitedly told Dr. Eisenhauer about an interview she had at the East Carolina University Medical School on October 1. He wished her well on the interview.

Carol spent the remainder of September recuperating from the surgery. Dr. Medina planned to start the chemo about four weeks after the surgery. Thus allowing time for the incision to heal.

On September 30th, Carol and I left on our 6 1/2 hour trip to Greenville NC. She was excited and nervous about her interview the next day. Carol had begun to experience nausea and vomiting again, though not to the degree she had before the gastric bypass surgery. She got sick once at a rest stop at Winston-Salem.

OCTOBER 1997

The next day we rose early and ate at the Hampton Inn's complimentary breakfast buffet. I was actually relieved when Carol got sick right after breakfast. I had been worried that she would get sick during her interview. Since she usually went several hours between emesis (vomiting) episodes, I felt she had a better chance of getting through the interview before she got sick again.

230

We travelled to the ECU School of Medicine, and I dropped Carol off at the Brody Medical Sciences Building. That building was eight stories high, and was attached to the rear of the Pitt County Memorial Hospital. The Brody Building housed the entire ECU School of Medicine. While Carol completed her interview, I strolled around the hospital.

PCMH is a huge facility. It is long and low-slung, never more than two stories high -- except for the Brody Building. It consists of a number of connected clinics -- pediatrics, oncology, etc. I understand it is one of the best medical facilities in the state. When Carol completed her interview, she was even more excited. The interview had gone superbly, and she had a good chance of being accepted. She called Mom on the cell phone and told her the good news. Carol wanted to get an ECU Medical School sweatshirt, but the medical school did not have a gift shop. She considered making the drive across town to East Carolina's main campus, but she was too tired. We still had that long drive home ahead of us.

Back home at Hendersonville, Carol prepared for the surgery to install the vital port and the commencement of chemotherapy. She was perplexed by the recurrence of the nausea and vomiting. She hoped the gastric bypass surgery had resolved that problem, but it was returning with a vengeance.

On October 8th, Carol and I reported to the Pardee Outpatient Surgery Clinic for the insertion of the vital port. After a long wait, a nurse took Carol to be anesthetized. I headed for the elevator to get a bite of lunch. I would be back before the completion of the surgical procedure.

Dr. Eisenhauer caught me before the elevator doors closed. He asked to talk to me while Carol was being prepped for surgery. We went into a small consultation room and sat down.

"I want to talk with you alone for a few minutes," he said. "I was pleased at how excited Carol was about her medical school interview, and I don't want to discourage her or you from pursuing her goals, but I want you to know that the chemotherapy has a big job to do."

I felt like I had been punched in the stomach. I knew that Carol was in a risky situation. Anytime you deal with cancer in a major system it is bad news, but I had avoided thinking about the implications. "What are her chances?" I asked. I already had an idea of where Dr. Eisenhauer was going with this.

"We can't remove the cancer surgically because it is wrapped around a major blood vessel which feeds the stomach and small intestine. The fact that the cancer is inoperative makes a good prognosis much more difficult," he replied. "Who knows, perhaps in five years or so, we can look back at this conversation and laugh about it, but the chemo has its work cut out for it. I'd have to tell you that if the three of you have planned a big trip in the next couple of years, you might want to think about moving it up."

I began to cry. While the news was hard, I respected Dr. Eisenhauer for being honest with me. I watched Dr. Eisenhauer swallow a big lump in his throat. He has a small daughter, and he could understand what I felt.

"Do you think I should tell her?" I asked.

"Why don't we wait. Perhaps the chemotherapy will work, and my worries will be for nothing," he responded. "If the chemo doesn't work, we can discuss it with her then."

Dr. Eisenhauer and I stood. He gave me a hug and left to perform Carol's surgery. I stayed behind to dry my eyes and compose myself. I also had to decide how to interpret Dr. Eisenhauer's message. I didn't take it to mean that Carol's condition was already terminal, only that the prognosis looked bad. I could only leave things up to God. If He wanted Carol healed, He could do it. If that wasn't in His will, I would have to figure out how to accept it. For the meantime, we would give medical science every chance we could to cure her.

When Carol returned from the surgery, I had a very difficult time remaining composed and chipper. I think Carol sensed that I was upset, but she didn't ask why. Perhaps she thought it was just the strain of waiting through yet another surgical procedure, or perhaps she was afraid to ask.

Over the next couple of days, I struggled to decide how to handle the news that Dr. Eisenhauer had given me. I agreed with his recommendation that Carol not be told yet. It would serve no purpose at this point. I knew how important a positive attitude was to the successful treatment of cancer, and I didn't want to bring Carol down from her optimistic approach. I did think it was important to discuss it with Elaine, however. I decided to wait until after Carol's appointment with Dr. Medina on October 10th.

Carol's appointment with Dr. Medina was at 4:00. Elaine left school early so she could attend as well. The nurses took a

battery of blood tests to establish a
baseline of data, and did a medical history.
Dr. Medina explained that the chemotherapy
would be a combination of 5FU and leucovorin.
These weren't particularly noxious as
chemotherapy medicines go. Carol had a good
chance of keeping her hair. It shouldn't
make her real sick, either, which was good
news. She didn't need more nausea on top of
what she had already. He explained that he
would administer the chemotherapy once a week
for four weeks, then do an evaluation.

"What are the chances the chemotherapy
will work?" asked Carol.

"This chemotherapy works in about 30% of
the cases," Dr. Medina answered. Carol
flinched. "These are the best chemicals for
the kind of cancer you have," He continued.
His approach was a little more oblique that
Dr. Eisenhauer's but the news was much the
same. Carol and Dr. Medina scheduled the
first session for the following Tuesday.

On the drive home, Carol chose the
positive approach, as I knew she would. "Dr.
Medina says 30% of the cases are successful.
I'll just have to be one of the 30%."

Later I tried to relate my discussion
with Dr. Eisenhauer to Elaine. She was not
ready to hear that type of news. I decided
to wait. Who knows, maybe Carol **WOULD** be one
of the 30%.

On Tuesday the 14th, Carol and I
reported to Dr. Medina's office at 2:00. As
a teacher, Elaine was unable to take off work
as easily as me. I became the supportive
parent during school hours, while Elaine took
over as soon as she could. The first thirty
minutes of our visit was devoted to bloodwork
and getting ready. Finally, the nurse hooked
Carol to the IV.

Graduation

The chemotherapy room was small, with
two reclining chairs equipped with IV poles.
There was a TV, a VCR and a mediocre
selection of movies. One wall contained a
bulletin board with cards that chemo patients
had sent to Dr. Medina as they travelled
around the world. I envisioned a card from
Carol on that board. Perhaps she would send
it from the Grand Canyon a year from now.
That was where we planned to take a vacation
in 1998.

As Dr. Medina predicted, Carol didn't
have much trouble with the chemotherapy. She
did become weak, and ran a low-grade fever.
Since she was already having trouble with
nausea, it was hard to assess how that area
was affected. It didn't seem to make her
nausea and vomiting worse, however.

The following Saturday, Elaine, Carol
and I travelled to High Point University so
Carol could visit her classmates. Hala
Qubein and Gwendolyn Ruffin, friends of hers
from the Annex met her on campus. Carol
visited with them and several other friends
during the day. They walked around campus
and talked about school life. Elaine and I
went to a nearby shopping mall. That
afternoon we returned to pick her up.

The day had been an emotional one, but
Carol was happy she had made the trip. She
was exhausted and slept most of the way home.

The following Tuesday, Carol's second
chemo session was scheduled for 2:00 again.
That morning, however, Carol called me at
work to tell me she was vomiting repeatedly.
I went home to get her, and took her to Dr.
Eisenhauer's office. Dr. Eisenhauer arranged
for the Pardee Radiology department to run a
CT scan immediately. He was concerned that
the new opening made by the gastric bypass
surgery had closed.

The CT scan showed that material could pass from Carol's stomach to her small intestine -- although sluggishly. The doctor was unsure why Carol was still vomiting. All he could do at the moment was prescribe a stronger anti-nausea medicine. This didn't stop her vomiting, but it did seem to ease it up a bit.

Carol studied a daily devotional book based on the "Experiencing God" series by Henry T. Blackaby and Richard Blackaby. On October 26, Carol made this note in the margin:

"Through the cancer God has brought revival to my heart again. Never before have I longed for Him as I do now to feel His presence and strength. Thank God for cancer!"

Carol tolerated her chemo sessions on the twenty-first and twenty-eighth okay. On the twenty-ninth, she left for High Point University, on her own, to take care of pre-registration for the Spring semester. She still had plans to return to school in two months. While Elaine and I had some qualms about her travelling alone, we knew if she really did return to school in January, she would have to function independently then.

The following day, I had to come home from work early. I was running a fever and had a ferocious headache. The next day, I awoke with a 101 degree fever and had to call in sick. Not long after, Carol called from HPU. She was sick again -- not my symptoms (which turned out to be a sinus infection). She needed to come home, but she knew she couldn't drive all the way. I was in no shape to drive, either. In the end, Carol called Elaine at school. Elaine left school and she and Paul and Bonnie Black, First Baptist's youth minister and his wife (Jim

Pearce had taken the ministry of a new church
in the Arden area) drove to Hickory, about
half-way between Hendersonville and High
Point. Carol managed to drive from High
Point to Hickory. Paul then drove his car
back, while Elaine drove Carol's car.

NOVEMBER 1997
 I finally acceded to Elaine and Carol's
wishes and went to the Pardee Express Care
Center. The doctor easily diagnosed my sinus
infection and prescribed an antibiotic. By
the next day, I was feeling better. If only
Carol's condition could improve that easily.
 By Sunday, Carol, still vomiting two or
three times a day, was dehydrating again.
Elaine took her to the ER, while I
convalesced at home. A couple of hours
later, Elaine called to report that Carol had
been re-admitted.
 The doctors were at a loss to explain
why Carol was still vomiting. Dr. Eisenhauer
and Dr. Varner did another EGD, and confirmed
that the gastric bypass opening still
existed. Perhaps there was another blockage
somewhere else. Dr. Eisenhauer and Carol
decided another surgery was called for. In
this surgery, Dr. Eisenhauer would try to
accomplish two things: first, he would bring
another loop of small intestine up to connect
to Carol's stomach and "bypass the bypass";
second, he would cut away as much of the
tumor as he could. "Debulking", he called
it. He warned us this "debulking" would not
improve the prognosis much, if any. He just
wanted to do it while he was doing the other
surgery.
 My parents, sister and her husband had
come to see Carol and offer her their

support. The six of us sat in the OR waiting room while Carol underwent the surgery.

It was late when Dr. Eisenhauer came out to brief us on the outcome of the surgery. He reported that the new bypass had been completed. Only time would tell if it helped Carol's condition improve. The rest of the news was grim. He was unable to remove any of the tumor. In spite of four weeks of chemotherapy, the tumor had grown considerably and was even more involved with the blood vessel which supplied her abdominal organs. No doubt the cancer was using it to receive its own blood supply, as well. The cancer had spread to Carol's abdominal wall and was clearly out of control.

It soon became clear that the new bypass hadn't worked either. Carol still threw up. It seemed that Carol's stomach had just stopped working. Although there was an opening for food to go through, it just wouldn't do it. The only conclusion the doctors could make was that Carol's digestive system wouldn't work normally until the cancer was gone.

That meant another surgical procedure. Since Carol would be unable to eat to provide nourishment for herself for the indefinite future, Dr. Eisenhauer would have to insert another feeding tube. This one actually had two tubes. One tube ended in Carol's stomach and would be hooked to a suction pump to empty the gastric juices from Carol's stomach. Even when no food enters the stomach, it still fills with gastric juices. Each day about a quart of gastric juice is made by the stomach, and another quart of saliva empties into the stomach from swallowing. With no place to go, this gastric juice has to be vomited out when the stomach gets too full. The other tube

continued through the new opening in the stomach and into the jejunum, at the top of the small intestine. This tube would be hooked to an enteral pump. This feeding pump would introduce liquid nourishment into Carol's small intestine to keep her alive.

While the news on the medical front continued to be bad, Carol finally did get some other good news. She received a letter from the ECU School of Medicine. She had been accepted! The dean invited her to enroll next fall, when she graduated from High Point. If Carol could make it to school in the spring, she would still graduate on schedule. She only needed three more hours (a required course) to get her degree. Delighted, Carol instructed me to send the enrollment deposit to ECU. She hung her hopes on getting there in the fall of 1998.

Dr. Medina planned to start Carol on a new regimen of chemotherapy, using different chemicals, in early December. This allowed Carol time to heal from her surgeries. Carol had now been cut open from breastbone to bellybutton four times. She would have done just as well to have a zipper.

Shortly before Carol was to be discharged, I drove from the hospital back to my office. I spotted Dr. Medina walking toward his office from the hospital with his long, loping strides, a distance of only one block. I pulled over, grateful for the opportunity to talk privately, without having Carol present.

"Dr. Medina, can you give me a prognosis on Carol's condition?" I asked.

Dr. Medina frowned in concentration. "Well, you know that the first chemotherapy didn't work," he said. "In fact, the cancer grew considerably, even while the chemotherapy was being administered.

"I'd have to say the prognosis is poor," he continued. "The 5FU and leucovorin has a success rate with this type of cancer of about 30%. The next chemicals we will try has a success rate of about 20%."

"Don't misunderstand my next question, Dr. Medina," I began. "Elaine, Carol and I are very pleased with the treatment you have provided, but do you think it might help to take Carol to one of the major cancer centers to let them examine her?"

Dr. Medina nodded. "Carol's condition is very unusual. Cancer of the small intestine is rare, and for someone of Carol's age to have it is almost unheard of. I would have no objection to referring her. In fact, I have already consulted with one of the best GI oncologists in the country on Carol's case. He is at the M.D. Anderson Cancer Center in Houston, Texas. M.D. Anderson and Sloan-Kettering in New York are the two best cancer clinics in the United States, in my opinion. Would you like me to set it up?"

So, we agreed. Dr. Medina scheduled an appointment with Dr. Jaffer Ajani for December 1. When I researched Dr. Ajani's credentials, I discovered he was listed as one of the ten best gastro-intestinal oncologists in the U.S. We spent the next several days arranging to have Carol's pathology slides FedExed to Houston, and collecting the various medical reports Dr. Ajani would need. The reports, along with Carol's X-rays, were to be hand-carried to Houston.

We continued to receive visits from well-wishers and supportive notes and cards from all over. The ministers from First Baptist came by daily. Jim Pearce visited often, keeping tabs on his protege, and

Marianna Dockery Dollyhigh visited often, too.

Carol was to be discharged on Tuesday, November 25th. Dr. Eisenhauer arranged for her to receive her nourishment by an enteral pump while at home. We hooked up a bag with 1200 cc's of Ensure through the pump to Carol's J-tube. The pump would push 100 cc's per hour into Carol's small intestine. By setting up this operation at 8:00 PM, Carol could sleep while the pump did its job. By 8:00 the next morning, Carol's feeding would be done for the day. In addition, we had to administer all of Carol's medicines via syringe through the J-tube.

We also had a gastric suction pump, called a GOMCO machine. This pump was connected to the G-tube, and worked to keep Carol's stomach empty of fluids. This didn't stop her vomiting, but it lessened the frequency and violence of the episodes.

Thanksgiving was a somber affair. we ordered a ham from Hickory Hams (we've never been especially fond of turkey), and Elaine fixed dressing with cranberry sauce and vegetables. Carol ate some, even though she knew that she would not be able to keep it down. We spent our time planning the trip to Houston and administering medicine for Carol (which was a daily thing, not just Thanksgiving).

Every four hours or so, we would assemble the medicines that Carol needed: Tylenol (for fever), pain, nausea and potassium, plus liquids. Some of the medicine was in elixir form which was easily administered by syringe. Some of the medicine was in tablet form, which had to be crushed and dissolved in warm water before we could inject it into her J-tube. We often

spent 30 or 40 minutes preparing and administering the medicines.

When word reached our church, workplaces and family about our trip to Houston, donations came pouring in. We didn't ask for a penny, but by the time we left for Houston, we had received enough to completely cover the costs of our trip - airline tickets, hotel room, food, everything. This was an example of how God takes care of a situation. The prayers that had enshrouded us all during Carol's illness were answered in part by the actions of the very people sending those prayers.

Our plan was to travel to Houston on Sunday, November 30th for our December 1st appointment. Ray Beckwith, a friend from church, drove us on the one hour trip to the Greenville-Spartanburg airport in Carol's car. Once we were on our way, he drove the car back home. That helped us avoid paying long-term parking charges for the car.

The trip to GSP was very difficult for Carol. The car's motion and vibration exacerbated her nausea and was painful for her surgical incision. In fact, the entire trip taxed Carol's endurance. By the time we reached our hotel, the Rotary House International. It was 2:00 AM Central Time. We collapsed into bed.

DECEMBER 1997

The Rotary House International is operated by the Rotary Clubs International organization specifically for patients of M.D. Anderson and their families. The rooms were equipped with small kitchens, and the bathrooms were similar to hospital bathrooms. Each had a roomy shower stall with a detachable shower head. There was also a

stool so the ill person could sit down while showering.

The hotel is connected with M.D. Anderson via an enclosed walkway over the intervening street. The clinic staff has a welcome center and library in the hotel lobby, and the hotel sponsors a variety of activities for the clinic patients. While the hotel was not cheap, its quality far exceeded the price we were charged. In my business, I had stayed in hotels of comparable quality and paid twice the price. Overall, I was impressed by the facility's concern for us.

Monday morning, Elaine and I risked leaving Carol asleep in our room while we rushed downstairs to eat breakfast. After we returned from breakfast, Carol rose and we set about getting her fed and medicated. Since we didn't have an enteral pump, we had to feed her by bolus. By giving her about 250 cc's of Ensure every four hours, we could give her 1250 cc's over a sixteen hour period.

That was do-able. The problem was evacuating her stomach. Theoretically, we could empty Carol's stomach by connecting a syringe (with the plunger pushed in) to Carol's G-tube, then by pulling the plunger back, the stomach's gastric fluids could be pulled into the syringe. In practice, this was almost impossible. Since we expected to order a GOMCO machine for our stay, we decided to forego trying to empty Carol's stomach with a syringe. While we were at it we would get an enteral pump as well.

After taking care of Carol's feeding and medication, we went to the welcome center in the hotel lobby. The friendly staff showed us an orientation video, and provided a map of the clinic. I was glad we got the map.

M.D. Anderson is a large building. It is
about four time the size of Pardee Hospital
in Hendersonville. Equipped with the
map and instructions from the welcome center
staff, we invaded the clinic. Our first stop
was at the new patient desk, where we checked
in. We were told to wait in the hospital
lobby until Carol's name was called. While
we waited, we listened to piano music
performed by a volunteer and watched the
people. I had never seen so many bald heads,
caps and scarves in my life. It was humbling
to realize that every one of the hundreds of
people meandering through the lobby were
cancer patients or family members of cancer
patients. Many were as young or younger that
Carol.

While we were waiting, Carol became ill.
She and Elaine rushed to the bathroom while
I struggled to control my despair. When
Carol returned, a pale young woman in her
20's, wearing a baseball cap to cover her
bald pate, gave Carol a pat and an
encouraging word. A young man was with her,
looking as desperate as I felt. I assumed he
was her husband. I recalled a high school
classmate of mine named Peggy Collums.
Shortly after we graduated, she married Ted
McKnight. Not long after that, Peggy
contracted ovarian cancer and died after a
long illness.

I remembered talking with Ted after
Peggy's death. He was torn apart by grief
and guilt at being unable to do anything for
his bride. At the time, I could only observe
Ted's sorrow. I had nothing with which to
compare it. Now I could truly understand how
Ted felt. I could also understand the
feelings of the young man with his wife.

Eventually, Carol was called back to a
small cubicle where a clerk completed a small

mountain of paperwork. The red tape was finished, and we were sent to the gastroenterology clinic on the seventh floor. Carol checked in upon arrival and was given another stack of forms to complete.

Carol was eventually called back to the examining room. The first person to greet us was a young man, no doubt a medical student, who gave Carol a thorough examination and took a medical history.

After this was completed, Dr. Ajani came in to meet us. He was a small man with black hair, olive skin, and sharp piercing eyes. His black pants and white lab coat were neatly pressed, with a crease. His manner was brusque.

Dr. Ajani consulted with the student and with us for a few minutes. He took the X-rays that I had brought, but seemed surprised that I didn't have the pathology slides. We discovered that M.D. Anderson's pathology department had not sent Carol's slides to the doctor.

Dr. Ajani and the student left to study the X-rays. The three of us were left to kill time in the exam room. Nobody felt good. Carol was in pain, and could find no comfortable position on the examining table or in one of the chairs. Elaine and I were tired from losing sleep the night before and from navigating through a strange building all day. In addition, we were worried about Carol.

When Dr. Ajani and his sidekick returned, he could only confirm Dr. Medina's diagnosis. He wrote a note to Dr. Medina to that effect and recommended that Carol be treated with a chemotherapy combination of Taxol and Cisplaten. From my conversations with Dr. Medina, I recalled this was his

first choice for the next round of chemotherapy, as well.

"You know that there is no cure for this type of cancer," Dr. Ajani said. "The course of therapy that I am recommending is palliative only."

Elaine, Carol and I just looked at each other. "Palliative" was a new term for all of us, but I knew I didn't like the sound of it. Carol, the future doctor, was always the last person to be intimidated by a white coat, but she was intimidated by Dr. Ajani. I knew that Dr. Ajani was one of the best GI oncologists around. When it came to bedside manner, however, Dr. Medina had him beaten by a mile.

Later I looked up the word "palliative" in the dictionary. Actually, I looked up "palliate", since "palliative" means something that palliates. "Palliate" means to lessen the pain or severity of, without actually curing. Once again, the message was not good.

What Dr. Ajani was telling us in an oblique way, was that Carol's condition was terminal. While my conscious mind was not yet ready to process this information, I believe this is where, subconsciously, I realized that Carol would not survive. At least not unless God intervened.

There was nothing else for Dr. Ajani to do, so our four day trip shrank to one. Dr. Ajani dismissed us and referred us back to Dr. Medina. Later, I rattled a few cages to make sure that Dr. Ajani received and got a look at Carol's pathology work. Unfortunately, that didn't change his opinion. Sometimes even the best doctors don't have an answer.

The three of us huddled to plan the rest of our week. Carol didn't think she could

make the return flight the next day, so we decided to return to North Carolina on Wednesday. We spent the rest of the day arranging for an enteral pump and gastric suction pump for Carol's use until Wednesday morning.

That night, the patient relations staff from M.D. Anderson sponsored a Christmas tree-trimming party in Rotary House's Mayfair Room. The Mayfair Room is a large sitting room filled with sofas and chairs. It is a suitable place for folks to sit and talk or read. A large Christmas tree had been erected against one wall.

When we arrived, each of us was given a small ornament to hang on the tree and a photocopied page of Christmas carols. The first half-hour or so was spent socializing and enjoying refreshments. Once again, I was struck by how wide-spread and destructive this demon cancer was. The life of each person in the room had been turned upside-down by this uninvited fiend. It helped me to realize that the "why me" syndrome didn't apply. There are thousands of "me's" who get cancer every year, or who have a loved one who does.

When the Christmas carols were sung, I could hardly sing for the lump in my throat. I knew Elaine and Carol were doing no better. Carol was getting tired and wanted to go upstairs to rest. Before we left we hung our ornaments on the tree.

The next afternoon, Carol wanted to make a trip to the Baylor School of Medicine to look around. The Rotary House has a service which will drive guests to any location within a two mile radius of the hotel for free. Baylor Medical School was easily within that area, so we arranged the trip.

I wouldn't recommend the school as a "must see" for Houston sight-seers. It is located in an aging building in the midst of Houston's medical complex. The area where M.D. Anderson and Baylor Medical School are located includes a number of hospitals, clinics, and medical schools sprawled across dozens of square blocks. If you get sick, this is the place to come.

Despite the lack of aesthetic appeal, Carol was excited about the visit. We wandered around the halls for a while until we discovered Carol's real purpose for going to the school -- the gift shop. Carol selected a ball cap, a sweatshirt, and a pair of shorts. The teachers at West High had given some money to Carol to be used to purchase a "happy" while at Houston. A "happy" is a trinket, or anything, that serves no useful purpose except to make one happy.

Since the items that Carol selected cost more than the money Carol had, I gladly chipped in the difference. I would have bought the school for her if she had wanted it.

Carol's excitement about the BSM clothing reminded me of her disappointment when she was unable to get an East Carolina University School of Medicine sweatshirt. I resolved to get her one for Christmas.

Even in the midst of such a sorrowful time, we experienced some blessings which lifted our hearts. One example was the rich outpouring of love and support from the many friends from church and work, and from our relatives. In addition to providing the funds necessary to make the trip to Houston. We had many people who did special things to help us out, or to lift us up. Friends from West High, church and the Social Security

office provided meals for us. This relieved Elaine of having to worry about preparing something for us to eat. During the time from Carol's diagnosis to Thanksgiving, I lost about thirty pounds all because I was to preoccupied to think about eating. I will admit, I needed to lose the weight, but this wasn't the way to do it. From Thanksgiving to the end the next February, I gained it all back because so many people brought by dishes of food for us.

My fellow workers at the Social Security office prepared a box-full of little gifts for Carol. They sent it to her with the stipulation that she was to open only one gift per day. Carol had so much fun choosing the gift she was to open that day, and anticipating the gift she would open tomorrow.

At other times friends ran errands for us. Some of the West High faculty raked the leaves in our yard, and cleaned our house for us. Elaine's brothers and sisters and their spouses came to visit us on several occasions. My sister and her husband, and my parents came to see us as well. Each one would have come many more times if we had let them. We didn't want them to exhaust themselves or the patience of their employers. We could only sit around and pray and offer encouragement to Carol and each other. So we asked them to stand by for us to call if we needed them rather than to keep running to Hendersonville all the time.

Back to Houston. Elaine and Carol spent Wednesday morning packing and getting ready for the trip home. I went back to M.D. Anderson to a research room that Elaine had found the day before. I found a gold mine. I had spent quite a bit of time on the Internet at home, trying to do research on

Carol's cancer. I thought I had done a pretty good job. Since cancer was M.D. Anderson's business; however, they knew many more sources.

In the hour or so that I had, I located several abstracts of medical journal articles, then rushed over to the University Of Texas Medical School library to copy a few of the full articles. By the time I went back to the hotel room, I had an armload of information.

Later, when I had a chance to sift through the material, I found more bad news than good. Basically, the information indicated that an inoperable adenocarcinoma of the small intestine was very bad news, indeed. In actuality, we knew that already.

We arrived at the airport quite a bit earlier than our flight departure time. We discovered we could switch to an earlier flight, and did so. As we boarded our flight to Atlanta, I noticed a flight at the next gate boarding for Salt Lake City.

Carol managed the flight home much better than her westward flight a few days before. This flight was in the afternoon and Elaine was able to enjoy the beauty of flying above the clouds.

Upon our arrival in Atlanta, we rushed to make our connecting flight to GSP. When we arrived at the gate, however, we discovered that the flight was being held to allow some connecting flights to arrive. It seemed that some bad weather in the midwest had delayed some flights. In addition, Elaine had been unable to reach Beth White, who was to drive us home from GSP, to tell her about our earlier arrival time. In the end, we didn't arrive home any earlier, after all. To make a bad thing worse, our luggage

got loaded on that plane going to Salt Lake City.

Our trip to Houston had not revealed some miracle cure. We felt the trip was worthwhile, however, because we had to take the chance that some new solution might be found.

We met with Dr. Medina the following day, and discussed phase II of the chemotherapy plan. Dr. Medina reported that the tests done at Thanksgiving made him believe that Carol's cancer might be neuroendocrine cancer. That is a more specific type of adenocarcinoma which is more responsive to the chemotherapy that Dr. Medina proposed.

A finding that the tests also showed was an infected lymph node in Carol's neck. It was located on the right side, just above her collarbone. That was bad news of a sort, it revealed that the cancer was "distantly metasticized". It had spread to locations far removed from her abdomen, where it had started. According to the research I had done, distantly metasticized cancer is more difficult to control because it has had the chance to spread over a larger percentage of the body.

We were encouraged by the report that the cancer might respond more favorably than we had expected. This was characteristic of our emotional trek. We are a houseful of optimists. We seized upon good news or potentially good news and our hopes would rise, only to be dashed later.

In any case, we felt encouraged by Dr. Medina's report. We knew that a trial still lay ahead. Dr. Medina planned to use a combination of Taxol and Cisplaten. Individually, these drugs were "aggressive". In combination they would be near lethal.

Dr. Medina's plan, as corroborated by Dr. Ajani, was to administer the drugs, then monitor Carol's health for three or four weeks. After that time, if Carol's health would tolerate it, he would administer another round. After four cycles, he would conduct another battery of tests to gauge how the cancer was responding to the chemo.

There were several side effects of these drugs. The first hurdle that Carol would have to cross was the effect they would have on her liver and kidneys. Unless Carol remained fully hydrated for the first three days after her chemo session, her liver and kidneys would be damaged, perhaps to the point they would cease to function. A person with a working GI system would have to drink about 2500 cc's of liquid per day. That's about two and one-half quarts. Carol had a unique problem in that she could not drink. In addition to receiving 1200 cc's of Ensure through her enteral pump and J-tube, we would have to pump her full of water. We would do that with a syringe. We would be very busy.

The second side effect that Carol would have to deal with was a suppressed immune system. Dr. Medina would check Carol's white blood count weekly. If it dropped too low, he would give Carol a shot to boost her immune system. The shots, we were told, were devastating in themselves.

Carol's first chemotherapy session would begin at 10:00 AM on December 5th. It would last until about 5:00 PM. When Carol arrived at the doctor's office, the nurse took blood for a battery of tests. She then administered an IV of Benadryl to suppress any violent reaction to the chemotherapy. Then she started the IV of Taxol. As the day progressed the nurse checked Carol's blood pressure, pulse and temperature. At times,

Carol became flushed, and perspired. At other times, she became chilled, and I had to bundle blankets on her to warm her.

Once the Taxol was finished, the nurse ran a saline drip to keep up Carol's hydration level. Following that, Carol received the Cisplaten. At 4:00, Elaine arrived from school, and I went home to get some rest. The battle against cancer was demolishing me. I could only imagine what it was doing to Carol.

Elaine and Carol arrived home at about 5:30. We spent the next few hours trying to get Carol comfortable. We also worked very hard at keeping up Carol's hydration levels. Most of our time was spent injecting medicine and water into Carol's J-tube. At about 9:00 PM, we hooked up the enteral pump and put Carol to bed.

Carol had a very difficult night. Her temperature spiked to 103 degrees. Dr. Medina's instructions were to call him if Carol's temp stayed above 101. Elaine gave Carol Tylenol (through the J-tube, crushed and dissolved in water) and her temp came down to 102. Finally, Elaine called Dr. Medina.

Fearing that Carol was getting an infection, Dr. Medina told Carol to report to the hospital. It was about 3:00 AM. Elaine had mercy on me and told me to stay home. She knew Carol would be admitted and she knew that I would need to take the day shift tomorrow.

This was getting to be old hat. The cashier at the hospital cafeteria kept thinking I was an employee and trying to give me a discount. I was honest and reported that I was not an employee. Abe Lincoln would have been proud.

Carol spent the next four days in the hospital. During that time, her temperature fluctuated. Dr. Medina prescribed a round of antibiotics. Sometimes, he said, the chemo can cause a fever when it attacks the cancer. This was another source of hope.

December 10 arrived, my birthday. Carol was feeling better and was seriously tired of that hospital room. Mary Jane, one of the oncology nurses, said she could tell when it was time for a patient to go home. They became so restless they would drive the nurses crazy.

Carol lobbied hard to get Dr. Medina to release her. Apparently the fact that it was my birthday made the difference. Dr. Medina released her as a birthday gift for me.

Carol still had difficulty with nausea and fatigue, but her fever was pretty much under control. As Carol started her third week after the chemo session, her hair began falling out, as predicted. Although Carol was prepared for it, it was still a psychological blow. She decided to get a buzz cut, cropping her hair down to about 1/4 inch. This was Carol's way of avoiding falling prey to the cancer and chemo. Rather than allowing the disease to take her hair, she took it herself.

Miraculously, Carol's white blood cell count had stayed up, and she hadn't had to deal with the shots to boost them.

Carol had some more lobbying to do. Christmas was approaching. We had never failed to spend Christmas visiting our families. Carol worked to convince Dr. Medina to let her go to Mississippi. Actually, Dr. Medina was all for the trip provided that Carol's white blood count stayed at an acceptable level. He felt that

a trip to see loved ones would help give Carol a lift.

Elaine's car packing skills were taxed to the limit. In addition to our clothes and the Christmas gifts we were taking to Mississippi, we also had to take the enteral pump and GOMCO machine. Getting all that into the Jimmy was nothing short of miraculous. I don't see how Elaine did it.

We received some news which put a damper on our Christmas cheer just before we departed. William Pannell's wife, Nona Faye, called to tell us that Claude Hood, the husband of Elaine's sister Doris, had died of a heart attack. Claude was a math teacher, and was responsible for influencing Elaine into entering the math education field herself. He had taught Elaine at East Union High School. Later he moved to Itawamba Community College. We always enjoyed the lazy summer days when, during our visits to Mississippi, the Hoods invited us to their house for a fish fry. We would miss Claude.

Carol had to stop by Dr. Medina's office early Monday, December 23, to give a blood sample. Then we headed for Mississippi. Carol made the ten hour trip remarkably well. Everyone's spirits were up. We had some serious fears about whether we could make this trip, and we were all excited about being able to complete it. Carol called one of the family members while we were travelling and learned that the funeral home visitation for Claude was scheduled for that night. In order to make it on time, we went directly there without stopping at Elaine's father's house. Carol attracted a lot of attention at the funeral home. Everyone was pulling for her to beat this thing. I was saddened by her pale, haggard look. I sensed how hard this visit was for her. We arrived

at Elaine's father's house without incident and got Carol settled in for the night. Our only hitch was finding an extra extension cord so Carol could run her enteral pump and GOMCO machine simultaneously.

Tuesday morning Carol awoke strong and refreshed. We made plans to go to Tupelo and shop. As usual, Carol and Elaine went together to shop for "girl things", while I checked out the bookstore and computer software store. That afternoon, we attended Claude's funeral. Christmas is no time to have to put a family member to rest, although I knew Doris and her family had no choice.

On Wednesday, Christmas Eve, Elaine's sister, Sylvia Kelly, invited us to go with her and her son, Jeffrey. She planned to pick up her paycheck and get lunch at a fast food place in town. We also decided to drop in on Billy and Pat Pannell while we were there.

We had another pleasant surprise when we arrived at Billy's house, Billy and Pat's daughter, Tonya Hatcher was there with her two children, so we got a big visit.

That night Carol ran out of her usual nausea medicine and had to switch to her backup, Atavan. I wasn't too happy about that because Atavan made Carol sleep a lot more. She also lost some of her sense of reality while on Atavan, it seemed.

We awoke early on Christmas morning and followed our tradition of opening the family gifts in front of the Christmas tree. Two weeks before, I called the manager of the Social Security office in Greenville NC, the home of ECU. I explained to Fred Lilley that I wanted to find an ECU Medical School sweatshirt for my daughter. He went to bat for me. A short time later, he called back

with the name and phone number of the local marketer of ECU clothing.

They had just what I was looking for. Carol was delighted with the ECU Medical School sweatshirt.

Later we went to Robert and Mary Ann Wigington's house for a breakfast of pork tenderloin, ham, bacon, eggs, biscuits and jelly, which is another tradition. My heart went out, once again, to Carol who was unable to eat the sumptuous meal.

As the day wore on, Carol became tired. I believed that part of Carol's fatigue came from all the activity of the previous two days, and part came from the change in the nausea medicine. She slept most of the afternoon, although she was able to visit with her aunts, uncles and cousins some. After the festivities at Papaw Pannell's, Elaine, Carol and I travelled the thirty miles to my parents.

We spent Christmas night there and all day on the 26th. Then we returned to Papaw Pannell's to spend the night of the 26th before returning to Hendersonville on the 27th.

After dinner on Christmas night, we exchanged gifts with my family. We had agreed earlier to forgo buying Christmas presents for each other because of several circumstances. In addition to Carol's illness, Pam had undergone surgery on her shoulder, and Daddy had been ill with an infection of the urinary system. Nonetheless, Mom gave every one gifts of cash.

We set up Carol's enteral pump and GOMCO machine for the night, and administered her medication. Carol slept in the bed room just off the living room, while Elaine and I slept on the fold-out bed in the living room,

putting us just a few feet from Carol in case she needed us.

Carol slept reasonably well that night. The next day; however, she was still lethargic. The poor girl was just worn out. She sat in a recliner against the west wall of the living room and slept. Her baseball cap covered her sparse head of hair. Her face was pale and waxen.

That night we returned to Papaw's, and drove back to Hendersonville the following day. The trip had been exhausting, but we were all glad Carol had the opportunity to visit with the Mississippi families. Now Carol had a couple of days to rest before her second round of chemotherapy, scheduled for December 31st.

I worried about our ability to provide the hydration necessary to protect Carol's organs. Dr. Medina agreed to arrange for a home health agency to administer an IV for two days after the chemo to cover that risk.

On December 31st, Carol returned to Dr. Medina's office for her second session of chemo. Once again, the session lasted all day. Once again, Carol had a flare-up of fever. This time, however, we were able to keep it below the 101 degree level, and Carol didn't have to go to the hospital.

JANUARY 1998

There were no resolutions this New Year's Day. We only had desperate prayers for our daughter. Carol was supposed to start the spring semester at HPU on January 12. There was no indication she would be able to fend for herself, much less attend classes. When Carol was a baby, Elaine and I alternated nights with "diaper duty". Whoever was on duty would get up to feed, change diapers, etc. whenever Carol cried.

We were so relieved when Carol began sleeping all night.

Now we were faced with similar duties with our twenty-one year old daughter. Whoever was on duty would get up to administer Carol's pain and nausea medicine. Dr. Medina had also added potassium to avoid hypokalemia, and Tylenol when Carol's fever went up. In addition, the person who was on duty would help Carol to the bathroom, or help if Carol had to throw up. We did this by holding a pan to catch her vomit. We sat beside her and wrapped an arm around her, offering some comfort and quiet words of encouragement. Sometimes we moistened a wash cloth and washed her face and neck to relieve the stress. I was saddened to realize that Carol now required just as much care (more, actually) as when she was a baby.

If Carol were going to return to school, she would have to be able to administer her own medication and operate her enteral machine and gastric suction machine. That just wasn't happening. I wanted her to **be able** to return to school so badly. I worried that perhaps Carol had given up, or that fear had rendered her unable to try. Elaine shared my worry.

During the first week of January we rode Carol pretty hard, trying to push her to make the effort to care for herself. I have to admit, part of my desire was to have Carol take care of herself at night so I could get some rest. I knew my energy reserve was shrinking, and I selfishly wanted Carol to take some of the load.

In retrospect, I now understand that Carol was trying just as hard as she could, and bless her heart, she did try. The cancer had just taken too much out of her. She had nothing else to give.

When it's played just for fun, some golfers will agree to give each other a "mulligan". This is a "do over" privilege, which allows the golfer a second chance when he hits a poor shot. I've wished many times I could have a mulligan for that first week of January. Out of my fatigue and frustration, I was asking too much of Carol at a time when she didn't need the extra pressure.

We finally realized that Carol wouldn't be able to return to school, although at first nobody acknowledged it. I knew that Carol would be devastated when she finally faced the truth. Elaine was also having difficulty accepting the idea, as was I. Elaine, who is a first-class worrier, fretted over the possibility that Carol might lose her scholarship. She also fretted over how Carol would handle the realization that she wouldn't graduate on schedule.

We also worried about whether the ECU School of Medicine would allow Carol to enter in 1999, rather than in 1998. It really doesn't matter, I argued, Carol is not able to go back to school. If the scholarship is lost, or if medical school is lost, we'll just have to deal with that when Carol is better.

The big job would be talking to Carol. About bedtime the Wednesday before Carol would have returned to school, I sat down on the edge of her air mattress and said, "We have to talk, Hot Shot.

"I've got something I want you to think about. Don't answer right now, but you'll need to make a decision within the next day or two. I know how important getting back to school is for you, but you need to think about whether you will be able to. School starts in five days. Will you be able to

make it to class, give yourself your medication, and handle your tube feedings by yourself? I want you to be able to go, but I am worried about whether you will be up to it."

A tear rolled down Carol's cheek. She rubbed the sparse hair on her head. "I don't know what to do, Daddy. I want to go back to school, but I don't know if I can."

I didn't want to be in the position of telling Carol she could not go to school. While I was not afraid of being the bad guy, I felt Carol would be more accepting of her situation if she reached her own conclusion.

"Why don't you spend a day or so praying about it? I'll bet God will help you decide." I said.

"Okay," Carol answered. Clearly, this had already been on her mind. I could tell by her response to my question, however, that she wasn't ready to make that decision.

On Thursday afternoon, I sat down beside Carol again. She knew what was on my mind.

"What do you think I should do, Dad?" she asked plaintively.

So, I was going to have to call the shot, anyway. "I just don't believe you are strong enough to make it, sweetheart." I had a lump in my throat the size of a basketball.

Carol nodded. She agreed, although I could tell it was hurting her to acknowledge the truth. It occurred to me that she might have been reluctant to admit her inability to return to school for fear of hurting her mother or me. The next day Carol called Gart Evans to cancel her enrollment for spring. Gart put our minds at ease on one of our worries. Carol's scholarship would be waiting for her next fall if she could make it then.

We decided to wait to talk to the ECU School of Medicine. We hoped that we might get a better feel for the long-term prognosis for Carol after her current chemotherapy cycle was over.

I was worried about the week of January 12th. The Social Security office was scheduled to have new systems furniture installed, and I would have to be on hand to resolve any questions or problems regarding the installation. If Carol were to have problems requiring my help, I would be in a quandary.

Sure enough, Carol called me early Monday morning on the 12th. When push came to shove, I had to choose my daughter's needs over those of the office. I headed for home, leaving Terry Parker in charge of the office.

Carol was having severe nausea and vomiting, which wasn't all that unusual. She was also experiencing disorientation and non-specific fears. I realized she was in no shape to be left alone. I called Betty Robinson, a friend of Elaine's who had retired from WHHS not long ago. Betty was happy to come and sit with Carol. I called Andi Moore, a friend from church, who agreed to stay that afternoon. I wasn't aware I was setting a pattern we would follow for the next month.

Once Betty arrived, I returned to the office. The rest of the day passed without incident. I only had to return home in the afternoon to give Carol her medicine.

The next day, Carol seemed a little better, so I risked leaving her alone. I did call frequently to check on her, and she made it okay.

My dad had been having problems with an inflammation of the urinary tract for several months. Because his doctor had been unable

to eliminate it, it was frustrating to Dad. On January 14th, my sister Pam's birthday, Dad's doctor discovered evidence of cancer in one of Dad's tests. He had squamous cell cancer of the lung. Dad had smoked a pipe in his early adulthood, but had quit over twenty-five years ago. I don't know if this was the source of his cancer, or not.

His doctor was not convinced the urinary tract difficulties stemmed from the cancer, but I had my suspicions. A week after he was diagnosed, Dad had his right lung surgically removed. We hoped that would resolve the problem, but the doctor found evidence of cancer in one of Dad's lymph nodes. That meant chemotherapy for him, too. Despite all our efforts, Dad succumbed to cancer on June 30th, a little over four months after his granddaughter died.

Elaine took a day off from school to drive Carol to Winston-Salem for a previously scheduled doctor's appointment on Wednesday. Carol was very disoriented. We assumed it was due to the Atavan she was taking. I didn't realize how disoriented she was until I received a phone call about mid-morning. It was Elaine on the cell phone, she asked me to talk to Carol, who was very upset.

"Dad," Carol said. She was sobbing. "You've got to tell Mom she's going the wrong way. She's going through Statesville, and you don't go through Statesville to get to Winston-Salem!"

In fact, you do go through Statesville to get to Winston-Salem from Hendersonville. Carol had a particular distaste for driving through Statesville because she had gotten a speeding ticket there once. I was amused at the intensity of Carol's concern, although I shouldn't have been. I should have been more sympathetic.

"Sweetheart," I said. "Statesville is right there on I-40 between here and Winston-Salem. Mom is headed in the right direction."

"No, she's not," Carol whined.

"Trust me, Carol. Mom knows what she is doing." I insisted.

"Okay, but when Mom gets lost, I'm going to say I told you so."

Later, Elaine wished she hadn't taken Carol to Winston-Salem that day. Here's a mulligan for Elaine. Of course, neither she nor I knew that Carol's days were short. By Thursday, we had gotten over the more difficult aspects of our furniture installation at the office, and my concerns about getting whip-sawed between two crises, one at work and one at home, were beginning to ease.

That was a good thing, too. Friday morning was a nightmare. I was making it a practice to get up at about 6:30, get ready and get to work at about 9:00 AM. That usually gave me time to give Carol her medication and stop her enteral pump. On those mornings when gastric fluid had leaked from around her J-tube, which happened occasionally, I would have to help change the dressing. That usually made me late.

This morning, January 16th, she had come a gusher. Gastric fluid had not only soaked the dressing, it had soaked her T-shirt, shorts and underwear. I helped Carol up to the chair, so we could change everything. I was upset. I wasn't upset at Carol, of course, but I could see that I was going to be very late for work, and this frustrated me. This would not be the crisis it would have been a couple of days ago, but it was still bad.

Carol was totally helpless. I gave Carol her underpants and shorts and asked her to change. She told me she couldn't. I had to help change them. That should have been a clue as to how bad her condition had become. Carol was very modest. Not since she was a baby had she allowed me to change her underclothes. Despite this signal, I lost my cool and yelled at Carol about how she needed to help me take care of her. All the while, Carol was crying in her own frustration, as well.

Carol couldn't have helped. Her condition was such that she could not. Here's another mulligan I wish I had.

Eventually, I got Carol's dressing and clothes changed. I tried to use a towel to cover the parts I shouldn't see. I then called Glenda Liese to sit with Carol while I went to work.

Elaine called later to tell me that Carol was being admitted to the hospital again. Her blood tests indicated several items out of balance, and Dr. Medina was concerned. Dr. Medina's office had called Glenda Liese, and she had called Elaine.

Elaine left school and took Carol to the hospital. We had assumed that Carol's mental disorientation was the result of the Atavan. In fact, it resulted from the blood chemistry imbalance. Carol was acting much like an Alzheimer's sufferer. She didn't know where she was or what day or time it was. At times, I don't think she recognized me or Elaine. This was also why she had gotten so confused on her trip to Winston-Salem, no doubt.

Dr. Medina offered a couple of possibilities for this. He believed that the chemical imbalances in the blood could have resulted from having too much gastric fluid

removed by the gastric suction machine. The human body, when it is working properly, is a finely tuned biochemical engine. The processing of the contents of the stomach through the GI tract allows the body to manufacture the myriad chemicals necessary to keep the body working properly. Since Carol's GI system had been haywire for so long, this had been an ongoing problem. I don't know why this could have caused such a serious problem so suddenly, since her stomach hadn't worked in many months, but I don't have the medical background to understand these things.

The other possibility that Dr. Medina considered was that the cancer had invaded Carol's liver. At any rate, Carol was in bad shape.

Elaine and I implemented our "hospital routine" again. She stayed at the hospital all night, and I stayed during the day. When I returned to the hospital on Saturday morning, Elaine told me that Carol had been restless all night. Saturday was no exception. I spent the day wrestling with Carol, trying to keep her from pulling the IV out of her port-o-cath, and from pulling on her J-tube.

Dr. Medina came by and talked about his findings. The second round of chemotherapy had clearly failed to work. The blood chemistry levels indicated that the liver function was impaired. Either the cancer was in the liver, or it was interrupting the flow of bile from the liver through the bile ducts. Dr. Medina also had observed (by feeling) that the tumor in the lymph node at the base of the left side of Carol's neck had grown. He was very worried about what else he could do.

When my "day shift" ended, Elaine came to the hospital and I returned home. I got something to eat and watched TV for a while, before settling into bed. Elaine called at about 11:00 PM. Her voice was surprisingly calm.

"You'd better come to the hospital," she said. "Carol is near death."

The news didn't shock me as much as I thought it would. I guess I'd seen it coming. "I'll be there in a few minutes," I responded. It took me only a couple of minutes to throw on some pants and a sweatshirt. On the ten minute drive to the hospital, I realized I wasn't surprised by the news. Carol's health had done nothing but decline over the last six months.

I arrived at Carol's hospital room within fifteen minutes of Elaine's call. I found Elaine sitting beside Carol's bed, ashen-faced. Deana Greene, Carol's nurse for the night, stood on the other side of Carol's bed watching Carol and talking to Elaine. One of the many strengths of the oncology nursing staff, I discovered, was helping family members deal with their loved one's illnesses.

Carol lay on the bed with her head tilted back slightly. Her unseeing eyes stared out through half-closed eyelids. She breathed through her mouth in loud, sonorous gasps. I believe this is known as Cheyne-Stokes respiration. Her skin was pale and waxen.

Later I learned that the oncology nurses had alerted the staff that they might have to "code" Carol. In hospital jargon, the staff issues a "code blue" alert if a patient's heart stops beating or if they stop breathing. The hospital staff then begins emergency resuscitation measures. We had not

had a chance to talk with Dr. Medina or the medical staff about our wishes regarding emergency resuscitation. Now it appeared that Carol would be unable to participate in that decision.

Dr. Medina arrived shortly after I did. I sympathized with the doctor's job. He seemed to work around the clock. Dr. Medina discussed his assessment of Carol's condition with us. He believed that Carol would not survive the night. At this point, we did discuss what to do if Carol went into cardiac arrest. Before we made a decision, we asked Dr. Medina to discuss his long-term prognosis. We knew that he did not expect Carol to survive the night, but what if she did?

Dr. Medina explained that even though Carol had undergone two types of chemotherapy, both of which held the best, although slim chances of success against this type of cancer, her cancer had continued to grow unchecked. If he were to try another type of chemo, it would have a 5% chance of slowing down the cancer. It would have no chance of stopping it.

There it was. The handwriting was on the wall.

Although Carol was unable to take part in the decision, we knew what her wishes would be. We had discussed this type of situation in the abstract before. Unfortunately, we had not acknowledged the reality of Carol's danger enough to discuss it specifically. We had always known that Carol might die, but I had never been willing to go beyond that.

Carol, we knew, would not be in favor of artificially prolonging her life, not if there was little medical hope of recovery. None of the three of us believed in

euthanasia. We would not decide to take action to end someone's life, not Carol's or anyone elses, no matter what the circumstances. On the other hand, none us (including Carol) would be in favor of keeping a person alive when God came to take them home.

That decision made, we prepared to face what the night brought for us. Dr. Medina made some minor adjustments in her medication. Elaine and I settled into the chairs around Carol's bed, waiting and watching.

Surprisingly, Carol's condition improved. As the night wore on, her labored breathing evened out, and by morning she was breathing more or less normally. She still breathed through her mouth, but in a regular rhythm. She remained comatose. Her eyelids were half-open and unseeing. She didn't respond to sound or touch.

The next day, Dr. Medina talked with us again. He was as surprised as anyone that she had survived the night. He was convinced that the cancer had spread. The tumor in the lymph node at the base of her neck was substantially larger. I touched the area above her collarbone and was surprised to feel a rough, hard texture, somewhat like the surface of a cinder block.

Carol remained comatose for two days. Word spread to our friends at church, and we received a steady stream of visitors Sunday afternoon and Sunday night.

Carol left the medical personnel dumbfounded again on Tuesday when she roused from her coma. At first, she did little more that focus her eyes on things. Then she was able to follow motion. Still she did not respond to sound, although she did appear to respond to some touch.

I was concerned, however, when Carol had two grand mal seizures on Tuesday. To me, that seemed to confirm that the cancer had moved into her brain, or at least that her brain function was affected. These were Carol's first seizures since 1994. Plus, the 1994 seizures had been of the petit mal type.

Because Carol seemed so near death on Saturday and Sunday, Elaine and I arranged to take the week off from work. We feared that we would have a funeral to plan before the week was out.

I was using email to keep many of our friends posted on Carol's condition. I found it therapeutic to share with these colleagues a little of my hopes and fears. Carrie Holley, one of Carol's cousins sent an email to me:

> Uncle Tommy,
> There is something that I wrote for Carol back in November, but I never got up the nerve to give it to her. I deeply regret that decision now, and I know I always will. It was something that I thought she should know. If she does not ever hear this poem, I know I will regret it for the rest of my life. I could not bring myself to give it to her at Christmas because I wasn't sure if she would get upset or not. I can't live with the thought of her not knowing that she is my role model. I would like to send this poem to you, so that you can do whatever you like to with it. I only wish I had told her, in person, at Christmas. She's still in my prayers.

Graduation

God Bless,
Carrie Lynn Holley

Words From The Heart

My heart is hurting deeply from a
 mistake made in my past
I did not speak when I should have,
 and so my chance did pass
I have another chance to say what
 I'm feeling in my heart
But I'll have to say it in a poem
 because we are apart

Last time we met I should have told
 you how much I thought of you
A person who I want to be like
 in everything I do
A person who can be relied on
 morning, noon, or night
A person whom, I believe, will
 fight for what is right
A person with ambition who knows
 what she wants to do
A person with a strong will-
 these things they all name you.

I want to have the tenderness that
 you have always shown
I want to be a friend to others
 like no one has ever known
Your faith you hold in your heart
 can move mountains in your way
Your loving smile and tender words
 mean more than words can say

When I was with you I felt as
 though I could say what's in
 my heart
But I couldn't tell you how I felt

 until we were apart
 It's hard for me to voice my
 feelings when I feel something
 so deep
 So hear my words and know they're
 from my heart and with you
 always keep
 Know always that you have a friend
 who upon you can depend
 Who will look up to you and love
 you until the very end!!!

 Written For Carol Hooker
 By: Carrie Lynn Holley
 November 22, 1997

 Some of Carol's HPU friends came to
visit on Tuesday nigh, including Gwendolyn
Ruffin and Pete Yoder, a young man Carol was
"sweet" on. When he came into the room,
Carol's face lit up like a beacon. She
hardly took her eyes off Pete for the
duration of his visit.
 Dr. Ron Ramke, a professor at High Point
University called one afternoon when Jim
Pearce and Ron Shuler were visiting with me
and Carol. Dr. Ramke was Carol's degree
advisor. He counselled her about which
courses to take and in what order. He told
me that the professors of the university had
met and had voted unanimously to grant Carol
her degree! "This is not a gift." Dr. Ramke
emphasized. "Carol has earned this degree.
She only needs three required hour of work.
We agreed that Carol's work with the Student
Government Association, the Odyssey Club, and
other on-campus extra-curricular activities
were enough to award her credit for those
hours."
 My heart sang! I knew this was a goal
that Carol had struggled for so diligently.

I thanked Dr. Ramke profusely. Later, Dr. Vance Davis, Dean of Academics at High Point University, visited Carol to make sure that we knew about the decision. I told Carol several times. I am not sure she completely understood, but now, in Heaven, I know she does. Four months later, in May, Elaine and I walked across the stage along with the High Point graduating class and received Carol's Bachelor of Arts in Sociology, magna cum laude with all University honors. When Carol's name was announced, the entire graduating class, the professors, and the families stood and applauded. Thank you, God for giving Carol this victory.

Carol continued to grow more alert, but she still couldn't speak. We discovered one problem that had created difficulty for her speech recovery. During her comatose period, she had continued to breathe through her mouth. Since she wasn't taking any liquids through her mouth, her tongue became very dry. As a result, it lost a great deal of its flexibility. Once we realized the problem, we began using sponge swabs to lubricate her mouth and tongue.

On Thursday morning, Dr. Medina came by on his rounds. Carol watched him enter the room. "Good morning," he said to Carol.

"Good morning," Carol responded. Her speech was somewhat slurred, but understandable.

Dr. Medina almost dropped his notepad. He didn't expect Carol to be able to speak to him. He continued to be concerned about the blood chemistry level, especially those indicating liver function. Things had now settled into a day-to-day watch of blood chemistry, vital signs, etc.

Now that Carol was out of immediate danger, Elaine and I had to plan our next few

weeks. We couldn't stay away from work forever. We decided that Elaine would stay with Carol at night, as she had been doing. I would relieve Elaine at 6:00 AM, and she would go home, get ready, and go to school. I would stay with Carol until 9:00 AM. One of our church friends would relieve me, and I would go to work until noon. Then I would return to the hospital and relieve the morning church person. At 1:00 another friend from church would come and stay until 4:00. I would work from 1:00 until 4:00, then stay with Carol until Elaine came for the night shift between 6:00 and 7:00.

We were very fortunate to have many friends from church, school and elsewhere who volunteered to stay with Carol or perform other tasks for us.

When Carol first began to speak, and to rouse from her comatose state, her mental processes seemed almost childlike. I was very disturbed to see this college dean's list scholar struggle to speak and act rationally. I feared that she may have suffered brain damage as a result of the cancer or high fever. As time progressed, she did improve, and I had hopes that she might recover her mental acuity completely.

That Saturday (January 24) three of her college buddies returned for a visit. Jamie Henton, Jenn Romania, and Sean came by. During most of Carol's illness, even though she had been unable to eat, her appetite had been mercifully absent. She had to deal with thirst from time to time. Now her thirst had returned with a vengeance.

The nurses had agreed to allow Carol to have popsicles and liquids. Now the nurses couldn't keep her supplied with popsicles fast enough. The HP bunch were amused with

Carol's delight from eating a popsicle. She also went through soda by the liter.

There was a price to pay however. The stomach pump couldn't keep Carol's stomach empty, and the nausea returned. Carol resumed her daily vomiting routine. She'd had a respite of about a week.

Carol's appetite also returned. Because of her diminished mental state she was unable to realize that she was confined to her bed. She decided that a bowl of jambalaya from the Savannah Beach Grill would be just dandy. She pleaded with me and Elaine to take her to get a bowl of the Cajun treat. "I'll come right back," she promised.

It broke my heart to say no. If I thought she even had a chance of making the trip, I would have taken her in a heartbeat.

Since she couldn't convince us to let her to get some jambalaya, she went for her second choice. How about some McDonald's Chicken McNuggets? Once again we had to say no. This continued for the next week and a half.

Carol was also getting tired of that hospital room, and I didn't blame her. She had tubes connected all over, like a marionette. She had an IV line running to the vital port just under the left side of her collarbone, and she had an oxygen line running under her nostrils. She had the G-tube which emptied her stomach. The J-tube had become totally blocked, and she could only get nourishment through the IV. She had a Foley catheter to empty her bladder.

She tried to cajole Elaine into bringing her some underwear and a change of clothes, so she could leave the hospital, at least for a while. She spoke in a matter-of-fact voice, as if it was a done deal.

"All you have to do is bring a pair of panties, those blue sweatpants, and that red sweatshirt. Uh, and I'll need a pair of tennis shoes. I'll put them right on, and we'll go home."

We had to laugh, otherwise we'd have to cry.

Linda Thomas' Sunday School class was a blessing to us throughout Carol's illness. All of our church friends blessed us, but Linda's entire class seemed filled with a sense of service. Later another of our church members and friends, Pam Miller, died from the effects of cancer. During Pam's illness, I observed Linda's class care for her and her family just as they had cared for Carol and us.

Glenda Paul was a member of Linda Thomas' class, and was one of the first friends to offer to sit with Carol in the hospital. She shared some memories of her time with Carol:

I did not know Carol or her parents, but my daughter Robin knew Carol. When word came to my Sunday School class that Carol's parents would like volunteers to sit with Carol in the hospital, I went home and called Tom. I must insert here that this is not something I had ever done before and I found myself doing something that I never thought I would do.

As I arrived the first day to sit with Carol I knew this was such a special young lady and that as I sat with her and listened to her and tried to grant her request I absolutely fell in love with her. She wanted so badly that day to get

dressed and go out to eat, I knew
that was impossible, but I spoke
with the nurses and several of them
went in the room and bathed and
dressed her in a real cute outfit
and sat her in a chair. As I came
in the room I was amazed at her
strength to sit there, I reminded
her that her Dad would be there
soon.

My next visit was very quiet.
Dr. Medina came and put his hand on
her and just said, 'Carol, you have
fought a good fight.' Most of my
time this day was in prayer, mostly
saying thank you to God for the
opportunity to have met such a
faithful young lady.

Both of my times sitting with
her there was a presence in the
room and then I knew it was HIM.

On Wednesday, January 28th, we asked Dr.
Medina to have a sit down conference. With
Carol's miraculous awakening from the coma,
we wanted him to review his assessment of
Carol's condition. We had another decision
to make. Carol's J-tube had become
completely blocked. Dr. Eisenhauer offered
two choices. The first choice was to replace
the combined G-J tube with a simple catheter,
which would terminate in the stomach. This
tube would only empty the stomach. No liquid
nourishment, such as Ensure, could be
introduced into the GI tract this way. Any
nourishment would have to be provided with
the IV. The advantage to this method was
that no surgical procedure would be required.
Dr. Eisenhauer would be able to remove the
blocked G-J tube and insert the G-tube

277

catheter in Carol's room. The procedure would take five or ten minutes.

The second option involved replacing the G-J tube with another just like it. Since the portion of the tube which delivered the liquid nourishment to the small intestine would have to be threaded through the opening into the small intestine, another surgical procedure would be required. Carol would have to be anesthetized, and a scope would have to be passed through her esophagus into her stomach. The scope would allow Dr. Eisenhauer to guide the J-tube to its proper placement.

Before we made this decision, we needed another talk with Dr. Medina. Vickie Sanders and Tima Duncan came by to check on Carol and sit with us a while. We left Carol in their care while Dr. Medina, Elaine and I filed into the small family conference room beside the nurses station.

I began by explaining that we needed to make some decisions about Carol's care, and we wanted his honest opinion of Carol's prognosis.

We weren't asking Dr. Medina to do anything different. He had always been honest with us. One of his skills, however was to be honest with extreme tact. Essentially, he had already told us that Carol was terminal, without using the word terminal.

It may seem that we drifted back and forth between accepting Carol's condition one moment and denying it the next. That is exactly what we were doing. The concept of our daughter having a terminal illness was more than our mind could handle for any length of time. While we knew that, barring a miracle from God, Carol would not survive,

we still had to ask the question and mentally process that information over and over again.

Dr. Medina spoke slowly and thoughtfully. He briefly summarized Carol's medical history. Two different chemotherapies had been tried unsuccessfully. The cancer had grown unabated. There was nothing else to try which would have even a slim chance of success. Dr. Medina recommended no further treatment of the cancer.

Based on our discussion that night, we decided not to make Carol go through another surgery. We would ask Dr. Eisenhauer to insert a catheter to keep Carol's stomach empty. Carol's only nourishment would come from the IV.

This was a very difficult decision to make. We realized, however, that using a J-tube to feed Carol was in fact an artificial means of life support. We had been willing to do this while we had some hope that the chemotherapy would work. Now with that hope gone, we were unwilling to use artificial means to prolong her death. We were still willing for God to miraculously heal her, but He wouldn't need a J-tube to do that.

So the decisions were made. We thanked Dr. Medina for his honesty, and returned to Carol's room.

We tried not to show our emotions to Carol. We weren't intending to hide Carol's fate from her or to lie to her, but we weren't going to volunteer the information, either.

Carol knew, or at least suspected. She decide not to put Elaine or me on the spot, however. Later that night Mary Carson, Carol's night duty nurse, came in to check on Carol.

"I am going to die, aren't I?" Carol asked her.

Elaine lay in the cot in the corner of the darkened room, crying silently.

I suppose Mary had been asked this question before. In any event, her behavior was compassionate, but honest. "Yes," she answered. Her voice was soft and tender.

"What will happen to me?" Even a Christian who faces death experiences fear.

Mary thought for a moment. "You will begin sleeping more and more, and will be awake for shorter periods of time. Eventually, you will go to sleep completely. When you wake up again, you will be in Heaven."

Brother Steve Scoggins used the following story in a memorial service once. I like its portrayal of dying. Peter Marshal told the story of a young boy who had been very ill for most of his life. Finally, the doctor told his mother that he could do no more, and the young boy would die soon. Of course, the mother was distraught. She decided not to tell her son of the doctors prognosis. The boy, however, was very perceptive and realized that his life was nearing its end.

"Mother," he asked one day. "What will it be like when I die?"

The mother was so surprised by her son's question she couldn't answer right away. She jumped up from her chair and ran to the kitchen, where she gripped the edge of the sink and prayed. "Father, please tell me how to answer my son." God provided an answer.

She returned to the living room, where her son sat, and took his hand as she sat beside him. "Do you remember when you played outside in the afternoons, and got so very tired?" She asked. "When you came into the

house, you would lie down on the couch and drop right off to sleep. Later your father would come in from work and see you sleeping on the couch. He loved you very much, so he gently lifted you in his arms and carried you upstairs to your bedroom. Then he would tuck you into your bed, and kiss you good night.

"The next morning, you would wake up in your bed, and you wouldn't know how you got there. You had slept so soundly while your father carried you to your room.

"That is what it will be like when you die," the mother said, with a lump in her throat. "You will go to sleep. Then your Heavenly Father will lift you up in His arms and will carry you to Heaven. When you wake up, you will be in Heaven with Jesus, and you won't know how you got there."

FEBRUARY 1998

As Dr. Medina predicted, Carol began to decline in alertness and strength. Each day she slept more and more. When she was awake, she was confused, often incoherent. Carol also seemed to be in more pain when she was awake. She was often agitated and irritable. When this happened, Elaine or I called for a nurse to give her a shot of morphine. We hated to steal the last few hours of "awakeness" she had left, but we believed this was preferable to the pain she was suffering.

Our friends continued to come by, offering comfort and giving a few minutes of solace from our vigil. Keisha Corn, one of Elaine's students at West came in when I was alone with Carol once. She stood by Carol's bed, looking into her sleeping face and weeping silently. She had no words, just tears. A few minutes later, she left as quietly as she had come. When Keisha learned

I was writing a book about Carol, she sent a note describing her feelings about Carol:

> Carol was always an inspiration to me. She just had the greatest personality and was so beautiful. We had great times together at church camps. She was my counsellor many times. I really admire her for her strength and everything about her. I visited her in the hospital a lot when she was there, and she was always so fun and always cheered me up. She loved those popsicles! I will never forget her. She is a hero to me that has left a lasting impression on my heart.

Friends from church continued to spend mornings and afternoons with Carol, so I could go to work. Marianna and Trent Dollyhigh, Skip Fendley, Karen Scoggins, Dick and Gail Bowling, Glenda Paul, and many others. Dick & Gail Bowling stayed with Carol two mornings in a row when icy road conditions kept one of the other sitters at home. Dick's four-wheel drive pick-up was up to the challenge.

Elaine and I were exhausted. Elaine probably more than I, since I at least got some sleep in my own bed at night, albeit in a lonely house. Since it appeared God would not heal her, we prayed that God would take her quickly.

I had almost reached the end of my rope mentally and physically. I couldn't bear to see my daughter just lying on the bed, wasting away. I know Elaine felt the same way. One afternoon I was alone with Carol. Elaine had gone home to do some household

chores before returning to stay the night.
I read an article about the Apostle Paul from
"Christian History" magazine. Electricity
ran down my spine. The article contained a
passage which seemed to speak directly to
Carol's condition. Not only that, it offered
a promise that lifted a great burden from my
heart. This is the passage:

> "Therefore we do not lose heart.
> Though outwardly we are wasting
> away, yet inwardly we are being
> renewed day by day. For our light
> and momentary troubles are
> achieving for us an eternal glory
> that far outweighs them all. So we
> fix our eyes not on what is seen,
> but on what is unseen. For what is
> seen is temporary, but what is
> unseen is eternal. Now we know
> that if the earthly tent we live in
> is destroyed, we have a building
> from God, and eternal house in
> Heaven not built by human hands."
> 2 Cor. 4:16 - 5:1 NIV

Through this passage, God reminded me
that although Carol had endured a life
fraught with pain and trials, these troubles
were "light and momentary" compared to the
reward that awaited Carol. I was so proud of
Carol's life. No father could have asked
more of a daughter. With this verse, I
received the assurance that her Heavenly
Father was also proud of her, and that He
waited at Heaven's door to welcome her home.
Losing her would be hard, but I would be
selfish to deny her the reward that she would
receive in just a short while. I thanked God
for giving me this assurance at a time when
I needed it so badly. The next time I went

home, I put that verse on a 8 1/2" by 11" poster and taped it to the wall of Carol's room. Every time I found myself struggling, I looked at that verse and received encouragement from God.

I received a letter from Mindy Allen, one of the youth that Carol had worked with at Churchland. Mindy had graduated from high school and had entered college at High Point University since Carol's tenure at Churchland. Mindy asked for an honest report about Carol's condition. It appeared that a lot of rumors were circulating, and Mindy was unsure about what was actually happening. Probably, Mindy had heard that Carol was dying, and hoped it was a false rumor.

I believed that it was best to be truthful with Mindy. I also believed it was important to reassure her about Carol's eternity. I tried to convey those messages in my letter to Mindy.

On Saturday, February 7th, Steve Martin brought a group of youth and parents from Churchland to see Carol. Mindy was with them, so she learned first-hand about Carol's condition before my letter reached her. I regretted that Carol wasn't alert enough to visit with them. She roused long enough to recognize Steve and welcome him, but I don't think she recognized anyone else.

The Churchland group brought a sackful of gifts and cards. They stayed long enough to leave them and to have a good cry. I pointed to the passage I had posted on the wall and encouraged them about Carol's future. Then they left. I tried to imagine their tears and somber mood on the three hour drive home.

William Pannell called Monday the 9th, offering to come and be with us for a while. I discouraged him from coming. We didn't

know how long Carol would last. I worried that they might come and stay a week, only to have Carol die while they were on the road back home. William allowed me to talk him out of the trip. Later, he admitted that he had a feeling that he should make the trip anyway.

On Tuesday, the 10th, Larry and Sherrie Orr came at 9:00 to stay with Carol while I went to work. I was so tired I know I contributed practically nothing at the office. I tried to do what I could, and I at least was there in case of an emergency.

At noon, I rushed back to the hospital to relieve Bo and Sherrie. Bo told me they had tickets for the Daytona 500 and were on their way there. I wished them well.

Cyndi Blanchard arrived at 1:00 to take the afternoon shift. Carol remained unconscious. Dr. Medina had arranged for Carol to be put on a morphine pump. This way, she received a steady flow of morphine and didn't experience the roller coaster of pain effect that periodic morphine shots would have caused.

I stumbled back to work for the afternoon. Cyndi recalled that afternoon with my daughter:

> The first time I met Carol, she was in the hospital. I remember seeing her smiling, even though at the time she was in a great amount of pain. I had mentioned my visit with her to my daughter, Heather. Heather did not know Carol very well, but wanted to visit her, and soon thereafter did. They formed a very special friendship, which was an answer to one of my prayers. I had been

praying for God to send a friend
for my daughter since we moved to
North Carolina, and He answered my
request with a very special young
woman ... Carol.

I remember sitting with Carol
in her hospital room, and noticing
that each time someone entered her
room, she would smile. I had a
slight apprehension before sitting
with Carol for the first time, not
knowing her very well, and not
knowing what to say to her. That
feeling **quickly** changed to
anticipation, because of the person
Carol was.

The last time I sat with Carol
was the last day she spent in our
world. I brought a book with me,
and asked her if she wanted me to
read to her. She was very
uncomfortable, but once I started
reading, she seemed to relax a bit.
I remember feeling such peace in
her room, in spite of her struggle.
Jesus was there.

When I returned to the hospital at about
5:00, Elaine had arrived to relieve Cyndi.
Carol was breathing is gasps, just like she
had the night in January when she was so near
death. If I hadn't been so exhausted, I
would probably have noticed the similarity.
It wouldn't have made any difference. We had
already decided to welcome Carol's release in
death, so she could journey home to Heaven.

Elaine went home to clean up and prepare
for another night at the hospital. I leaned
back in the recliner and dozed off. I woke
about fifteen or twenty minutes later to a
silent room.

Graduation

I knew what had happened even before I walked over to the bed. Carol lay on the bed, completely still, not breathing. Her eyes were half-open, unfocussed. Her forearm was cool to the touch. It was still warm, but beginning to cool down.

I pushed the nurse call button and Judy came into the room. "Can you get a pulse?" I asked.

Judy looked at me. "I'll try," she said. I could tell she knew Carol was already dead, too. She placed her stethoscope on Carol's chest. After a moment, Judy said, "She's gone."

Although Judy was only confirming what we both already knew, the wave of grief that swamped me was overwhelming. I sobbed and sat on the chair beside Carol's bed, struggling to compose myself. I picked up the phone to call Elaine, but Judy interjected. She volunteered to call for me. I gave her our home phone number, and the number for Shuler & Luck Funeral Home. She left to make the calls.

I called my mom and repeated Judy's words, "She's gone." I cautioned Mom not to make the trip to Hendersonville. Her job was to take care of her husband, my father, who was recovering from cancer surgery himself.

While the nurses were preparing Carol's body for transport to the funeral home Mary Carson said, "I'll never forget Carol. She changed my life. I'll never be the same."

TAPS
Day is done, gone the sun
from the lake, from the hills,
 from the sky
Safely rest, all is well.
 God is nigh.
 Anonymous

AFTERMATH

"He will wipe every tear from their eyes. There will be no more death or mourning or crying or pain, for the old order of things has passed away."

Revelation 21:4 (NIV)

His loved ones are very precious to Him and He does not lightly let them die. Psalm 116:15 (LB)

What happened after Carol's physical body breathed its last? Some who have had "near death experiences" say that they see a bright light at the end of a long tunnel, and that passing along the tunnel, they approach the light. They usually are revived before reaching the end. I don't know if something like this happens or not.

I kind of like the story related by Peter Marshall. When Carol's body died, I think her Heavenly Father (who had been in the room all along, as related by Glenda Paul and Cyndi Blanchard) picked up Carol's spiritual body in His gentle arms, cupping her knees in one nail-scarred hand and cradling her back in the other. Her head rested on His shoulder in sleeping repose. In this fashion, Jesus carried his child to Heaven, perhaps laying her on a soft cloud, and waited for her to awaken. When she did awaken, Jesus was there to show her new home to her. Perhaps He spoke those cherished words, "Well done my good and faithful servant." For the first time in months, Carol had no pain or nausea. She felt wonderful. She was strong and happy. I think Jesus took some time to explain to her about her illness and why it was important to His purpose. For the first time, Carol had complete understanding of all

things. Carol had no sadness for her earthly parents grief, because she knew that we would join her one day, and she understood that all was for our Heavenly Father's glory.

Many who read this book have lost a loved one. Many have suffered the grief and pain from such a loss, or from some other trial in their lives. What would Carol say to us?

"Don't be dismayed," perhaps she would say. "Everything is just fine. We are here in Heaven with Jesus. Would you want us to leave such a place? Our spirits, once housed in jars of clay, are now housed in golden vessels. Our illnesses are gone. Our pain is no more. Our life is full of joy and praise for God. Don't feel sad for us. Be patient, you will see us again."

Several months after Carol's death a friend of ours, Pam Miller died of cancer. Skip Fendley sang a song and her memorial service that touched my heart. I believe the title is, "If you could see me now." When I first heard the title, I thought Skip was about to sing a Broadway tune. Instead he sang a touching description of life in Heaven. I could just see Carol and Pam in the words of his song. The first verse and chorus goes like this:

> Our prayers have all been answered.
> I've finally arrived.
> The healing that had been delayed
> has now been realized.
> No one's in a hurry, there's no
> traffic in the street.
> We're all enjoying Jesus, just
> sitting at His feet.
>
> If you could see me now - I'm
> walking streets of gold.

If you could see me now - I'm
 standing tall and whole.
If you could see me now - you'd
 know I'd seen His face.
If you could see me now - you'd
 know the pain's erased.
You wouldn't want me to ever leave
 this place,
If you could only see me now."

Of course, we do feel sad, but for our
own loss not because our daughter is in
Heaven. We are still separated by that
mysterious veil which shields our view. We
must wait for the time when our understanding
is complete. That time will come, but only
when Jesus deems it.

A month or so after Carol died, Elaine
and I went to the theater to see the movie
"Titanic". We hoped that some entertainment
would help relieve the grief. We knew that
the movie was a real tear-jerker, but it was
the big movie event of the moment, so we
decided to go. Except for a couple of scenes
that we objected to, it was a very good
movie.

Rose and Jack, passengers on the doomed
ship, fall in love during the voyage. When
the ship sinks, Jack dies and Rose lives.
Rose's life is changed forever. In the next-
to-last scene, eight-four years after the
tragedy, one hundred year old Rose dies
peacefully in her sleep. The final scene
depicts Rose aboard the Titanic once again,
being met by Jack and the rest of those who
died that fateful day. As Rose enters the
ballroom of the ship, those who greet her
applaud.

When this scene played in the theater,
I cried uncontrollably. I knew that the
scene was the director's depiction of Rose's

entry into Heaven, where she is met by her friends who died before her.

While I don't think of Heaven looking like the R.M.S. Titanic, this scene conveyed a vivid mental image of Carol's arrival in Heaven after her death. I could just see her being met by her grandmother, Lula Blanche Pannell, and her Uncles Paul Hayes Kelly and Claude Hood, and by all her Christian friends who had died before her. Paul was there, as were the disciples. When Carol arrived, I could just see everyone applauding her, welcoming another child of Calvary home. I envisioned Jesus, welcoming her with a hug and a smile. The Heavenly Father who was just as proud as her earthly father.

During Carol's memorial service, Brother Steve Scoggins remarked about the many people who expressed confusion about why Carol's life had to end so soon. She was so young. She showed so much promise. She had earned her university degree. She was headed to medical school. She had such a firm grip on life, and a mature plan for what she wanted to do; but it was not to be. Of course, there is no answer on this side of Heaven, but Bro. Steve quoted a Bible verse and gave an answer that I think is very cogent. First, he read 2 Timothy 4:7, "I have fought the good fight. I have finished the race. I have kept the faith."
Then he said, "Carol did more in twenty-one, almost twenty-two years, than most do in seventy. She touched more lives than many do in 70 years. Her race was only to be this long, but she finished it. I meet very few people who finish the task God gives them. Carol finished her race."

That made sense to me. Carol had done what God had set out for her to do. God had

no purpose in keeping her here on Earth any longer. It was time for her to go Home.

Andi Moore wrote this inside her Bible the day Carol died.

Carol,

You died today and I miss you. I'll never forget your eyes and how they pleaded with me to let you out of your hospital bed. And I'll never forget how you apologized every time you asked for anything. I'll never forget how brave you were. I'll never forget your voice, your laugh, and your wit. You hated where you were, but you never complained. You suffered so, and it broke my heart. Your disease stripped you of all human dignity, but you never complained and I know it is because your Jesus never opened His mouth when He suffered. Oh, how I wish I knew why you had to go through this.

You are my earthly hero. I want to be more like you, Carol. I know you have met our precious Savior face to face and I know if you could tell us anything it would be that you are home.

I love you my sweet friend. I know you will be there with a hug for me the moment I step into eternity. I can't wait to see you again. I love you.

When Carol encountered someone who was carrying a heavy load of emotional pain, she would always offer to help carry the load for a while, or offer to help ease the load if she could. But she always had more to offer.

"Look!" She would say, pointing to the Cross. "There is One who can take that load from you forever! Wouldn't you like to meet Him?"

A young woman named Amy Beale travelled to South Africa in 1995, financed by a Fulbright Scholarship. She planned to use the funds from the scholarship, her love for the people of the country, and her desire to help ease their load to try to improve the dreadful living conditions of the black people in the South African townships. Instead, she was killed by three young black men, people that she had come to help. To this day, no one knows why they killed her.

I know how Ms. Beale's parents felt. Their lovely young daughter had been snatched from their lives. What were they to do? They decided to undertake the unfinished work begun by their daughter. They travelled to South Africa to the very village where Amy was killed. They ministered to the very people Amy had ministered to, even the three young men (now in prison), who had killed their daughter.

When Elaine and I brought Carol home from the hospital four days after she was born, and we trembled at the awesome responsibility that God had given us in this young child, we decided to pray for God's help in raising her. That she would grow into a fine young Christian woman who would glorify God. As Carol grew from childhood into womanhood, and demonstrated that she was, indeed, that prayer answered, I believed that God's calling for me had been to be Carol's father, and to raise her to love God.

Carol's death changed that belief. My job, no doubt, had been to be Carol's father and guide her with God's help for the twenty-one years of her life. But now she is in Heaven and I am still here, so that can't be

all God has for me to do. Perhaps part of Carol's job was to shape me into the kind of Christian man who can love God and glorify Him. Perhaps my job now, like Amy Beale's, father, is to take up Carol's work. Perhaps now I am to help ease someone's load and point them to the Cross. Pray for me in this respect.

As Carol grew from childhood into womanhood, and demonstrated that she was, indeed, that newborn bedside prayer answered, I envisioned my last days on Earth, when I could say to God, "Thank you for answering my prayer, and making Carol into such a treasure." Instead, I find myself the survivor instead of Carol, and I find myself looking back on Carol's life. Yet, I still say, "Thank you God, for Carol. Thank you for giving me and my wife twenty-one wonderful years with our daughter. Thank you for giving us the privilege of being her parents."

Aftermath

And God Said

I said, "God, I hurt."
And God said, "I know."

I said, God, I cry a lot."
And God said, "That's why I gave
 you tears."

I said, "God, I get so depressed."
And God said, "That's why I gave
 you sunshine."

I said, "God, life is so hard."
And God said, "That's why I gave
 you loved ones."

I said, "God, my loved one died."
And God said, "Yes. So did mine."

I said, "God, it's such a great
 loss."
And God said, "I watched mine
 nailed to a cross."

I said, "But God, your loved one
 lives."
And God said, "So does yours."

I said, "God, where are they now?"
And God said, "Mine is on my right,
 and yours is in the light."

I said, "God, it hurts."
And God said, "I know."
 Author Unknown

Most of you don't know Carol and Carol
 was never
 a student of mine--
But I knew her all the time.
I saw her walk in the halls at West and
 I knew she
 was one of our best.
Most people don't know the time we went
 through
 renovation--
 There were fumes in the air--
 particles of God knows what!
Fumigation, pollution and Carol had to
 wear a mask--
I would see her as she walked passed.
Some students would make fun--but
 everyone knew Carol
 was the one who would succeed.
Through her own initiative she got a
 scholarship to High Point College,
 but illness after illness followed
 as her gradepoint soared and her
 reputation grew. She even went to
 Harvard to impress them too.
Carol--yes--I know her--though I never
 really did--I saw
 her spirit--I felt it--every time
 she was near.
Carol, who touched the lives of many,
 has left us now--
What will we remember?
 a smile,
 a determination,
 a sureness,
 a courage,
 a spirit,
 an inspiration.

Aftermath

She will always be in our hearts.
Although it was so sad to see her part,
We know that she is in a place of rest
 and care,
And some day we will see her there.

 Janice Anderson